TURNER

TURNER

by

John Rothenstein
and
Martin Butlin

GEORGE BRAZILLER NEW YORK

For the Trustees
and our colleagues
on the staff of the Tate Gallery

Foreword

This account of Turner's art is almost entirely concerned with his oil paintings, partly because these are readily accessible to the general public, partly because his literally thousands of watercolours deserve separate treatment. The original titles of the works exhibited by Turner are used, wherever practicable, when first quoted in the text and also in the list of plates; later additional or alternative titles are given in square brackets. Exhibited works may be taken to have been first shown at the Royal Academy except where otherwise stated. The custody of works in the Turner Bequest is divided between the National Gallery, the Tate Gallery and the British Museum, London, but their distribution is occasionally modified; in the winter months one room at the Tate Gallery usually contains a selection, changed from time to time, of watercolours from the British Museum.

The authors wish to acknowledge the assistance and encouragement of their colleagues at the Tate Gallery, in particular Miss Mary Chamot and Mr Stefan Slabczynski, and of Mr Adrian Stokes, who, though his recent work on Turner listed in the bibliography was not available to the authors at the time of writing, made several useful suggestions. They also wish to thank Mr Edward Croft-Murray, Mr Paul Hulton and other members of the staff of the British Museum print room and the staffs of other museums and art galleries in the British Isles and the United States for their helpfulness in supplying information and granting access to their collections, and similarly the staff of the Witt Library of photographs. Besides the literature mentioned in the bibliography the authors are indebted to lectures and

classes given by Sir Kenneth Clark and Mr David Thomas at the University of London. Mr Michael Kitson kindly made accessible material prepared for the catalogue of the Romantic Movement exhibition before it appeared in print. Finally both the authors and the publishers would like to thank all the owners of works reproduced in this book for their co-operation and Mr Geoffrey Agnew, Mr Oscar Johnson and Mr Evelyn Joll for their good offices in getting in touch with certain of these owners.

Contents

J. M. W. TURNER

JOSEPH MALLORD WILLIAM TURNER was born in 1775 and died at the age of seventy-six in 1851. His first known watercolour was painted in 1787 and this marks the beginning of a long career during which he produced a succession of masterpieces unequalled in range and power by any other British artist; only in his very last years was there any falling off. The range of his subjects, although confined largely within the field of landscape, and the vast sweep of his development from his first topographical drawings to his late evocations of light and atmosphere, to say nothing of the intrinsic qualities of the works themselves, proclaim him the greatest painter the English-speaking peoples have yet produced. However, until a few decades ago the chromatic symphonies of his final years were mostly unshown and comparatively few people were aware of their existence. They are astonishing pictures by any standards and as products of early Victorian England almost incredible. They are now justifiably regarded as the culmination and distillation of Turner's genius, but their impact of recent years has been so influential that there has grown up, in part as a reaction against their previous neglect, a tendency to admire them to the exclusion of his previously acclaimed works. Nevertheless one cannot disregard the importance Turner himself attached to his exhibited works — it was indeed only these that he wished to bequeath to the nation — and it is a falsification of his achievement to dismiss the greater part of his career as a period during which he turned away from his true vocation to set

himself up in rivalry to the Old Masters. Turner's aims were multifarious and ambitious as well as original and in order to realize them even a painter of his preternatural industry and endowments had need of a long period of preparation. But from early in his career, that is to say from well before he discovered a way of seeing the world in a way entirely his own and evolved a style appropriate to this highly personal vision, he painted pictures that reveal his genius.

Much has been made of the inadequacy of Turner's education in the light of his ambition to paint subjects from classical mythology and from the history of the Ancient World. It is more likely, as T. S. Eliot wrote of Blake, that the fact that he was not compelled to acquire any other education than he wanted, or to acquire it for any other reason than that he wanted it, was a favourable condition. Much too has been made of the prosaic character of his beginnings as a topographical draughtsman. But this beginning gave Turner a technical grounding for his later imaginative works and a professional approach to his art rare among English painters. Moreover the very conventionality of Turner's beginnings favoured the eventual fulfilment of his aims. His topographical work not only gave him the financial security necessary to survive the attacks that were inevitable as soon as the revolutionary character of his genius became apparent, but also won him the honour and renown which gave him the necessary confidence to disregard criticism; early conformity protected the innovating spirit until it could soar above its critics.

* * *

It must be confessed, however, that Turner's earliest watercolours give little indication of his powers. An example like *View on the River Avon near Wallis' Wall, Bristol* (plate 2a), the product of a sketching tour made in the West Country in 1791, shows an aptitude for picking a 'picturesque' viewpoint but also a somewhat inept attempt at breadth of treatment; there is no sign of the interest in light that was to become the most important element in his art. The even earlier view of *Radley Hall* (British Museum, Turner Bequest III-C) is a naïve record of a house conventionally framed by trees. It was not until about two years later, in such works as *Tom Tower, Christ Church, Oxford* (plate 4a), that he showed himself master even of the traditional style and technique of contemporary topographical draughtsmanship. This watercolour and the well-known *Inside of Tintern Abbey, Monmouthshire*, exhibited in 1794

4

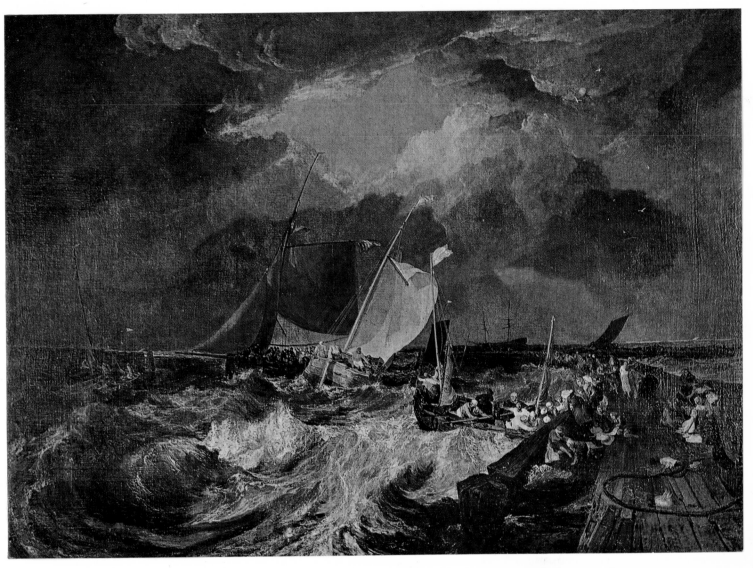

I. Calais Pier, with French Poissards Preparing for Sea: an English Packet Arriving. 67¾ × 94½ *in. Exhibited* 1803. *Tate Gallery.*

(versions in the Victoria and Albert Museum and the British Museum, Turner Bequest XXIII-A), are already exceptional in quality although still within the formula of the 'tinted drawing', in which the outlines were drawn first and the main areas of light and shade then laid in, the local colours and detailed forms being added last (see plate 3a). A responsiveness to light is apparent in the modulation of tones over Tom Tower and in the contrast between the dark foreground and arch and the lighter supporting piers of the Abbey, arranged in a way that gives a first faint intimation of Turner's great vortex-like compositions revolving round a light centre. A comparison with the routine topographical watercolours of such artists as Edward Dayes and Thomas Malton, Turner's first master, shows Turner's superior quality even at this early date. His rapid progress reflects his enormous industry in these years, in which annual sketching tours provided material for finished watercolours and, from 1794, engravings. These annual tours became a practice from which Turner rarely deviated for the rest of his life, and despite his early successes in oils and his ambitions as a subject-painter he never abandoned his topographical work, which retained its popularity long after his exhibited paintings had begun to lack purchasers.

For three winters, probably beginning in 1794, Turner was among the artists employed by Dr Thomas Munro to make finished drawings on the basis of sketches and unfinished watercolours by J. R. Cozens. Turner's particular task was to colour the pencil copies made by Thomas Girtin, a mechanical and impersonal task but one which introduced him to a radically different conception of watercolour from that in which he had been trained hitherto, one in which topographical accuracy was subservient to poetic and personal feeling. One of Cozens' watercolours, *The Coast under Vietri, in the distance Salerno* (Victoria and Albert Museum), painted for Beckford on the basis of a sketch made in 1782, had even anticipated Turner in the linking together of coast and storm-clouds in a single vortex-like form; Cozens' sketch is in a notebook which also contains other drawings copied at Dr Munro's at this time, while Turner could have seen the finished watercolour itself when he stayed with Beckford at Fonthill in 1799. Cozens' works also prepared Turner for his first visit to the Alps in 1802, when he made sketches of many of the same scenes, such as the Great Falls of the Reichenbach and the Grande Chartreuse.

Turner would also have seen works by other artists in Dr Munro's extensive collection but more important was his contact with his fellow copyist

Thomas Girtin, who had like him been liberated from the strict topographical tradition by the influence of Cozens and who had also, late in 1794 or early in 1795, taken a decisive step away from the established practice of tinting over a monochrome ground. In Turner this change to direct colouring seems to have taken place rather later, but in such a work as *Old London Bridge* (plate 2*b*) of about 1796–7 he shows himself completely free of both the technical and the pictorial trammels of the topographical tradition. This technical revolution made possible a greater flexibility of expression in his finished watercolours, which were no longer governed by the first laying in of the outlines and main forms, and a change from the predetermined to the improvisatory that was to make possible his later revolutionary masterpieces. Turner himself was conscious of this: according to Farington, writing of a visit on 21 July 1799, Turner 'told me he has no systematic process for making drawings. He avoids any particular mode that he may not fall into manner. By washing and occasionally rubbing out, he at last expresses in some degree the idea in his mind.' (After another visit on 16 November of the same year Farington made the much-quoted note, 'Turner has no settled process but drives the colour about till he has expressed the idea in his mind', which would seem to be a later lax re-statement of his note of July rather than a record of Turner's considered views in 1799; even Turner's 'colour-beginnings' of the 1830s and '40s (plates 104*a* and *b*) hardly anticipate abstract expressionism to this extent.)

Though Turner remained content to execute finished topographical water-colours for patrons, such as those of Fonthill for Beckford (plate 16*b*), or for engravers, as in his nine views published between 1799 and 1811 in the 'Oxford Almanac' (see plate 25*b*), other works of the same period such as his Highland and Alpine drawings (plates 17*a* and *b*) show the influence of Cozens' audacious treatment of mountain scenery. Moreover he was already capable as early as 1801, in *Edinburgh from St Margaret's Loch* (plate 16*a*), of a magical delicacy in his use of washes of colour which anticipated his Venetian watercolours of 1819.

By 1801 however his oils had revealed an artist at the opposite pole from the delicate watercolourist, and an even more striking development from tentative beginnings.

* * *

Turner's first oil-painting was almost certainly the work exhibited at the Royal Academy in 1796 as *Fishermen at Sea*. Though it was hung in the 'Anti

Room' which also contained watercolours the context of contemporary criticism suggests that it was an oil. This work was described in one report as a night-scene and Thornbury, Turner's first full-length, although unreliable, biographer quotes a manuscript note by the engraver Edward Bell stating that Turner's first important oil was 'a view of flustered and scurrying fishing boats in a gale of wind off the Needles'. Both night-scene and Needles are features of the Cholmeley sea-piece (plate 5), the composition of which reappears as one of the unengraved designs for the 'Liber Studiorum', many of the plates of which were based on Turner's existing compositions. The similarity in technique to Turner's first fully documented oil, *Moonlight, a Study at Millbank* (plate 6), another almost monochrome night-scene exhibited the following year, confirms its identification with the work shown in 1796. Despite their praise the critics made little of the fact, particularly significant in view of Turner's later development, that it is primarily an essay in light, the scene being lit by moonlight but with a second source of illumination, a lantern, in one of the boats. This combination of natural with artificial light, as well as the rather leathery finish, suggests that Turner had seen pictures by Joseph Wright of Derby. Certain details such as the band of light on the horizon anticipate Turner's methods of suggesting distance in his seascapes of a few years later, although here the effect is more pictorial than spatial. In addition the Cholmeley sea-piece displays a feature that remarkably foreshadows one of the most pronounced characteristics of the art of the later Turner: the elliptical form of the composition. Turner's apprehension that our natural field of vision is not the rectangle of the picture frame but an oval was eventually to express itself in his use of a vortex-like composition, culminating in such a work as *Snow storm — Steam-boat off a Harbour's Mouth* of 1842 (colour plate XXI).

Moonlight, a Study at Millbank is a less ambitious but more successful work. In his choice of a commonplace stretch of river as the setting for his study of a particular effect of light Turner comes his closest to Girtin, but a comparison with the latter's celebrated watercolour, *The White House* of 1800 (Tate Gallery), demonstrates the difference between the picturesque approach and subtle composition of the one and the directness of vision and seemingly casual acceptance of the scene of the other.

Turner's handling of oil paint came suddenly to life in the pictures he exhibited in 1798, when at last it shows a freshness and assurance parallel to that of his watercolours. Although *Dunstanburgh Castle, N.E. Coast of Northumberland.*

8

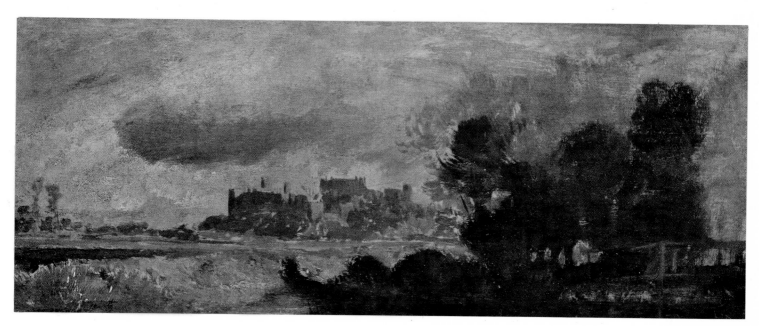

II. WINDSOR CASTLE FROM THE MEADOWS.
$8\frac{3}{4} \times 21\frac{1}{2}$ *in. Painted* 1807 (?). *Tate Gallery.*

Sun-rise after a Squally Night (plate 9) suggests, like *Mountain Scene, Wales* (plate 8) of about the same time, that this advance owed much to a study of Wilson, other of his exhibited paintings clearly proclaim an emerging personal style. In *Buttermere Lake with part of Cromackwater, Cumberland, a Shower* (plate 7) the smoky greens in the middle distance, although reminiscent of Wilson, are shot with flashes of white expressive of Turner's peculiar feeling for light, and the rainbow, an effect reminiscent of Wright and the fashionable Picturesque, is part of Turner's all embracing vision of a particular effect of nature as it floats with its subtle, muted colours over the luminous atmosphere that wreathes the mountains. The artificially raised foreground, barely indicated by a screen of branches in the bottom left-hand corner, helps to focus attention upon the light-toned centre of the picture. A similar expedient, even more radically employed, marks *Morning amongst the Coniston Fells, Cumberland* (plate 10), in which the whole of the lower half of the picture is given the minor role of leading the eye upwards and into the brightly lit distance, which is itself tilted so as to be seen from above. The handling is freer than in *Buttermere Lake*, especially in the use of flecks of pink to enhance the effect of pearly distance, and the contrasts of tone are more pronounced. The foreground branches remain a convention but in the distance instead of a rainbow we see the rising smoke singled out by Ruskin as one of Turner's favourite images. It is interesting to recall that the same year, 1798, saw the publication of 'Lyrical Ballads', as these works seem to be the first major pictures of scenes in the Lake District, which later formed the setting of so much of Wordsworth's poetry. But Wordsworth's deliberate simplicity and everyday language were a far remove from Turner's development at the turn of the century, though to a certain extent they may have underlain the greater economy and severity of *Dolbadern Castle, North Wales* (plate 11), exhibited in 1800 and presented by Turner to the Royal Academy as his Diploma Picture.

It is noteworthy that Turner's early oil-paintings are more personal and ambitious in their imagery than his watercolours. Turner's evolving attitude to nature was indicated by the titles and quotations which he chose to be printed in the Academy catalogues. At first they mainly concentrated on the effects of nature themselves, such as *Moonlight, a Study at Millbank* or *Buttermere Lake, a Shower*, or the text from 'Paradise Lost' beginning 'Ye mists and exhalations' which accompanied *Morning amongst the Coniston Fells*; a later example is *Sun rising through Vapour: Fishermen cleaning and selling Fish* of 1807. Gradually

Turner began to evoke more specifically literary and historical sentiments. In the case of *Dolbadern Castle* he stressed the association of the scene with its tower

Where hopeless Owen, long imprison'd, pin'd,
And wrung his hands for liberty, in vain,

and a watercolour of Caernarvon Castle was exhibited, also in 1800, with similar 'Bardic' verses. In 1799 he reinforced the claims of what was probably his first essay in the grand manner, though one depicting a contemporary event, the lost *Battle of the Nile*, with further lines from 'Paradise Lost'. Turner's interest in literary and historical subjects finally led him to supply his own verses. The first may be those accompanying *Narcissus and Echo*, exhibited in 1804; the first verses definitely by him are a draft for an 'Ode to Discord' connected with *The Garden of the Hesperides*, exhibited, without the verses however, in 1806, and the first excerpt from the 'Fallacies of Hope' appeared in 1813; this, a store-house of quotations for the rest of Turner's life, was probably never a complete poem but is interesting as an example of the turgid epic verse that was popular in the late eighteenth and early nineteenth centuries; even William Blake's prophetic writings have their origin in this fashion. A notebook of about 1808 in the possession of C. W. Mallord Turner contains a number of Turner's drafts for his verses which show that he deliberately modelled his style on that of James Thomson, whose Aeolian harp is the theme of a poem in another sketch-book of the same period (British Museum, Turner Bequest CII) and was also the subject of a painting exhibited in Turner's gallery in 1809.

Literature continuously nourished Turner's conscious intention to create works worthy to rank in subject and treatment with those of the Old Masters and underlies the imagery of the rest of his career, which, to quote MacColl, was that 'of a vast elegy. It ranged from the serene melancholy of Claude and mirage of classic empires, to the wrecks of feudal landscape reinstated by Scott, and the passionate pilgrimage of Byron, evoking history and passing on where history gives out at the last peopled crag under rock and snowfield, or launches on the obliterating sea.' In particular, as Ann Livermore has shown, it was his early reading of Thomson's poetry that not only provided the titles and quotations for many of his exhibits but suggested the choice and treatment of their subjects. Passages from 'The Seasons' inspired, besides such pictures as *Butter-mere Lake* where Turner acknowledged his debt by quoting from Thomson,

11

such diverse works as the *Plagues* of 1800 and 1802, *The Departure of Regulus* painted in Rome in 1828, *The Evening Star* of about 1830, and *The Slave Ship* of 1840. The idea of contrasting *Modern Italy* and *Ancient Italy* in the pictures exhibited in 1838 and *Modern Rome* and *Ancient Rome* in 1839, as well as Turner's interest in the decay of ancient civilizations shown in many of his Roman and Carthaginian subjects, reflected the impact of Thomson's lesser known 'Liberty', while Turner's neglect of Gothic except in topographical works and certain of his late Venetian and German paintings, a neglect which so puzzled Ruskin, is probably also partly explained by the eighteenth-century rationalist dismissal of Gothic as the product of an age of superstition to be found in the same poem. That this literary influence persisted throughout Turner's life suggests that his titles and verses were not thoughtlessly added irrelevancies but that they played an essential part in the genesis of his pictures.

Turner's range was such, of course, that his choice of subjects cannot be explained by reference to any one source, and they seem also to reflect a knowledge of his contemporaries, the early Romantic poets. As we have seen there is at least a hint of Wordsworth's direct approach to nature in Turner's landscapes of the late 1790s and a similar naturalism was also conspicuous in his English landscapes of about 1807 to 1813. A debt to Byron was acknowledged in such works as *Childe Harold's Pilgrimage — Italy,* exhibited in 1832, and it was probably Byron who revived Turner's interest in Venice in the same decade, although even this can be shown to be in part the reawakening of an interest traceable to Thomson. However, though such influences affected much of Turner's approach to his subjects, he was able, from about 1815 at any rate, to transform this poetic imagery into a vehicle for feelings of a more personal kind. He became emotionally involved in his subjects for their own sake and these were at the same time invested with his own aspirations in a way possible only in the new era of Romanticism, so that, for instance, his approach to classical antiquity combines a splendour and nostalgia the closest parallel to which is the music of Berlioz. It is this personal transformation of what was in its origins an approach derived from eighteenth-century taste that makes us, in the words of Sir Kenneth Clark, 'want to stamp and clap our hands' before Turner's greatest masterpieces.

* * *

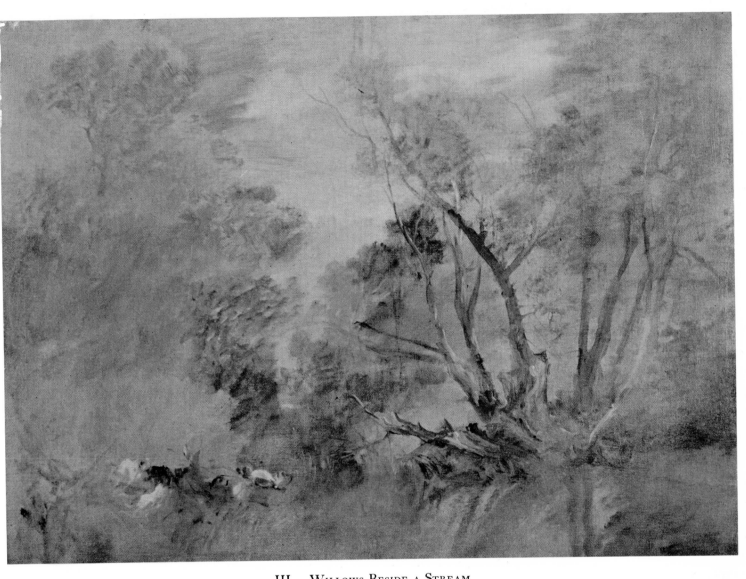

III. WILLOWS BESIDE A STREAM.
33½ × 45½ *in. Painted* circa 1807–8. *Tate Gallery.*

In 1799 Turner became an Associate of the Royal Academy at the youngest possible age, in 1802 a full Member. He justified his success by a series of early masterpieces in the grand manner, based on the intensive study of the Old Masters. Whereas his earliest works, including his only history-piece of before 1800 known at present, *Æneas and the Sibyl* (plate 12), were derived mainly from the works of his British predecessors (a possible exception was the untraced *Battle of the Nile* exhibited in 1799) the exhibition of *The Fifth Plague of Egypt* (plate 14) in 1800 immediately placed him in the European tradition. The 1790s were a particularly opportune time for students of European painting. Many art collections had been dispersed by the French Revolution and subsequent wars. Much of the Orleans collection was sold in London in 1793, Reynolds' collection was on view in 1793 and sold two years later, and the Altieri Claudes were shown before their purchase by Beckford in 1799; other works were to be seen at the dealers throughout the decade. In addition Turner was able to study in 1799 two important collections, that of William Beckford at Fonthill, where he stayed for three weeks making topographical drawings (see plate 16b), and that of the Duke of Bridgewater, who had bought a third share of the Orleans collection. Turner's visits to these two collectors were followed by the commission from the first to paint *The Fifth Plague* and from the second to paint a companion to his van der Velde sea-piece. These two commissions set the pattern of his work for the next five years, during which time his exhibited pictures were mainly historical and mythological or sea-pieces, with but few pure landscapes.

The oil-paintings of this period, like those of the 1790s, continued to be distinct in style from the watercolours and more ambitious. Turner, as conformist in his early years as he was revolutionary later on, accepted the eighteenth-century distinction between the various genres, according to which each had its distinct traditional character and mode of expression. This neo-classical hierarchy, with history painting at the apex, helps to explain the differences between Turner's works in different media and between his oils of different subjects. It was however already beginning to be disregarded within the Academy itself and Turner's development of an entirely personal style, common to all subjects and to his watercolours as well as his oils, was but part of the general movement already under way by which classical 'decorum' was replaced by the Romantic conception of the individual artistic personality.

In *The Fifth Plague of Egypt* (plate 14) Turner introduced the 'historical

landscape' into English art for the first time. This genre, in which the landscape is not merely the setting for an historical event but plays a dominant part in establishing its mood and content, had found its fullest expression in the dramatic landscapes of Poussin, and it is significant that Turner should have based himself mainly upon the most classical of landscape painters rather than upon the looser, more picturesque though superficially more dramatic art of Salvator Rosa and his followers. The discipline and knowledge that underlie the apparent freedom even of Turner's latest landscapes, such as *Norham Castle* (plate 124), are based upon the lessons of this period of his career. But the error in the title — for the plague depicted by Turner is really the seventh — shows that Turner's attitude to his subject lacked Poussin's concern for scholarly accuracy. Closer in his approach to Claude, and at the same time typical of the emerging spirit of Romanticism, he found in the Bible as in the classical writers of history an evocation of mood; his brain was filled with the sonorous clamour of the past in which strict accuracy was often disregarded. Just as his preternaturally retentive visual memory enabled him to elaborate finished paintings from the roughest of pencil sketches made years before, recreating the atmosphere of the scene, so the memories of his reading constituted a reservoir of poetic imagery through which he could relive the emotions aroused in him by the contemplation of the past.

The Bridgewater sea-piece, *Dutch Boats in a Gale: Fishermen endeavouring to put their fish on board* (plate 15), was exhibited in 1801. Its general composition is that, reversed, of the Duke of Bridgewater's *A Rising Gale* by the younger Willem van der Velde (though in fact Turner's picture is slightly larger and they are not therefore an exact pair) but there are significant differences: in the Dutch picture the position of the ships is clearly established and the eye is led into the distance by their diagonal placing; the sea and the sky have no part in the spatial composition. In Turner's painting all the ships, except those in the foreground, are parallel to the picture surface; depth is suggested by the sweep of the clouds and highly selective lighting of the sea; particularly important is the strip of light which picks out the most distant ships, the edge of the horizon, sharp where van der Velde's is diffuse, and the lighter tone of the sky behind the dark ship on the right. In addition Turner makes far more of the contrast between the dark lowering clouds and the luminous sails. These devices, foreshadowed in *Fishermen at Sea* (plate 5), are used in most of Turner's subsequent sea-pieces. In the Bridgewater sea-piece Turner breathed new life into the

tradition of marine-painting in England which for well over a century had consisted in little more than the mechanical imitation of the van der Veldes. In his next sea-piece he transformed this tradition.

This was the Egremont sea-piece, *Ships bearing up for anchorage* (plate 18), exhibited in the following year. The lighting, now far more complex, and the very forms of the clouds invoke the same heightened sense of drama as is found in *The Fifth Plague*. Turner would thus seem to have broken down the traditional distinction between genre and history painting were it not that he had treated *The Tenth Plague of Egypt* (plate 19), also exhibited in 1802, in a manner even more severely classical than its predecessor. Whereas the Egremont sea-piece is still based in part upon diagonals *The Tenth Plague* is based strictly upon verticals and horizontals, and its lighting, in spite of its dramatic contrasts, expresses nothing of the flickering excitement that marks the sea-piece. In the sea-piece the light on the foreground waves brings the illuminated ships immediately above them up almost to the picture surface; in the other the lighting leads the eye into depth in a steady clearly defined series of planes.

* * *

In 1802 the brief spell of peace afforded by the Treaty of Amiens allowed Englishmen to visit the Continent. Turner first went straight through France to the Alps, his interest stimulated by Cozens' drawings. His own watercolours (plate 17*a*) show an increased grandeur and expressive character compared with his Scottish scenes of the previous year (plate 17*b*), as if Cozens' precedent had finally freed him from the picturesque topographical quality that had continued to distinguish his watercolours from his oils.

On his homeward journey he spent from one to three weeks in Paris studying in the Louvre, its collections already vastly augmented by loot from the Netherlands and Italy. His notes and rough sketches demonstrate his extraordinary power of visual analysis, particularly of colour. His predominant interest in Titian and Poussin and his relative indifference to Rubens show that the painter whose own naturalism and brilliance of colour were shortly to scandalize academic opinion still largely shared at this time the taste of the eighteenth-century virtuosi.

The effects of his studies in the Louvre are clearly evident in his Titianesque *Holy Family* (Tate Gallery), exhibited at the Royal Academy in 1803, and in

16

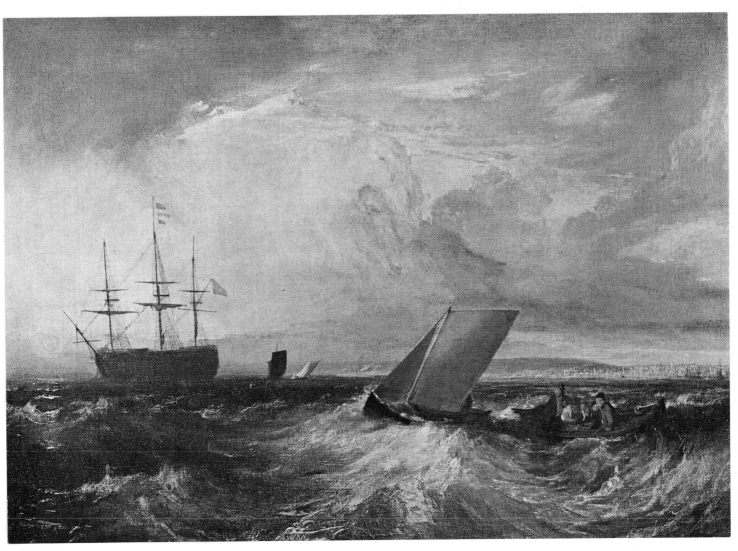

IV. SHEERNESS AS SEEN FROM THE NORE.
40 × 57½ in. Exhibited 1808 (?). Christopher Loyd, Wantage, Berkshire.

the *Venus and Adonis* (plate 24) of about the same date, which reflects, in particular, Titian's *St Peter Martyr*, lately removed from Venice. Sir Stephen Courtauld's *Chateaux de St Michael, Bonneville, Savoy* (plate 21), the more classical of the two paintings of this subject that Turner exhibited at the Academy in 1803, exemplifies his application of Poussin's principles of composition to a scene encountered on his travels, although the foreground foliage, like that in *Conway Castle* (plate 20), shows that he had also studied the Dutch landscape painters, particularly Cuyp, always a special favourite in England. In *The Festival upon the Opening of the Vintage at Macon* (plate 22), another subject derived from his French tour and exhibited at the Academy the same year, Turner looked directly to Claude instead of, as in *Æneas and the Sibyl* (plate 12), to his reflection in Wilson; the type of composition with its vast distances with river and bridge and framing trees can be seen in Turner's almost exact copy of a Claude of ten years later (plate 54), though in *The Vintage at Macon* the raised foreground still harks back to Wilson.

Calais Pier, with French Poissards preparing for Sea; an English Packet arriving (colour plate I), another picture exhibited at the Academy in 1803, exemplifies the synthesis of history and genre that Turner began to develop from this time. It is a brilliantly successful attempt to treat a scene from ordinary contemporary life with the lofty poetry usually reserved for history or myth. Though in subject a sea-piece based on Turner's recent stormy crossing of the Channel and comprising genre elements such as the slightly caricatured figures derived from Teniers and the still-life fish (which anticipate Turner's later range and delicacy of colour), the scale of the work and the discipline given to these elements by a composition on classical principles produce an essay in the grand manner. The composition depends upon the near-vertical of the pier, which at once leads the eye into the distance and links the other elements in a stable surface design. Diagonal stresses and alternations of light and dark, already used by Turner in similar contexts and perhaps reflecting the 'pathetic' quality of the leaning trees, contrasted in tone, of Titian's *St Peter Martyr*, add a sense of excitement and danger. Several of the devices prominent in the earlier sea-pieces reappear, such as the rent in the dark clouds echoed by the brightly lit distant sail and the knife-edge of white along the horizon, but *Calais Pier* is less glassy in finish, altogether freer in handling. The weakness inherent in an empty bottom left-hand corner, in his later pictures sometimes rather tritely evaded by the introduction of a buoy, is brilliantly avoided by the dramatic

curving wave: an intimation of the great unequivocally vortex-like compositions to come is used to solve a problem in part posed by Turner's appreciation of the elliptical nature of natural vision with its growing lack of definition at the edges. Though the scene is one which Turner had personally experienced, his device of an artificially raised viewpoint, combined with the strict compositional structure, produces a sense of detachment which places the painting in the classical tradition. This detachment remained a feature of Turner's works even when he developed far beyond his early classical manner.

In *The Shipwreck* (plate 23), one of the pictures on view when Turner first opened his own gallery in 1805, he created a still more tempestuous sea-piece by stressing the dramatic effect of diagonals, which diagonals also form a lozenge-shaped surface pattern holding together all the storm-tossed elements of the scene. Instead of the somewhat obvious drama of the rent in the clouds found in his earlier storm scenes the same effect is here secured with more naturalistic lighting. The far distance, usually stressed by Turner, is obscured in mist and spray. Unlike *Fire at Sea* (National Gallery, London) of some thirty years later where the elements hold total sway over the diaphanous and helpless figures, the figures here make a positive contribution to the overall effect, and into his still somewhat Teniers-like repertory he has introduced an expressive, Madonna-like figure — another token perhaps of his intention of raising this representation of an incident from contemporary life to the dignity of history painting.

At this time even Turner's English landscapes show a move away from the comparative naturalism of such a work as *Conway Castle* (plate 20) to a more rigidly classical treatment, as in *Windsor Castle from the Thames* (plate 26). This is signed 'J. M. W. Turner, R.A. Isleworth', where Turner almost certainly had a house from 1811 to 1813, but this was presumably done on its sale to the third Earl of Egremont — Turner's signature is only found on works which left his possession — for its composition, based largely on forms lying parallel to the picture surface, its Titianesque colouring and relative absence of atmosphere, the forms of its clouds and its figure-style, are all very close to the large history-painting *The Goddess of Discord choosing the Apple of Contention in the Garden of the Hesperides* (plate 27), exhibited at the British Institution early in 1806. Though ostensibly an English landscape it has a still and timeless quality and a monumentality very different from the paintings which followed Turner's renewed study of the English scene a year or so later.

In the summer of 1807 Turner published the first part of his 'Liber Studiorum', the scheme of which throws light upon his conception of landscape at this time. The previous summer he had been persuaded by W. F. Wells, the founder of the Water Colour Society and an engraver and publisher, to prepare this series of engravings on the pattern of Claude's 'Liber Veritatis', though in fact the resemblance is only superficial: Claude's work was a record of his existing oils, made as a precaution against forgery, and it was not engraved until after his death, whereas the 'Liber Studiorum' was from the beginning designed to be engraved, partly to ensure against pirated engravings of poor quality but mainly as an independent collection of landscape compositions in different genres. For the plates Turner used both his own existing works, oils and watercolours, and compositions made especially for the purpose. In a draft title page the types of landscape were listed as 'History, Mountains, Pastoral, Marine [see plate 32a] and Architecture', to which Turner added a category 'E.P.', a subdivision of Pastoral qualified most probably as Epic, though Elegant and Elevated have also been suggested; the works in this group (plate 32b) tend to be Claudian and Italianate as opposed to the more naturalistic Pastoral designs. Though the complete series of a hundred plates was never completed parts continued to be published until 1819, retaining to the end this subdivision into categories which once again reflects Turner's traditional approach to the theory of his art.

* * *

The same year, 1807, saw a sudden change of balance in Turner's subject-matter. Turner's exhibits at the Academy included for the first time since 1798 no history-pieces or dramatic sea-pieces but two paintings only, representing scenes from contemporary life. One was *A Country Blacksmith disputing upon the Price of Iron, and the Price charged to the Butcher for shoeing his Poney* (plate 29), which was perhaps inspired by the rising reputation of Wilkie, although it suggests too a continuing indebtedness to Teniers. It represents Turner's most intimate treatment of an everyday subject up to this time. It is the first of a number of interiors with figures, such as *The Garreteer's Petition* (Tate Gallery), exhibited at the Academy in 1809, to which there exists, in sketch form only (British Museum, Turner Bequest CXXI-B), a satirical pendant showing a painter in his studio with an apprentice, the subject of which is hinted at by Turner's draft verses which refer to

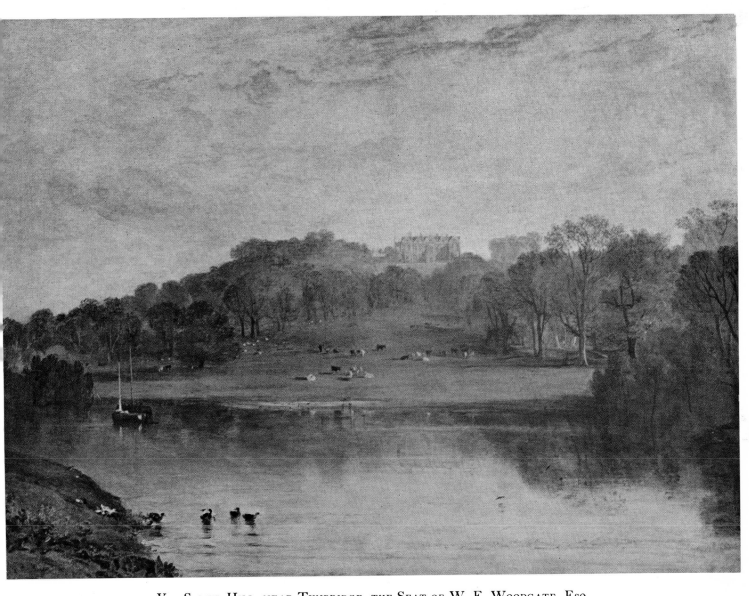

V. Somer-Hill, near Tunbridge, the Seat of W. F. Woodgate, Esq.
36 ×48 *in. Exhibited* 1811. *National Gallery of Scotland.*

Old Masters staked on floor,
Stolen hints from celebrated pictures,

while the attitude of the painter

Pleased with his work he views it o'er and o'er
And finds fresh Beauties never seen before

is contrasted to that of the apprentice who

Nor cares for taste beyond a butter'd roll.

The other painting exhibited in 1807, *Sun rising through Vapour: Fishermen cleaning and selling Fish* (plate 28), is in certain respects a successor to *Calais Pier* (colour plate I). It is similar both in construction and as a combination of genre and sea-piece treated in an elevated style, in this case one derived largely from the idyllic landscapes of Claude. But there is a new serenity and an enhanced subtlety in the naturalistic representation of light. In comparison with *Calais Pier* there is little attempt at grandiose effects: the composition, based entirely on verticals and horizontals, is less dramatic, the sea is calm, the horizon less remote, the transitions between light and dark less abrupt, and the entire scene is suffused and unified by the atmospheric effect which gives the picture its title. The traditional progression from dark foreground to light distance is retained but justified naturalistically. The wisps of cloud foreshadow the almost tangible vault of the sky that distinguishes many of Turner's later works. Although this painting, which Turner bought back in the sale of the collection of Lord de Tabley (formerly Sir John Leicester) in 1827, was one of the two paintings singled out in his will to be hung with Claude's *Sea Port* (*The Embarkation of the Queen of Sheba*) and *Mill* (*The Marriage of Isaac and Rebecca*) in the National Gallery, one is no longer conscious of a deliberate striving to emulate the Old Masters; this spirit of emulation returned however in the next decade.

Although Turner continued to exhibit history-pieces during the next five years or so these were far outnumbered by less ambitious English landscapes, in which the closest observation of nature is fused with poetic feeling. In these landscapes Turner developed the Claudian mood of *Sun rising through Vapour* but his arcadia is completely English in form and expression. At the same time this arcadia, though no less idyllic than that of Gainsborough's late years, differs in being entirely credible, in belonging, so to speak, to the waking rather than

to the dream world. For, suffused with poetry though they are, these works conform to the most exigent standards of realism, especially in their light and atmosphere. The majority, though not all, of these landscapes were exhibited in Turner's own gallery, as if Turner were conscious that their new restraint was less suitable to the competitive atmosphere of the Academy (an atmosphere into which he himself was only too happy to enter on varnishing days).

An entirely external circumstance may have been partly instrumental in this change of emphasis: after the brief period of peace in 1802–3 war again severed communications with the Continent for a further twelve years. It was primarily however the result of Turner's own renewed preoccupation with nature. After his first visit to Scotland in 1801 and his tour of France the following year his sketching tours seem to have become less frequent and extensive, though he made a few expeditions to the Home Counties and the south-east coast. In the second half of the decade however he made numerous studies on the Thames which testify to a new interest in the everyday aspects of the English scene. His expeditions up and down the Thames resulted in a number of watercolours (see plate 33a and b), but their most fruitful consequence was a series of small oil sketches on panel, mostly made, internal evidence suggests, from a boat, probably in 1807 (colour plate II, plates 34 and 35); their revolutionary features are hinted at, no more, in the small oil sketches on paper made at the time of Turner's visit to Knockholt in 1806 (plate 25a).

In these panels, which followed immediately upon the plagues, storms at sea, mythologies and elaborately contrived Poussinesque landscapes of the first half of the decade, Turner showed a radically different side to his art, that closest to his great contemporary Constable. He revealed himself as what Constable called 'a natural painter', but 'a natural painter' with an emphasis different from Constable's. In his sketches Constable was concerned with his direct experience of nature, recording its actual features under particular conditions of light or weather, whereas with Turner the process of composing a picture took over almost from the start. Even in the extreme instance of *Tree Tops and Sky* (plate 34) Turner was interested in the pictorial effect of trees against clouds, while in Constable's cloud studies, each with a careful note of the precise weather conditions and hour of day, the interest is in the clouds themselves. Turner's technique was, relatively speaking, a pictorial rather than a descriptive one, the tonality being more diffused, the effect less crisp, than Constable's. Whereas Constable's horizons are usually closed, confining one's attention to a

particular clear-cut area of landscape, Turner's are open, indicating that the scene represented, however intimately, is only a part of a limitless whole. And even in these river scenes, among the most personal of all Turner's works, he chose, by using a slightly raised viewpoint rather than exploiting his actual, unusual position only a little above the surface of the water, to set himself apart from his subject, to hint at a detachment that saw beyond the stretch of river before him.

Both Turner and Constable have been claimed as precursors of Impressionism, but the superficial 'impressionism' of Turner's late technique conceals a very different aim. The Impressionists, whose avowed purpose was to reproduce the appearance of nature, were in line of descent rather from Constable, who, though contemptuous of any attempt to represent nature literally, without an informing vision, was a realist with nature as his first and abiding love, whereas Turner was a poet with a cosmic vision for whom natural appearances, however deeply loved, were primarily a means rather than an end; but living when he did he was led to express himself in terms of a greater understanding of physical and optical laws than that enjoyed by earlier visionary painters.

At about the same time as these small sketches on panel Turner painted a number of large sketches on canvas, also of places on the Thames or the Thames Estuary (see colour plate III and plates 36 and 38). Thornbury reports the son of Turner's friend the Rev. John Trimmer as saying that Turner painted large sketches from his boat, but the size of these canvases makes it unlikely that they could in fact have been painted on the spot, though some, such as *Willows beside a Stream*, show a freshness lacking in even the best of the finished works of the next few years. Some are related to finished oils, in particular *Mouth of the Thames*, which is close to a number of variants of the same theme, including *Sheerness as seen from the Nore* (colour plate IV), probably exhibited in Turner's gallery in 1808, the *Shoeburyness Fisherman hailing a Whitstable Hoy* (National Gallery of Canada, Ottawa) exhibited in Turner's gallery in 1809, and *The Junction of the Thames and Medway* (National Gallery of Art, Washington) of about the same date. Another of the sketches, smaller in size however, was used with negligible modifications as the basis for *Harvest Dinner, Kingston Bank* (Tate Gallery), exhibited in Turner's gallery in 1809. Turner's earlier sketches, so far as they are known, are drawings such as those in chalk on grey-blue paper for *Calais Pier* and other sea-pieces (British Museum, Turner Bequest LXXXI, LXXXVII, etc.) and it seems that with his urge towards

VI. Devonshire Landscape.
Oil (?) *on card,* $5\frac{1}{2} \times 9\frac{1}{4}$ *in. Painted* 1813. *British Museum.*

greater naturalism Turner began at this time to experiment with the full-scale oil sketch to preserve like Constable a feeling of spontaneity; his procedure was however more flexible, the finished work rarely following the sketch so closely as Constable's. It is even possible that, foreshadowing a much later practice, these sketches are in fact unfinished pictures, laid aside either as unsatisfactory or to be worked on as the occasion arose. One of them, *Trees beside a River, with a Bridge in the Middle Distance* (Tate Gallery), is more heavily painted than the others, as if carried further towards completion.

A group of small unpretentious landscapes, such as *Cliveden on Thames* (Tate Gallery), probably exhibited in Turner's gallery in 1807, and *Eton College from the River* (plate 37), exhibited in Turner's gallery the following year, show a first tentative return to nature, shedding the classicism of such works as *Windsor Castle from the Thames* (plate 26), but they lack the mastery of light and atmosphere which, although already manifest in *Sun rising through Vapour*, was only fully realized in the field of pure landscape after the prolonged experience before nature represented by the Thames sketches. The results of these sketches can be fully seen in such a painting as *Ploughing up Turnips, near Slough*, usually known as *Windsor*, exhibited at Turner's gallery in 1809 (plate 41). The transformation of his treatment of English landscape since *Windsor Castle from the Thames* (plate 26) is astonishing. In *Windsor* the exact observation of nature manifest in such a sketch as *Windsor Castle from the Meadows* (colour plate II) is combined with a typical genre scene in a formal composition based upon receding diagonals, but one's attention is primarily drawn to the distant castle seen through haze. This emphasis on a distant motive recalls the early *Morning amongst the Coniston Fells* (plate 10) but in that work there are no competing genre or topographical elements. Here Turner subordinates the genre element to the topographical, but at the same time he veils its forms by his atmospheric treatment; however, although the castle is hardly visible as a structure of stone and mortar its presence is felt, presiding over the whole scene. Even in subjects which would seem to call for a more topographical treatment detail is suppressed in the interest of atmospheric unity. In *London [from Greenwich]* (plate 40), exhibited in Turner's gallery in 1809, the central motive of Greenwich Hospital is broken up into contrasting sections of light and shadow, while the lozenge-shaped composition draws the spectator's eye towards the mist-shrouded St Paul's; the rays of light falling diagonally through rain-clouds are balanced by rising smoke, blown by the wind to create diagonals

26

in the opposite direction. Likewise in *Petworth, Sussex, the Seat of the Earl of Egremont: Dewy Morning* (plate 46), exhibited at the Academy in 1810, the house is not only placed in the distance — this indeed was a feature of the earliest English topographers and had been developed by such artists as Wilson and Wright of Derby — but is obscured by morning mist and partly concealed by the hill: atmosphere and accidents of site are exploited to transform a mere likeness of a house into a radiant presence at one with and enriched by its setting of benign landscape and light.

Somer-Hill, near Tunbridge, the Seat of W. F. Woodgate, Esq. (colour plate V), exhibited at the Academy in 1811, may be regarded as the culmination of Turner's revolutionizing of the topographical tradition, though Turner painted further works in this genre right up to his Italian tour, for example *Raby Castle, the Seat of the Earl of Darlington* (plate 58), exhibited in 1818. *Somer-Hill* combines the placing of the focus of interest in the extreme distance with careful attention to the overall surface design. One's eye is first led in from the ducks in the foreground to the cattle on the far side of the lake, but, because one tends on looking at the picture as a whole to equate the size of the cattle with that of the ducks, the effect of their distance is minimized, thus preventing the recession from seeming too abrupt. One's attention is then drawn up the hill to the house by alternating bands of light and shadow which culminate in the distant streak of bright light, similar to those in Turner's sea-pieces, on which the house rests; at the same time this alternation helps to reduce the tunnel-like effect of the converging trees. That this interest in preserving the unity of the surface is deliberate is shown by the pentimento raising the height of the bank in the left foreground; if this repoussoir were lower or absent altogether the progress into depth would be much more abrupt.

The genre element of everyday country life depicted in *Windsor* was treated in its own right in such works as the *Sketch of a Bank with Gipsies* (plate 42), also on view in Turner's gallery in 1809 — 'sketch' is a relative term compared with the true sketches discussed above, which were almost certainly never exhibited — and it reaches its most perfect expression in *Frosty Morning* (plate 51), exhibited, once again with a quotation from Thomson's 'Seasons', at the Academy in 1813. It was this picture with its detailed observation of the hoar-frost in the foreground that so impressed Constable's patron the Rev. John Fisher.

It was in some of these oils, such as *Petworth: Dewy Morning* and *Somer-*

Hill, that Turner began to exploit a white ground in the interest of a high tonality. In the Thames sketches on panel he had shown his appreciation of the colouristic possibilities of the mahogany veneer but this made for a low tonality; in the oils made immediately afterwards he continued to use the relatively subdued colouring of Wilson and Titian, though in a more naturalistic form. For the sketches on canvas Turner had used a white ground for water or sky, but other landscape forms seem to have been painted over a pale brown ground, a differentiation of function reminiscent of the traditional process followed in his first watercolours. But now that it was his intention, apparent even to a hostile critic writing of the pictures exhibited in 1810, 'to express the peculiar hue and pellucidness of objects seen through a medium of air, in other words to express the clearness of atmosphere', it is not surprising that, inspired perhaps by the effects obtained by the use of white paper for his watercolours, he began to use a white ground for his oil paintings. This device freed him from the need — which to the same critic seemed desirable — of selecting 'those dark material objects which serve as a foil to aerial lights and [so] to produce atmosphere by their contrast', and enabled him to reverse the traditional procedure of working upwards from the darkest tones and to work instead from the lightest. He only fully explored the possibilities of this innovation in paintings of a much later date in which, as a creator of brilliant light by a harmony of light tones instead of by contrasting light and dark tones, he was indeed a precursor of the Impressionists. This revolution in outlook and technique provoked Sir George Beaumont, whose early praise of Turner had already been followed by criticism of the breadth of his handling, to direct a savage attack on 'the white painters', as he termed Turner and such followers as Callcott.

In strong contrast to these naturalistic landscapes is *Mercury and Herse* (private collection, England), exhibited at the Academy in 1811. This is a historical landscape of a kind otherwise absent from Turner's work during these years, though one which forms a link between *The Festival at Macon* (plate 22) of 1803 and the similarly Claude-like works of 1814 and later (colour plate VII; plates 54 and 55, etc.). The general acclaim accorded this picture as the best landscape of the year is a significant reflection on contemporary criticism.

The increased intimacy and serenity of Turner's treatment of landscape is also found in some of his sea-pieces of the same period. In the group of Thames Estuary scenes mentioned above, such as *Sheerness* (colour plate IV), the high

VII. CROSSING THE BROOK.
76 × 65 in. Exhibited 1815. Tate Gallery.

drama of the earlier sea-pieces is absent and more everyday subjects are shown. This is most apparent in *Fishing upon the Blythe-sand, tide setting in*, usually known as *Bligh Sands* (plate 44), exhibited at Turner's gallery in 1809, in which, as in the later *Frosty Morning*, all associative and picturesque elements have been discarded, the intensity of the treatment itself evoking a response to the scene in a way characteristic of the new Romantic movement. As in the earlier sea-pieces the dark foreground acts as a repoussoir to a distant illuminated area, which here however only occupies a minute fraction of the canvas. The foreground details and the silhouetting of a dark boat against the light ones behind are all that remain of a lingering conventionality.

Nevertheless some sea-pieces of the same period show Turner's continued interest in the grand manner. These include *The Battle of Trafalgar as seen from the Mizen Starboard Shrouds of the Victory* (plate 31), also known as *The Death of Nelson*, which was exhibited unfinished at Turner's gallery in 1806 and at the British Institution in 1808, and *Spithead: Boat's Crew recovering an Anchor* (plate 39), so entitled at the Academy in 1809 but first exhibited, also unfinished, at Turner's gallery in 1808 as *Two of the Danish Ships which were seized at Copenhagen entering Portsmouth Harbour*, a subject the political implications of which were soon out-dated. In these two works Turner treated contemporary events on a grand scale, following the practice established by Benjamin West and John Singleton Copley in the 1770s, and for both paintings Turner hurried as soon as possible to make pencil sketches of the ships concerned, in the second case arriving in time to see the actual event; he was always ready to make special trips in search of suitable subjects, as later in connection with the paintings of George IV at Edinburgh (see plate 65) and *The Fighting Temeraire* (plate 108). *Spithead* is Turner's most stately reinterpretation of the van der Velde tradition, but the only precedent for the close-up view of a naval engagement in *The Battle of Trafalgar* seems to have been Copley's *Siege of Gibraltar*. In the *Wreck of a Transport Ship* (plate 45), almost certainly completed in 1810 for Charles Pelham, later 1st Earl of Yarborough, Turner developed the vortex-like composition of the *Shipwreck* of five years earlier, bringing the viewpoint nearer still.

Turner's early essays in the grand manner culminated, though with radical differences, in *Snowstorm: Hannibal and his Army crossing the Alps* (plate 49), exhibited at the Academy in 1812. Here memories of the Alps, the close observation of a storm at Farnley, a historical subject and a composition derived

from his sea-pieces were combined in an entirely new synthesis. In his earlier history-pieces Turner had relied largely on the rectilinear compositional scheme of his prototype, Poussin, animated by diagonals to create a more dramatic effect. Two works painted before *Hannibal crossing the Alps* show the development in Turner's treatment of the elemental forces of the Alps. *Fall of the Rhine at Schaffhausen* (plate 30), exhibited at the Academy in 1806, is very close in composition to *The Garden of the Hesperides* (plate 27) exhibited the same year, with a similar contrast between a diagonal crag in the centre and a vertical bluff on the right. The water dashes tumultuously between these but its diagonal thrust is countered by the enlarging of the bluff and by the alignment of the foreground figures to give a horizontal stress more strictly parallel to the picture plane, and in fact the picture, despite its subject, is hardly more dramatic in effect than Turner's other works of the same year. By 1810 however, when he exhibited, in his own gallery, *The Fall of an Avalanche in the Grisons*, usually known as *Cottage destroyed by an Avalanche* (plate 48), he had extended his range sufficiently to express to the full the drama inherent in the subject while continuing at the same time to paint other works, pastoral English landscapes and placid sea-pieces, very different in mood. In this picture the composition, contained within a rectilinear framework of diagonals, is dominated by the dramatic forces of the avalanche, driving rain and huge fallen boulders. The last two motives are also found in *Hannibal crossing the Alps*, but here Turner released the swirling forces already implicit in his sea-pieces and the picture became one vast whirlpool. The drama is enhanced by the juxtaposition of dark storm-clouds against a summer sky of pale blue and white and by the leap (which at the same time helps to preserve the unity of the surface) from the most prominent incident in the foreground to the elephant silhouetted against the sky on the horizon. The foreground scene of pillage shows a personal development of classical figure style, though on the right there is a more audacious use of Tintorettesque highlights on impressionistic figures.

* * *

The years immediately preceding Turner's first visit to Italy in 1819 show no striking stylistic developments; they were rather a time of consolidation of past achievements, though his oils show a revived interest in Italian landscape as if in preparation for this visit. Peace with France was declared in 1815

31

but, though he spent a few weeks on the Rhine in 1817, Turner was so busy working for engravers that he had to postpone this journey, apparently so inevitable, for another two years. The watercolours of this period, made primarily for the engraver — his tour of the south-west in 1811 was the first of many undertaken with topographical publications in book form in view — tend to be somewhat pedestrian in comparison with his earlier works in this medium; only the Wharfedale and Rhine subjects (plates 53*b* and *a*), which were painted not for the engraver but for his friend and patron Walter Fawkes of Farnley Hall, show that he was still capable of producing masterpieces equalling or surpassing his previous achievements.

At the same time his exhibited oil-paintings dwindled in number, though his interest in classical subjects revived in a specifically Claudian form, an immediate stimulus being his decision to compete in 1814, with several other Academicians, for the British Institution's annual premium for a landscape 'proper in Point of Subject and Manner to be a Companion' to a work of Claude or Poussin. His own entry (plate 54) was in fact very closely based upon Claude's *Jacob with Laban and his Daughters*, then belonging to Lord Egremont and still at Petworth; even the figure composition is almost the same, one figure being an exact copy, though Turner took as his subject *Apullia in Search of Appullus*. More personal interpretations of Claudian landscape are *Dido and Æneas* (Tate Gallery), exhibited at the Academy later in the same year, and *The Temple of Jupiter Panellenius in the Island of Ægina with the Greek National Dance of the Romaika; the Acropolis of Athens in the distance* (plate 57), signed and dated 1814; this was based upon a sketch made on the spot by H. Gally Knight and was exhibited in 1816 together with an imaginary reconstruction of the same temple, at present known only through an engraving. These works set the pattern for a series of landscapes which extended well into the 1830s.

His adaptation of a Claudian style to English landscape, notably in such pictures as *Crossing the Brook* (colour plate VII), exhibited in 1815, and *England: Richmond Hill on the Prince Regent's Birthday* (plate 55), exhibited in 1819, is more surprising. The first depicts in idealized form the River Tamar in Devon and, with its artificially raised foreground and small-scale figures leading with an unexplained break to a Claudian panorama, seen like a vignette through a frame of trees and clouds, is much closer in composition to the classical *Mercury and Herse* (private collection, England), exhibited in 1811, than to the English landscapes of that period. The naturalism of those works does however express

VIII. VENICE, FROM THE GIUDECCA LOOKING EAST: SUNRISE.
Watercolour, 8¾ × 11¼ *in. Painted* 1819. *British Museum.*

itself in such features as the sunlight glinting through the trees in the centre foreground, while Turner's new development of a lighter tonality is shown in the dominance of delicate greens and blues, browns being relegated to the framing motives and immediate foreground. The colour was sufficiently novel to provoke Sir George Beaumont to condemn the picture as 'all of *pea-green* insipidity!' *Richmond Hill* has the richer, browner tonality favoured by tradition and the somewhat heavy impasto that is one of the chief causes of the cracking that disfigures many of Turner's finished paintings of this period. Here the figures, in many of his pictures little more than clumsy dummies, are fashionably dressed real people: the turning movement of the seated woman with the book is conveyed with particular success, and an impressionistic technique, anticipating the watercolours made at Petworth in about 1830, is adroitly used to depict such incidents as the dog dragging a dropped scarf and the child with its hobby-horse. The red of the herald's tunic is transformed in the shadow of the trees into delicate tones of lilac and pink. In this, the largest picture Turner ever painted, a Wilsonian subject is enlarged to a literally monumental scale while yet being enlivened by the charming foreground detail.

With *Dido building Carthage; or the Rise of the Carthaginian Empire* (plate 56), exhibited like *Crossing the Brook* in 1815, Turner again challenged direct comparison with Claude, a challenge (which was also an act of homage) later forced to its ultimate conclusion when he bequeathed the picture to hang with the National Gallery's works by that master. Its composition is based upon Claude's *Sea Port*, with buildings on either side framing a prospect of the sea with the sun low in the sky. The second picture similarly bequeathed to the National Gallery in Turner's first will of 1829 — it was subsequently replaced, as already noted, by *Sun rising through Vapour* — was *The Decline of the Carthaginian Empire* (Tate Gallery), exhibited in 1817. By pairing the two Carthaginian subjects Turner gave them a didactic content absent from the Claudes on which they were based: they were the first of a large number of pictures in which, inspired in part by Thomson's 'Liberty', Turner meditated upon the decline of the great civilizations of the past, with the implied warning to England against allowing over-concern with material prosperity to invite a similar fate.

This emulation of Claude's Italian idylls can only have increased Turner's desire to visit the Roman Campagna, from which Claude had drawn his inspiration, but meanwhile his visit to the Low Countries and the Rhine led to what was perhaps the greatest achievement of this period, *Dort or Dordrecht: The Dort*

Packet-boat from Rotterdam becalmed (plate 59), exhibited in 1818. In this he returned to another of his earlier sources of inspiration, this time a northern master, Cuyp, whose style, by then completely absorbed in Turner's own, paradoxically enabled Turner to regain the naturalistic vision of nature which had temporarily been overlaid even in his English landscapes by Claudian overtones. The *Dort* had some successors in the 1820s, such as *Harbour of Dieppe (changement de domicile)*, exhibited in 1825, and *Cologne, the Arrival of a Packet-boat: Evening*, exhibited in 1826 (both in the Frick Collection, New York), but in its perfect equipoise of personal vision and the inspiration of an Old Master, of naturalism and traditional methods of composition and technique, it marks the culmination of the first half of Turner's career.

<p style="text-align:center">* * *</p>

'Turner should come to Rome. His genius would here be supplied with materials, and entirely congenial to it. . . . The subtle harmony of this atmosphere . . . can only be rendered, according to my belief, by the beauty of his tones. . . . The country and scenes around me, . . . Turner is always associated with them. . . .' 'The only person who, comparatively, could do it [Tivoli] justice would be Turner, who . . . approaches, in the highest beauties of his noble works, nearer to the fine lines of composition, to the effects and exquisite combinations of colours, in the country through which I have passed, and that is now before me, than even Claude himself.' Thus wrote Lawrence, ever generous to his fellow artists, in two letters from Rome in the summer of 1819, urging his friends to encourage Turner to come to Italy. Turner hardly needed this encouragement: the orientation of so much of his work, his impassioned interest in the Old Masters, the Italianate style of his recent English landscapes, all testify to the hold of Italy upon his imagination.

In August 1819 he left for Italy, where he remained for about five months. The effect of this journey is immediately apparent in the watercolours he made on Lake Como and in Venice on his way to Rome (plate 60*a* and colour plate VIII). They are the result of a revolution in his technique, which, liberated by the pervasive brilliance of the Mediterranean light, enabled him to exploit as never before the white of his paper and the delicacy of washes of pure colour. An extreme economy of means is evident in the group of small sketches of Vesuvius in eruption (plate 61*a*). As had Wright of Derby forty-five years before, Turner

hurried to Naples on receiving news of the eruption; the spectacle was one which impressed fire upon his imagination as one of the great destructive forces of nature, one that was to dominate some of his finest works. *Monte Gennaro, near Rome* (plate 60*b*), with its magical evocation of shimmering heat above the plain with mountains rising beyond, justifies Lawrence's highest anticipations. It is the kind of effect he had previously achieved, curiously enough, rather in oils such as *Abingdon* (plate 47) than in watercolours, but it is here associated with the transformation of his watercolour technique which was in turn to effect a similar but gradual transformation in that of his oils. These watercolours would appear to have been painted indoors on the basis of pencil sketches made on the spot: a witness reported Turner as saying 'that it would take up too much time to colour in the open air — he could make 15 or 16 pencil sketches to one coloured'. However none of the watercolours made in Italy were exhibited in his lifetime; they served instead as working material for oils and more highly finished water-colours made in England during the next fifteen years.

Turner's first work to be exhibited on his return home, in 1820, was alas at the furthest remove from these exquisite watercolours. The vast *Rome, from the Vatican. Raffaelle, accompanied by La Fornarina, preparing his Pictures for the Decoration of the Loggia* (plate 62), with its anachronistic inclusion of a Claudian landscape, reflected the overwhelming impact of the art treasures of Rome rather than the capacity to profit from them as he had from those in the Louvre seventeen years before. This was an aberration; far more successful as an expression of Turner's ambition under the spell of Rome to paint in the grand style is the *Forum Romanum* (plate 63), exhibited in 1826 as having been painted for John Soane's museum but now part of the Turner Bequest. In this, his last truly monumental work, his earlier study of Poussin helped him to give an authentic expression to the grandeur of Rome. An important contribution to the monumentality of this work is the heavy stone arch which frames and unifies the scene.

More characteristic, as the first of a long series of Italian landscapes combining Claudian inspiration with his own enchanted recollection of Italian light, is *The Bay of Baiæ, with Apollo and the Sibyl* (plate 64), exhibited in 1823. In this picture the classical equilibrium of the Claudian subjects of the previous decade, based upon a series of planes parallel to the picture surface, is replaced by a curvilinear and more complex system of composition based upon serpentine lines leading into depth, though without sacrifice of the surface design. Turner's

IX. SHIPPING OFF A HEADLAND.
18 × 24 in. *Painted* 1827. *Tate Gallery.*

use of this system, with little modification, can be seen in pictures painted up to the end of the 1830s, such as *Palestrina — Composition* (Tate Gallery) exhibited in 1830, *Childe Harold's Pilgrimage — Italy* (colour plate XVI) exhibited in 1832, *Mercury and Argus* (National Gallery of Canada, Ottawa) exhibited in 1836, and *Cicero at his Villa* (plate 107) exhibited in 1839. In *The Bay of Baiæ* and the pictures that followed it there is, in comparison with the Italianate works painted before the Italian visit, a marked lightening of tone, with translucent distances of blue glazes, corresponding to the development of his watercolours. For some years however he continued to model his foreground in the traditional manner, using chiaroscuro as opposed to contrasted colours, and it is not until the late 1830s, in such a picture as *Phryne going to the Public Bath as Venus—Demosthenes taunted by Æschines* (plate 105), exhibited in 1838, that the foreground and all other solid forms are dissolved in a single ethereal harmony of colour.

In each of these Claudian idylls, as in *Rome from the Vatican*, Turner's exuberance led to a proliferation of incident and detail which would have served as the basis for any number of pictures. Perhaps more successful, because less ambitious, are the works resulting from a second visit to Rome in 1828, *The Loretto Necklace* (plate 80), exhibited in 1829, and *View of Orvieto* (Tate Gallery), actually painted and exhibited in Rome and exhibited at the Academy in 1830, in which topography is enlivened by light-hearted anecdotal incident.

Turner's second journey to Rome, in 1828, may also have been the occasion of his making a group of small oil sketches on millboard, now at the Tate Gallery (plates 72 and 73), never exhibited until recently on account of their condition but now brought to light by cleaning. Most of these represent Italian landscapes and in several of them Turner has used the Claudian formula of a deep atmospheric vista framed by trees. A few however, such as *River with Trees* (plate 73), are English in feeling. These sketches, far more audacious and poetic than the exhibited oils or even the Italian watercolours of 1819, may have been painted on the spot, constituting a sort of parallel to the small Thames sketches of some twenty years before, though their forms are more generalized.

A group of seventeen larger sketches on canvas, also in the Tate Gallery (colour plate X; plates 74 and 75), are again mainly if not entirely of Italian subjects but were painted as studies for possible works for exhibition, one being a sketch for *Ulysses deriding Polyphemus* (plate 77), exhibited in 1829. They too were probably made in Italy, eight of them having been painted on a single large

canvas which was subsequently rolled, presumably for ease of transport (as in the case of the sketches made on the Isle of Wight mentioned below). These may be regarded as successors to the large Thames sketches on canvas. Instead of the subtle modulations and restricted tonal range of the millboard panels they are broadly painted in boldly contrasted blues and reddish-browns, their different purpose being reflected in their different technique. In the finished version of *Ulysses deriding Polyphemus* however the contrast between cool blues and warm reds and orange, despite its expressive function in contrasting the relief of the escaping Greeks with the anguish of the blinded giant, is not used structurally: modelling and recession are realized by traditional means.

Rocky Bay with Figures (plate 76) is close in composition to one of the larger sketches but differs in its handling, which is richer, areas of a single colour being worked, partly with the brush-handle, to produce fine variations in tone; it is also much subtler in its colouring, for instance the delicately touched-in pinks and yellows of the sky. It may indeed be the beginning of another work intended for exhibition, the sky in particular being as finished in its more delicate style as that of the exhibited *Polyphemus*, but it is also similar in colour and texture to the nine slightly earlier sketches painted on two large canvases in 1827 when Turner was staying in the Isle of Wight with John Nash (Tate Gallery, Nos. 1993–2001). Finished versions of two of these were exhibited in the following year, *East Cowes Castle, the Seat of J. Nash Esq.; the Regatta starting at their Moorings* (Victoria and Albert Museum) and *East Cowes Castle, the Seat of J. Nash Esq.; the Regatta beating to windward* (plate 71). In their small size and subtler modulations of tone these sketches are closer to those on millboard than to the large oils to which they are nearer in function. They range in mood from the placid serenity of shipping in a calm (colour plate IX) to the graceful movement of yachts racing in a choppy sea (plate 70, one of three similar sketches) and the crowded bustle of a regatta. *Between Decks* (Tate Gallery) recalls an open day on board ship with its sailors and girls seen from close to in the cramped space of the gun-deck, and in addition the group includes what seems to be Turner's first study in oils of an expanse of sea and sky unrelieved by shipping. The conspicuous differences between the various groups of Turner's oil sketches are signs not so much of variations of mood as of Turner's empirical approach to his art; it is therefore not surprising that the Petworth studies of about 1830 are again different in character from those already described and that he finally seems to have adopted yet another, more

radically different, method, working up his exhibited pictures on the same canvas as his first sketch.

The East Cowes pictures painted for Nash were not the only examples of Turner's continued acceptance of such commissions, but in the 1820s the topographical elements were more than ever subordinated to aesthetic considerations. In 1826 and 1827 he exhibited two companion pictures of *The Seat of William Moffat, Esq., at Mortlake*, seen from opposite directions and at different times of the day, one *Early (Summer's) Morning* (plate 66), the other *Summer's Evening* (National Gallery of Art, Washington), in which he infused the tradition of the Thames *vedute* of Canaletto and his English followers with an immensely enhanced feeling for atmosphere and light.

In strong contrast to the serenity of these sunlit pictures and to the festivity of the Cowes scenes is *Port Ruysdael* (plate 67), exhibited in 1827, in which Turner recreates in his own terms Jacob van Ruysdael's depiction of the overcast and blustery North Sea. The tribute paid to an admired painter by the use of the Dutch artist's name for an invented locality was matched at the same exhibition by *Rembrandt's Daughter* (Fogg Museum, Harvard) and by a number of later works.

Another field which he cultivated with particular success at this time was work for the engraver. Ever since Charles Turner had engraved the *Shipwreck* in 1805–7 Turner had taken a great practical interest in this medium, which brought his work before a far wider public than his oils, many of which remained unsold. Most of the engravings were of topographical subjects but whereas the plates of the 'Liber Studiorum' were based on monochrome drawings these were made from finished watercolours. Those of the 1820s and early 30s, such as *Newcastle* (plate 68a), painted and engraved in 1823 for 'The Rivers of England', in which Turner distilled poetry from the emerging industrial landscape, and 'The Rivers of France' series (plates 69a and b) of 1826–33, are deep-toned and richly coloured, their effect owing much to the use of body colour on tinted paper. Although groups of topographical drawings were exhibited by Turner's publishers in 1829, 1832 and 1833 the fact that he regarded them as working drawings rather than as finished works in their own right preserved them from the effects of the conscious desire to please that often marred his exhibited work, though in certain of them, such as *Richmond Bridge — Play* (plate 68b), engraved in 1832 for 'Picturesque Views in England and Wales' (and the first Turner to be acquired by Ruskin), there is a

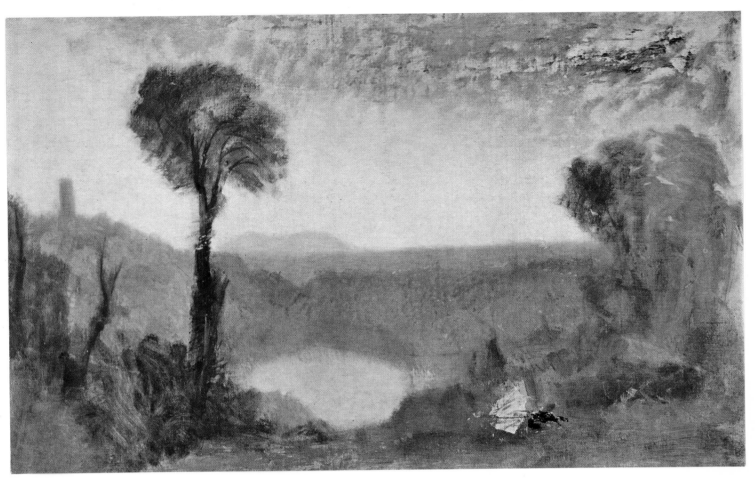

X. LAKE NEMI.
23 × 39½ *in. Painted* 1828 (?). *Tate Gallery.*

disproportionate insistence upon the genre element which, particularly in its deliberately playful quality, reflects Turner's new interest in the anecdotal already noted in such oils as *The Loreto Necklace*.

This interest, which Turner shared with an increasing number of his contemporaries at this time, played an important part in his work throughout the 1820s, especially in a series of works in which figures came to play a central role rather than being merely subordinate elements in a landscape composition. The gay incidental figures in the foreground of *Richmond Hill* are transformed into the subject of *What you will!* (plate 78). This, the only work exhibited by Turner in 1822 and the first since *Rome from the Vatican* two years before, perhaps represented a reaction after the failure of that portentous response to his first experience of Italy. With its group of exotically dressed women in a rococo garden ornamented by sculptures of Cupid and Psyche and the Graces, it was described by 'The Literary Gazette' as 'a pretty bit of colouring, something in the style of Watteau'; it also reflects Turner's admiration for the art of Thomas Stothard, whom he is recorded as praising highly while touching up another picture in this vein, *Bocaccio relating the Tale of the Birdcage* (Tate Gallery), on the varnishing days before the exhibition of 1828. Turner paid a direct tribute to Watteau in his *Watteau Study by Fresnoy's Rules* (plate 81), exhibited in 1831. The reference to 'Fresnoy's rules' is made more explicit by the quotation in the catalogue from Charles Du Fresnoy's 'De arte graphica':

White, when it shines with
unstained lustre dear,
May bear an object back or
bring it near.

As in his later pictures illustrating Goethe's theory of colour Turner here manifests his interest in the theoretical aspects of his art, especially those concerned with colour.

A number of other pictures of the late 1820s, besides the *Bocaccio*, showed Turner's growing preoccupation with figure subjects. In some of these the rococo charm of Watteau or Stothard is strangely fused with a reinterpretation of Rembrandtesque chiaroscuro in terms of brilliant colour. Turner never seems to have shown much enthusiasm for Rubens, at first sight a far more obvious master for a painter with Turner's predilection for grand landscapes and light tonality, but in Rembrandt he found a master of light glowing out of darkness

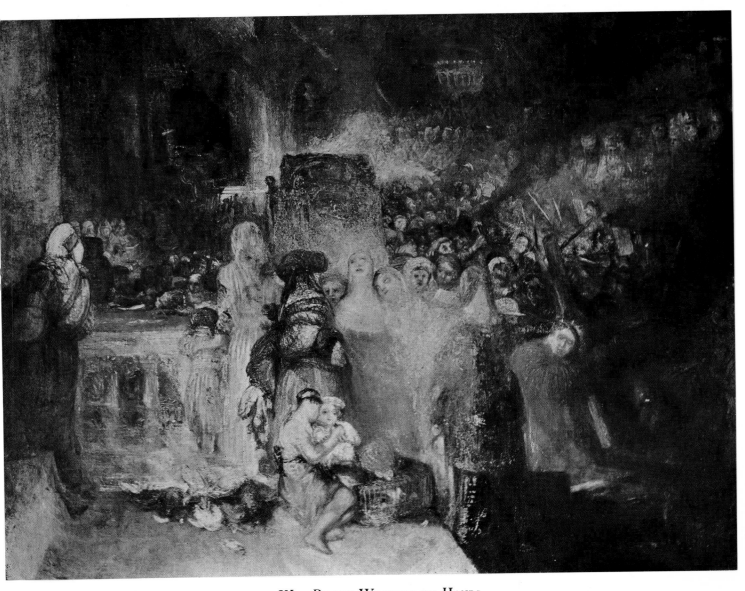

XI. Pilate Washing his Hands.
36 × 48 in. Exhibited 1830. Tate Gallery.

who pointed the way towards the application to figure painting of the exultant response to colour released in him by the light of Italy. Turner's intention is explicit in the title of *Rembrandt's Daughter* (Fogg Museum, Harvard), exhibited in 1827, and obliquely in his reference to Rembrandt's Jewish subjects in *Jessica* (plate 79), an illustration to 'The Merchant of Venice' painted in Rome in 1828 and exhibited at the Academy in 1830. Even the handling of such a detail as Jessica's veil clearly reflects that of the late Rembrandt.

Rembrandt also showed the way to a greater concentration on the figure in dramatic subjects, in sharp contrast to the Poussinesque storms and plagues of the early 1800s in which the landscape was the chief means of expression. In the Biblical paintings of *Pilate washing his Hands* (colour plate XI), exhibited in 1830, and *Shadrach, Meshach and Abednego* (Tate Gallery), exhibited in 1832, the figures, though still fairly small in scale, dominate and virtually fill the picture in the manner of the early Rembrandt. Pilate and the statue of Dagon are both set well back behind a crowd of figures, but they remain, like the buildings or luminous distances in certain of his early landscapes, the undisputed centres of attention. In spite of the weakness of the figure-drawing these small paintings are overwhelming in their impact; the strong light and deep glowing colours give the entire picture surface an expressive character.

* * *

The culmination of Turner's development of the figure subject owes much to the particularly happy circumstances of his position as a privileged friend and visitor of the 3rd Earl of Egremont at Petworth. Egremont was among the earliest purchasers of his paintings and Turner had already worked at Petworth in 1809 in connection with *Petworth: Dewy Morning*, but it was not until after the death of his father in 1829 that he seems to have become a regular visitor with his own studio and a favoured position in the household.

An important product of these visits was a notebook containing sketches both of the park and the interior of Petworth (colour plate XIV and plates 90 and 91), painted in body-colour on blue paper. These sketches resemble those for the 'French Rivers' engravings but show an even higher pitch of economy and boldness of colour. Turner's interest in human behaviour, already seen developing in the 1820s, reaches its climax in the glimpses of his fellow visitors, in which a pictorial shorthand expresses to perfection his humorous observation.

The technique of the interiors in the sketch-book led to the bold handling and complete dominance of colour in *Interior at Petworth* (colour plate XVIII) and its immediate predecessors, *Music at Petworth* (plate 92) and *The Letter* (plate 93), oils probably painted at Petworth in the mid-1830s. In these luminous interiors the influence of Rembrandt apparent in the figure paintings of the immediately preceding years has been absorbed into a completely personal expression through colour alone. The last, the *Interior at Petworth*, though the culmination of Turner's figure subjects, shows the almost total dissolution of the individual forms. The distinction between light and colour has finally disappeared and local colours, such as the green on the right, permeate the enveloping atmosphere. The scene is virtually indecipherable; the atmosphere of confusion, with animals and birds invading a spacious hall which does not in fact exist at Petworth, has led to a suggestion that the picture is Turner's response to the ending in 1837 of this, the happiest phase of his career, at the death of the Earl of Egremont. But it is light and colour, which by now had become Turner's main preoccupation, that are themselves the chief subject of the picture. It is paradoxical that Turner, primarily a painter of landscape, should have first arrived at this almost complete liberation from the obligations of realistic description in a different field, that of the subject picture; it was not until the very end of the 1830s or even the 1840s that he achieved a similar liberation in landscape. On the other hand the picture can be seen as a symbol of the invasion of the field of Turner's conscious aspirations, the world of human actions treated in a manner ultimately derived from the classicism of Poussin, by the elemental forces of nature that were in fact the deepest felt theme of Turner's most original achievements.

Not one of these revolutionary interiors was exhibited in Turner's lifetime but the intimate atmosphere of Petworth found some reflection in two small subject pictures, *Watteau Study by Fresnoy's Rules* (plate 81) and *Lord Percy under Attainder* (Tate Gallery), exhibited in 1831. This last offers evidence of Turner's interest in the Van Dyck portraits at Petworth, elements from two or three of which can be seen in the unexhibited *Lady trying on a Glove* (Tate Gallery). *Woman reclining on a Couch* (plate 89) reflects another painting at Petworth, Hoppner's *Sleeping Venus and Cupid*, bought by Egremont at the de Tabley sale in 1827; it may also represent Turner's ambition to create a picture of a reclining nude in the tradition of Giorgione's *Dresden Venus* and Titian's *Venus of Urbino*. Despite its large size it is only the first beginning of

a composition, with several forms completely undefined and considerable pentimenti, though in certain places Turner's bravura handling, as in the scraping away of the paint on the curtain to indicate a flowered pattern, already suggests texture in some detail. The painting of the flesh has a freshness and luminosity unmatched in English painting of the nineteenth century.

Besides figure paintings and interiors Turner's visits to Petworth also inspired what are often regarded as the finest of all his landscapes, the four long canvases painted to hang beneath the full-length seventeenth-century portraits in the panelled Grinling Gibbons room (plates 85 and 87), and the related sketches of the same size in the Tate Gallery (colour plate XII, plates 84, 86 and 88). These show scenes in Petworth Park and the neighbourhood and seem to have been painted in 1830–1. A reference in the number of the 'Library of the Fine Arts' for April 1831 to a recent visit by Turner to Petworth 'to paint a landscape composition for the Earl of Egremont', probably relates to one of the finished paintings, while one of the Tate sketches not used at Petworth, *Ship aground*, served as the basis for the *Scene on the French Coast* exhibited the same year (colour plate XIII).

In *Calais Sands, Low Water, Poissards gathering Bait* (plate 83), exhibited in 1830, Turner had evoked again the serenity that marked such sea-pieces of twenty years before as *Bligh Sands*, though in terms of the luminous colour and brush-strokes at once energetic and ethereal, that he had evolved in the 1820s. This serenity is still more marked in the Petworth paintings, and is accentuated by their long low format. The mood of elegiac solitude of *Calais Sands* appears again in *Ship aground*, with its muted harmony of greys and yellows, but the other Petworth paintings are, in contrast, pervaded by a sense of the joyful beneficence of nature.

The paintings installed at Petworth are more conventional than the sketches, and also the interiors, that remained in Turner's possession. In the finished pictures Turner still modelled, at least in part, by chiaroscuro, as for example the boats in the foreground of *Chichester Canal* and *The Chain Pier, Brighton*. In the Tate sketches on the other hand, as in those of the immediately preceding years, he modelled with colour. Similarly in composition: in the Tate's *Petworth Park: Tillington Church in the distance* the sweeping inverted arch of the foreground balances the arch of the sunset sky to form a bold lozenge-shaped composition; in the picture based on this sketch at Petworth, *Petworth Park, Sunset with fighting Bucks*, this bold simplicity of composition is

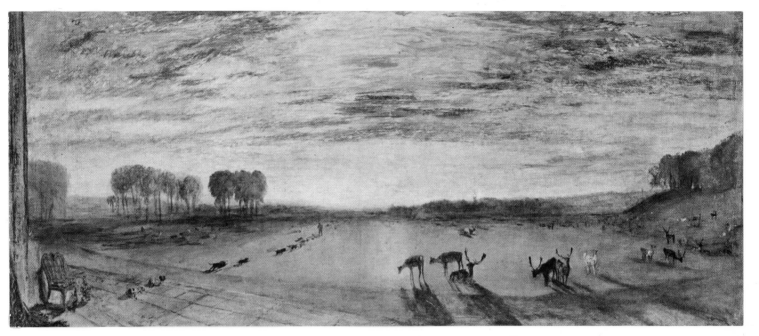

XII. PETWORTH PARK: TILLINGTON CHURCH IN THE DISTANCE.
$25\frac{1}{2} \times 58$ *in. Painted* circa 1830–1. *Tate Gallery.*

conventionally masked. The procession of dogs rushing out into the immense luminous expanse to greet their returning master — a peculiarly personal conception as found here — is replaced by the conventionally picturesque fighting bucks and genre cricket match, motifs more in accord with the taste of the time. The finished version (together with the earlier *Petworth: Dewy Morning*) could serve as the inspiration for the minor artist William Frederick Withington when he painted, in 1836, the albeit delightful *Fête in Petworth Park* (Petworth House), whereas the audacious sketch would have been far beyond his comprehension. However most of the lyricism and something of the searching observation, the way, for instance, in which the setting sun bites into the horizon in the sketch of *Chichester Canal*, is preserved in the finished pictures.

It is interesting to compare the different use made of full-size sketches by Turner and by Constable. For Turner the sketches were preparatory to finished pictures, to be freely modified as circumstances might require. For Constable the sketches would seem to have been painted almost by way of compensation for the freedom and energy he lost in the process of achieving his highly finished exhibited paintings. A comparison can also be made between Turner's two pictures of *The Chain Pier, Brighton* and Constable's treatment some five years earlier of the same scene (Tate Gallery). These illustrate their respective preoccupations, Constable's with weather, Turner's with light.

To modern eyes such pictures as Turner's Petworth sketches are in effect complete works of art in their own right. So also, in spite of its easily visible pentimenti, is the unfinished *Evening Star* (plate 82), a picture close to the *Calais Sands* of 1830. With its delicately poetic colouring and the economy and fluency with which the boy and his dog on the shore are represented this is now one of Turner's most treasured works, but it may be only by a lucky chance that it was not worked over at a later date to produce something for exhibition. Indeed the hot colouring and heavy pigment of such a picture as *The New Moon; or 'I've lost my boat; you shan't have your hoop'* (Tate Gallery), exhibited in 1840, may well cover a masterpiece of similar quality. For it would seem that from about 1835, if not earlier, many of Turner's finished paintings were worked up as he required them on top of existing sketches. John Burnet, in his 'Turner and his Works', published the year after Turner's death, says that in his later years he would send in his canvases for exhibition with the forms barely laid in, converting them into finished works on the varnishing days; Thornbury, quoting John Scarlett Davis, gives one of the versions of *The Burning of the*

48

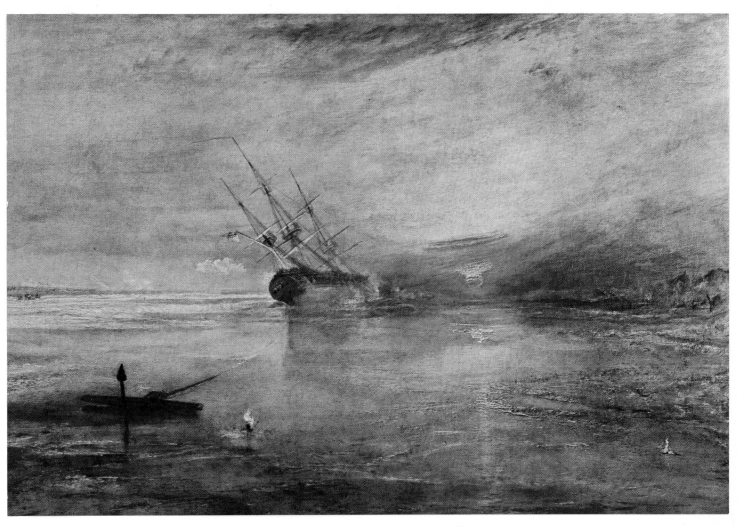

XIII. SCENE ON THE FRENCH COAST.
28 ×42 in. Exhibited 1831. Private collection, Great Britain.

Houses of Parliament (see colour plate XVII), exhibited in 1835, as an example. Burnet describes how the canvases were laid in with blue where there was to be sea or sky and orange-yellow shading into brown for trees and landscape, and his account of this practice is confirmed by the many such lay-ins from the Turner Bequest now in the Tate Gallery. Examples are *Southern Landscape with an Aqueduct* and *Landscape with Water* (colour plate XIX), the comparatively warm colouring of which suggest that they belong to the 1830s, preceding such works as *Sunrise: a Castle on a Bay* (colour plate XX) and *Bridge and Tower* (plate 110) which are cooler in tone and translucent as the most delicate watercolour; more ethereal still are *Norham Castle* (plate 124) and *Sunrise with a Boat between Headlands* (colour plate XXIV), exquisite spectres of the blues, lemon-yellows and whites that seem to lie beneath *The Slave Ship* (plate 109), exhibited in 1840, and showing the cool tonality, dominated by white, that is found in some of the more finished works of the mid-1840s. One must regret the probability that similar sketches underlie those of Turner's later finished oils which, once equally brilliant in their colouring, are now so often darkened and cracked as a result of his brilliant but reckless forays on Academy varnishing days. But to him such sketches, like the masterly 'colour-beginnings' preserved among the watercolours of the Turner Bequest (plates 104*a* and *b*), were working material, not for the public eye.

* * *

The happy serenity that pervades Turner's work at Petworth was characteristic of many of the pictures he painted during the 1830s, in particular those of Venetian subjects of which the first oil was exhibited in 1833. But his fascinated preoccupation with the destructive energies of nature, most often manifest in fire and storm and never long in abeyance, reasserted itself in *Staffa, Fingal's Cave* (colour plate XV), exhibited in 1832 with a quotation from Sir Walter Scott, with whom he had stayed before visiting Staffa. This dramatic picture makes its effect largely in terms of the subtly muted blue-greys and dusty pinks of *The Evening Star*, here given a deeper and more sombre note which is accentuated by the contrasted accent of the setting sun; this, painted in orange over pink, may however have been heightened later, as the painting remained in Turner's studio until 1845 when it became his first work to enter an American collection. As in many of Turner's earlier works a vertical accent, in this case the ship's funnel, stabilizes a composition based upon diagonals, the

storm-swept clouds and the smoke which, with the ugly little steamer, add a man-made feature to the forces of nature. The heavy flecks of pink on the more distant part of the cliff recall Turner's early Wilsonian works, but otherwise the picture is an example of the assured and highly personal technique of his maturity, with the light, free brushwork acquired during the 1820s and early 1830s. The strokes at the extreme left describing both the striations of the cliffs and the tossed-up spray of the waves tend to coalesce to form an overriding vertical accent, foreshadowing the blurring of distinctions between natural forms by the elemental forces of nature to be found in the storm-pictures of ten years later. A painting in which this growing tendency towards the dissolution of the outlines separating one form from another is particularly marked is *Mouth of the Seine, Quille-Bœuf* (plate 97), exhibited in 1833 with a note in the catalogue on the dangerous quicksands at this point. A single sweep of wave and cloud dominates the right half of the picture and, echoed by the flight of seagulls on the left, dwarfs the works of man, the ships, lighthouse and church in the background. In such a way Turner made use of the many studies of waves painted in the 1830s (see plate 96) to express his feeling of man's powerlessness before nature.

In other sea-pieces of the earlier 1830s Turner kept more within the Dutch tradition, as is shown by their titles: *Admiral Van Tromp's Barge at the Entrance of the Texel, 1645* (Soane Museum, London), exhibited in 1831; *Van Tromp's Shallop, at the Entrance of the Scheldt* (plate 94) and *The Prince of Orange, William III, embarked from Holland, landed at Torbay, November 4th, 1688, after a Stormy Passage* (Tate Gallery), both exhibited in 1832; and *Van Goyen, looking out for a Subject* (Frick Collection, New York) and *Van Tromp returning after the Battle off the Dogger Bank* (Tate Gallery), both exhibited in 1833. The predominance of sea-pieces among Turner's exhibits at this time helps to explain how it was that the painter C. R. Leslie could point him out to his son, when visiting Petworth in 1834, as 'Mr Turner the great sea painter' to the exclusion of his other achievements.

In 1833, as already noted, Turner exhibited his first two oil paintings of Venetian subjects. Apart from three watercolours of 1820 and 1821 these oils were the first finished pictures he made as a consequence of his visit to Venice fourteen years before, but he continued thereafter, except in 1838 and 1839, to exhibit Venetian subjects every year until 1846. Although Turner had revisited Italy in 1828 there is no record of his having returned to Venice before, almost

certainly, 1835, and in spite of the absence of direct evidence it seems more likely that the inspiration for Turner's revived interest was Canto IV of Byron's 'Childe Harold', which had provided the title of the painting *Childe Harold's Pilgrimage — Italy*, exhibited in 1832.

The title of one of the two first Venetian pictures paid tribute not however to the poet but to the painter most intimately associated with the city: *Bridge of Sighs, Ducal Palace and Custom-house, Venice: Canaletti* [sic] *painting* (plate 95); in the same exhibition the sea-piece *Van Goyen, looking out for a Subject* paid tribute to a Dutch painter. Turner saw Venice in a wholly different way from the on-the-whole topographically accurate Canaletto. Using sketches made many years earlier he evoked a vision of the city, its architecture, its colour, above all its play of light upon stone and water. This work, like, it seems, its untraced companion in the Academy of 1833, *Ducal Palace, Venice*, is on a relatively small scale and rather heavy in colour.

But the *Venice* exhibited the following year, assuming that it is correctly identified as the picture of *The Dogana and San Giorgio Maggiore* in the National Gallery of Art, Washington (plate 98), was the first of the series of paintings of far-ranging perspectives, light in tone but glowing in colour, in which his response to the revelation of the light of Italy at last found completely successful expression in finished works on a large scale, thus fulfilling the promise of the watercolours of 1819. The series was continued with such works as *Venice, from the Porch of Madonna della Salute*, exhibited in 1835 and apparently the painting in the Metropolitan Museum, New York (though this in fact shows the entire porch of the Salute), *Venice, from the Canale della Giudecca, chiesa di S. Maria della Salute, etc.* (Victoria and Albert Museum, London), exhibited in 1840, and *Campo Santo, Venice* (plate 116), exhibited in 1842. The intoxicating effect of Turner's return to Venice in 1835 resulted however in works far more varied in mood than these. Although, of the watercolours made during the visit, *Entrance to the Grand Canal* (plate 100a) evokes the same idyllic peace, his continuing fascination with the destructive energies of nature is reflected in many of the other paintings, both oils and watercolours, in particular a large group of night scenes which include fire in one form or another.

These last were probably inspired by a recent disaster, the burning of the Houses of Parliament in 1834, which would seem in fact to have led to an entire series of fire pictures, not only of the event itself but of Venetian subjects and also of such works as *Fire at Sea* (National Gallery, London) and the

XIV. A Bedroom, Petworth.
Body colour, $7\frac{1}{2} \times 5\frac{1}{2}$ *in. Painted* circa 1830–1. *British Museum.*

watercolours *Fire at Fenning's Wharf* and *A Conflagration, Lausanne* (both in the Whitworth Art Gallery, Manchester). In *The Burning of the Houses of Lords and Commons, October 16, 1834* (colour plate XVII), exhibited at the Academy in 1835 and now at Cleveland, as in the other oil of the same subject shown earlier the same year at the British Institution (Philadelphia Museum of Art), Turner exploited to the full the contrast of warm and cold colours, accentuating the reds and oranges of the raging flames by juxtaposing them with the serene blues of the sky. These oils provoked criticism as being too light for nocturnes and indeed, in the Cleveland picture at any rate, Turner's use of the compositional formula of *Venice: Dogana and San Giovanni Maggiore* (plate 98) seems to have led to his adhering too closely to its light tonality. The drama is however enhanced by the superimposition of the disaster, the consuming flames and the vast drift of smoke, upon an idyllic river scene. The main reflection of the fire is painted in thick energetic strokes over the glassy smooth surface of the river while the contrasted delicacy of the lesser reflections of the flames on the water by the fire-tender and the flickering touches of white and blue over pink washes along the far bank of the Thames, to say nothing of the painting of the conflagration itself, show the degree of technical mastery achieved by Turner by this time.

Another exhibit at the Academy of 1835 was *Keelman heaving in Coals by Night* (plate 99), a scene on the Tyne. As in the watercolour of Newcastle of some ten years earlier Turner welcomed an industrial landscape for its pictorial possibilities, using it to depict the contrast of moonlight and artificial light that had fascinated him in his first exhibited oil. This picture was purchased by the owner of *Venice: Dogana and San Giovanni Maggiore*, almost certainly exhibited the previous year, and as the two pictures are identical in size they may well have been painted as pendants, devised to make a deliberate contrast between the industrial activity of the one and the timeless serenity of the other.

As already noted Venice itself, following Turner's visit of 1835, suffered fire and storm at his hands. Many of the watercolours he then made testify to his abiding interest in violent nature: for example *Storm at Sunset* (plate 101*a*) and *Storm in the Piazzetta* (plate 101*b*), in the second of which the drama of lightning against a dark sky is enhanced by the use of brown paper. The same effect is also found in night-scenes, moonlit or with rockets reflected in the water (for example British Museum, Turner Bequest CCCXVIII-5 and -29), and in dramatic interiors in which light is shown flickering over the mosaics of St Mark's (British Museum, Turner Bequest CCCXVIII-7) or the bottles in a

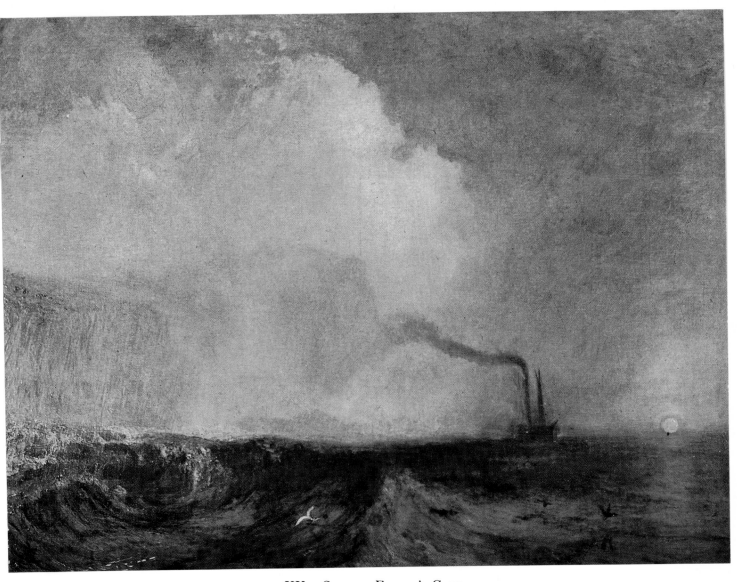

XV. STAFFA, FINGAL'S CAVE.
36 × 48 *in. Exhibited 1832. The Hon. Gavin Astor, London.*

wine-shop (plate 100*b*). The following year visitors to the Academy were able to see Venice in its new dramatic role in the subject-picture *Juliet and her Nurse* (plate 102). So overwhelming in his mind at this time was the association of Venice with the drama of light and storm that, in choosing the tragedy of Shakespeare most in accord with this image, he saw no incongruity in transferring its setting from Verona.

Venice, despite its strangely late appearance as a subject for Turner's oil-paintings, had become out of all Italy the place that evoked his most profound response. But the Roman Campagna continued to serve as the setting for Claudian mythologies such as *Mercury and Argus* (National Gallery of Canada, Ottawa), exhibited in 1836 and *Apollo and Daphne* (Tate Gallery), exhibited in 1837, for evocations of the glories of Rome such as *Cicero at his Villa* (plate 107) exhibited in 1839, and for works in which he meditated, as he had in his Carthaginian subjects, on the passing of these glories, such as the two paintings *Ancient Italy — Ovid banished from Rome* (formerly Mme C. Groult, Paris) and *Modern Italy — the Pifferari* (Glasgow Art Gallery), exhibited in 1838, and the similar pair of *Ancient Rome; Agrippina landing with the Ashes of Germanicus* (Tate Gallery) and *Modern Rome — Campo Vaccino* (Earl of Rosebery, Mentmore, Bedfordshire), exhibited in 1839. Quotations from 'The Fallacies of Hope' or the writings of other authors often pointed the moral.

From 1835 onwards, following a tour the previous year along the Meuse, Moselle and Rhine in connection with a projected series of engravings of German rivers, Germany also provided the setting for works of a similar character, such as *The Bright Stone of Honour (Ehrenbreitstein) and the Tomb of Marceau, from Byron's 'Childe Harold'* (Viscountess Allendale, Bywell Hall, Northumberland), exhibited in 1835, *Heidelberg Castle in Olden Time* (plate 106) of the later 1830s, and *The Opening of the Walhalla, 1842* (Tate Gallery), exhibited at the Academy in 1843 and at the Congress of European Art at Munich in 1845. In the last two one looks down on foregrounds densely crowded with people who add a sense of rather strained festivity to the magnificent but barely related landscapes behind. Such figures, often staring out at the spectator and whose presence is only superficially explained by the picture's subject, are characteristic of a number of Turner's later works, including some of his Venetian scenes and his very last Carthaginian pictures (see plate 127). They seem to express his view of the insignificance of humanity; they are the very negation of intimacy, an emotion which so rarely — except at Petworth — made itself felt in his work.

XVI. CHILDE HAROLD'S PILGRIMAGE — ITALY.
56 ×98 in. Exhibited 1832. Tate Gallery.

In the later 1830s Turner continued, even in pictures that did not contain such immediately dramatic images as storm and fire, to develop his use of colour to expressive effect. *Ulysses deriding Polyphemus* (plate 77) had pointed the way in this direction in the late 1820s but it was not until ten years later that Turner, his sense of colour now freed from all conventional trammels, achieved a series of masterpieces in which emotion is aroused primarily by the use of colour alone. In *The Fighting 'Temeraire' tugged to her Last Berth to be broken up, 1838* (plate 108), exhibited in 1839, he achieves a feeling of nostalgia which struck home to his contemporaries and is still powerful today largely by contrasting the browns and blacks of the tug with the pearly whites of the historic ship and these, together with the pale moon high in the heavens, all of which give the left-hand side of the picture a predominantly cool tonality, with the warm-toned right-hand side in which the orange and red vaulted sky is lit by the glowing rays of the setting sun. The colouring enhances reality without, as in the *Interior at Petworth*, transcending it, but now even in an exhibited work both form and space are expressed not through chiaroscuro but colour. This painting, although a lament for the passing of a great ship — the transitoriness of life and power was an idea which constantly obsessed Turner — is not symptomatic of any general nostalgia for the past on his part, for although sailing-ships continued to provide some of his happiest inspiration right up to *Van Tromp going about* (plate 123), exhibited in 1844, his greatest representations of the sea at its most elemental, such as *Staffa, Fingal's Cave* (colour plate XV) and *Snow Storm — Steam-boat off a Harbour's Mouth* (colour plate XXI), gain much of their effect from his introduction of the sturdy steamships of his own day, from the contrast between the untameable element and the prosaic man-made constructions which precariously ride upon it.

The Fighting Temeraire is the most popular and perhaps the finest of Turner's late, highly finished paintings; for Ruskin, writing in 1856, it was his last perfect work. Previously however, in the first volume of 'Modern Painters', published in 1842, Ruskin had chosen to rest Turner's claim to immortality on *Slavers throwing overboard the Dead and Dying — Typhon* [sic] *coming on* (plate 109), exhibited in 1840; he acquired the picture in 1843 but later found it too painful to live with. This painting, commonly known as *The Slave Ship*, was inspired, as T. S. R. Boase has shown, both by a passage in Thomson's 'Seasons', from which Turner took so many of his subjects, and by a recently published account of slaves smitten by an epidemic being hurled overboard, rather than

XVII. THE BURNING OF THE HOUSES OF LORDS AND COMMONS.
$36\frac{1}{2} \times 48\frac{1}{2}$ *in. Exhibited* 1835. *Cleveland Museum of Art, Ohio.*

allowed to die on the ship, because insurance could be claimed only in respect of those actually 'lost at sea'. In earlier pictures such as *Wreckers, — coast of Northumberland* (Mrs Lyon Slater, Long Island), exhibited in 1834, Turner had been content to treat rather similar subjects with a measure of detachment but here the bloodshot sea and the dark, menacing sky (the force of which enables one to accept the almost comic ravenous sea creatures which so disturbed the young Thackeray) suggest that Turner was in this case deeply moved by the terrible nature of the event. The technique of this remarkable picture is very different from that of the paintings of the early 1830s with their relatively limited range of colour and tone. Here, over his usual white ground delicately glazed in blues and pinks, a far wider range of colours is applied in a much greater variety of handling, from glazes to thick impasto, producing the most various effects. The dark areas of the sea, for instance, are achieved not only by the deep browns and blacks of *Staffa, Fingal's Cave* but by a multifarious and complex harmony of pure colours, built up in places to a considerable thickness.

The Slave Ship was technically the most advanced work exhibited by Turner up to this time and in the next few years the distinction between his exhibited and his unexhibited works practically disappeared. Though his style was growing further and further away from the contemporary trend towards smooth finish and detailed realism, he was now a 'grand old man' whose eccentricities could be tolerated if not understood. *Rockets and Blue Lights* (plate 113), exhibited in 1840, and *Snow Storm — Steam-boat off a Harbour's Mouth making Signals in Shallow Water, and going by the Lead* (colour plate XXI), exhibited in 1842, show no trace of the conventional finish of *The Fighting Temeraire* and the Venetian exhibits of the 1830s; the bare ground is allowed to tell between the broad brush-strokes of the waves, and such detailed forms as the foreground figures of *The Slave Ship* or the buoy in *The Fighting Temeraire* are dispensed with. In these two pictures, as in the unexhibited *Yacht approaching the Coast* (plate 118), the vortex openly and completely dominates the composition: everything is caught up in and even distorted by its whirling energy. Already in such works as *Phryne going to the Public Bath as Venus* (plate 105), exhibited in 1838, Turner had begun to break up his foregrounds into arbitrary zones of varying degrees of light and shade; in *Snow Storm — Steam-boat off a Harbour's Mouth*, and also in *Yacht approaching the Coast*, the arbitrarily imposed areas into which the sea is divided unite it with the similar but more naturalistically explained forms in the sky to form an overall centrifugal

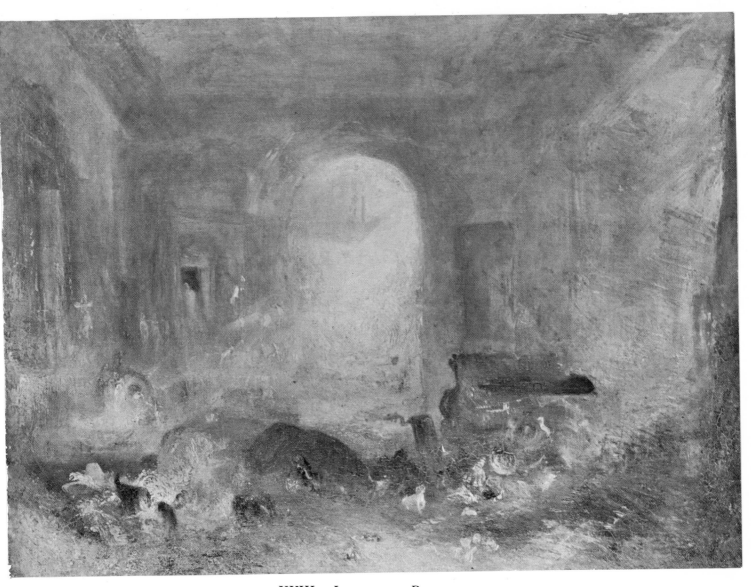

XVIII. Interior at Petworth.

35¾ × 47¾ *in. Painted* circa 1837. *Tate Gallery.*

design. In a work exhibited as recently as 1837, *Snow-storm, Avalanche and Inundation—a Scene in the Upper Part of Val d'Aout, Piedmont* (plate 103), the natural forms had retained their identities and their equilibrium, but now all forms whether of sea, sky or smoke come near to losing their identities in the flailing whirlpool. In comparison the still earlier *Staffa: Fingal's Cave* (colour plate XV), another stormy sea-piece, exhibited in 1832, seems tame and nearer in mood to the idyllic Petworth scenes, and these tempestuous canvases recall rather, in spite of the transformation of both vision and technique, those early exercises in the grand manner that had culminated in *Hannibal crossing the Alps* (plate 49). As in that work an actual personal experience underlay *Snow Storm — Steam-boat off a Harbour's Mouth*, which was painted after Turner had been tied to the mast in a storm he did not, on his own account, expect to survive, but whereas the drama in *Hannibal crossing the Alps* had largely centred upon the historical event it was now inherent solely in the forces of nature. These forces by themselves are the subject of a number of pictures of stormy seas painted in the first half of the 1840s (see colour plate XXIII) in which Turner came closest to modern abstract expressionism in the revelation of his personality through brush-work and colour alone. Again comparison with a work of the early 1830s (plate 96), which is near monochrome and relatively smooth in handling, shows how far Turner had developed in the process of achieving this unity of means and expression.

Whereas this group of stormy sea-pieces are fairly heavily worked, other works of the early 1840s are more lightly painted; with Turner's increasing mastery his technique became infinitely flexible and at the same time even the most thinly painted oil sketches have the effect of complete works of art, even if they were probably intended merely as the basis for more 'finished' pictures. *Norham Castle* (plate 124) is the supreme example of Turner's power of evoking form by the floating of colour over a white ground, the almost abstract play of colour being controlled by a classically disciplined composition which shows that the lessons of Poussin were still remembered. While the supremacy of pure colour is also asserted in such a work as *Yacht approaching the Coast*, with its unexplained scarlets to the left of the boat, the completely different technique and method of composition show the range of Turner's late style.

The technique of the late sketches of the kind of *Norham Castle* or *Sunrise with a Boat between Headlands* (colour plate XXIV) and of some of the more thinly

XIX. Landscape with Water.
48 × 71¾ in. *Painted* circa 1835–40. *Tate Gallery.*

painted finished oils was almost identical with that of his contemporary water-colours, both in the thin washes of delicate pure colour and in the suggestion of detail. In the watercolours resulting from his third visit to Venice of 1840 and those of Swiss and German subjects made during the early 1840s the pigment is floated over the surface of the paper to give a transparent pearly effect, and over this is often superimposed a multitude of rapid pen-strokes in undiluted reds or greens to give an impression of detailed form. Turner had always, of course, used line to help to describe forms but in these works the functions of line and wash tend to become distinct, line being used to suggest detail almost independently of the washes of colour underneath. In a number of the Swiss and German scenes, such as *Rheinfelden* (plate 115a), this method gives a gothic fairy-tale effect appropriate to the subject, but in others it is over-nervous and distracting. Turner's use of a similar technique in many of his late oils, involving red or blue calligraphy over thin, light glazes, likewise met with varying success. In *The Sun of Venice going to Sea* (plate 117), exhibited in 1843, the distant masts and buildings along the Riva are indicated in this manner with all the effectiveness and delicacy of the comparable passage in the Cleveland *Burning of the Houses of Parliament* (colour plate XVII). In other exhibited Venetian subjects of the mid-1840s the linear element remains unassimilated, and in the unexhibited *Venice, after the Ball* (Tate Gallery, No. 4659) this calligraphy was extended, in the process of giving the picture a higher degree of 'finish', to the figures in the foreground so that they become a discordant feature in the composition as a whole.

Though at first sight sharing the idyllic mood of most of the Venetian paintings of the later 1830s, and without the overt drama of *Juliet and her Nurse*, *The Sun of Venice* strikes a note of foreboding, expressed by the quotation from 'The Fallacies of Hope' in the Academy catalogue:

> *Fair shines the morn, and soft the zephyrs blow,*
> *Venezia's fisher spreads his painted sail so gay,*
> *Nor heeds the demon that in grim repose*
> *Expects his evening prey.*

The paint is cracked and some glazes may be missing, but the picture's mood of foreboding is conveyed with particular force by the turbulence of the white sky. Also ominous, on account of the unexplained distant fires, is the unexhibited *Procession of Boats with Distant Smoke, Venice* (?) (plate 119).

XX. Sunrise: a Castle on a Bay.
36 × 48 in. Painted circa 1835–40. *Tate Gallery.*

Most of the Venetian pictures of the 1840s however, such as *Campo Santo, Venice* (plate 116) and *The Dogana, San Giorgio, Citella, from the Steps of the Europa* (colour plate XXII), both exhibited in 1842, express the same idyllic mood as those of the preceding decade. They differ from their immediate predecessors in being even more boldly fluent in handling and still lighter in tonality, whites, light blues and pinks predominating. In the mid-1840s the titles became more evocative, as in the case of the two pairs of works exhibited in 1845 with references, unsupported by quotations, to the 'Ms. Fallacies of Hope', *Venice—Noon* and *Venice—Sunset, a Fisher*, and *Venice, Evening, going to the Ball* and *Morning, returning from the Ball, St. Martino* (all in the Tate Gallery). These particular examples are less pleasing in quality, being marred by the distracting fussiness of line mentioned above and by their over-yellow tones even after the removal of discolouring varnishes; they are in fact the first works to hint at the waning of Turner's powers.

During the last decade of his life Turner exhibited few English landscapes, the spectacular exception to this neglect being *Rain, Steam and Speed—The Great Western Railway* (plate 122), exhibited in 1844, although even this is rather an essay in the elemental forces of storm and steam. A personal experience, in this case the result of Turner's putting his head out of a train window during a rain-storm, again justified what was considered by some critics the extravagance of his poetic vision. The site of the incident (almost certainly the bridge, completed in 1839, between Maidenhead and Taplow) is transformed and the viewpoint is once again raised, both to command a more panoramic view and to set the scene somewhat apart from the spectator, giving it the timeless universal quality that was Turner's inheritance from the Old Masters and which came more and more to distinguish his work from that of his contemporaries. This picture more perhaps than any other illustrates Turner's unique place in the development of nineteenth-century painting. One has only to think of how a railway scene would have been depicted in the prevailing realist tradition of Wilkie and Mulready, which culminated in the work of W. P. Frith. *Rain, Steam and Speed* and *The Railway Station* (Royal Holloway College, Englefield Green, Surrey), completed by Frith in 1862 (his *Ramsgate Sands* in the Royal Collection, a work similar in spirit, was painted as early as 1851–3), are the creations of men from two different artistic worlds. Nor is the Impressionist devotion to the scientific depiction of appearances in Monet's *Gare Saint-Lazare* of 1877 any closer in intention to Turner's painting.

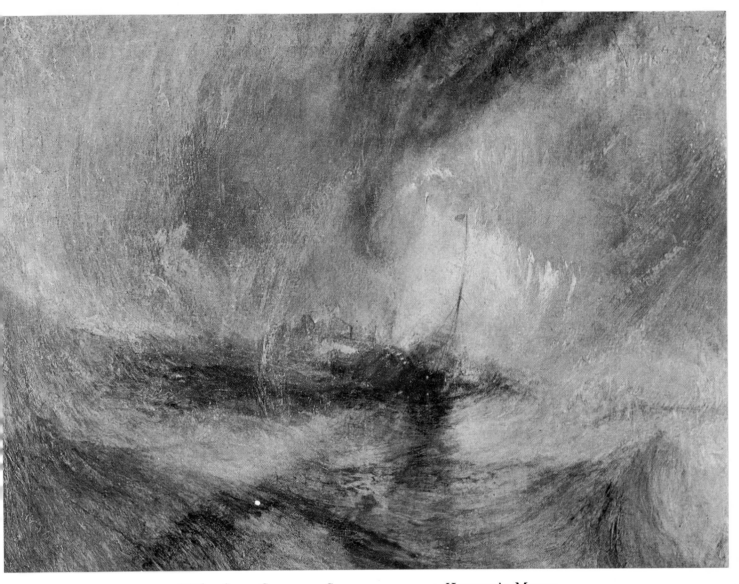

XXI. Snow Storm — Steam-boat off a Harbour's Mouth.
36 × 48 *in. Exhibited* 1842. *National Gallery, London.*

In the same year, 1844, Turner exhibited the last two of his great series of sea-pieces inspired by the Dutch tradition, *Fishing Boats bringing a Disabled Ship into Port Ruysdael* (Tate Gallery), and *Van Tromp, going about to please his Masters, ships a Sea, getting a Good Wetting* (plate 123), titles which recall respectively the *Port Ruysdael* exhibited in 1827 and the Van Tromp pictures of the early 1830s. While in handling they display the revolutionary freedom which Turner extended to his exhibited works in the 1840s they also show the persistence of Turner's respect for the tradition in which he had achieved so much of his contemporary reputation; in particular the composition of the Van Tromp picture, the foreground as it were forming a shelf on the surface of the canvas and so bringing the small boat in the centre out towards the spectator, and the distant ship on the left being placed parallel to the picture-plane against a contrasted white strip on the horizon, recalls the Thames Estuary pictures of about 1810 (see colour plate IV).

In his subject-pictures of the 1840s Turner continued to develop his powers of expression by means of forms and colours alone, already apparent in the contrast between *The Fighting Temeraire* and *The Slave Ship*. In *Peace — Burial at Sea* (plate 120), exhibited in 1842 as a tribute to the memory of Sir David Wilkie, the elegiac character of *The Fighting Temeraire* is simplified and enhanced. The glowing radiance at the heart of the composition, where the body of Wilkie is being lowered into the sea, stands out in poignant contrast to the encircling whites and blue-greys. The stark forms of the black sails — 'I only wish I had any colour to make them blacker', Turner is reported to have said — their angularity echoed by the low-flying bird which in turn echoes that of the felucca on the right, are wonderfully expressive of grief. The brush-strokes show the same audacious energy as those of the *Snow Storm — Steam-boat off a Harbour's Mouth*. Unfortunately he chose to pair this masterpiece with *War: the Exile and the Rock Limpet* (also at the Tate Gallery) in which the mastery of his handling of the setting is nullified by the grotesque superimposed figure of Napoleon.

These two paintings are among a small number similar in shape, square and in most cases with the corners cut across. With a few exceptions, such as the almost square *What you will!*, his previous finished paintings had been the usual oblongs or uprights save where some particular circumstance necessitated an unusual shape — the Petworth landscapes, which are particularly long in relation to their height, were painted to fill designated places — but in this group of works painted in the 1840s he was deliberately experimenting with a new format. It

68

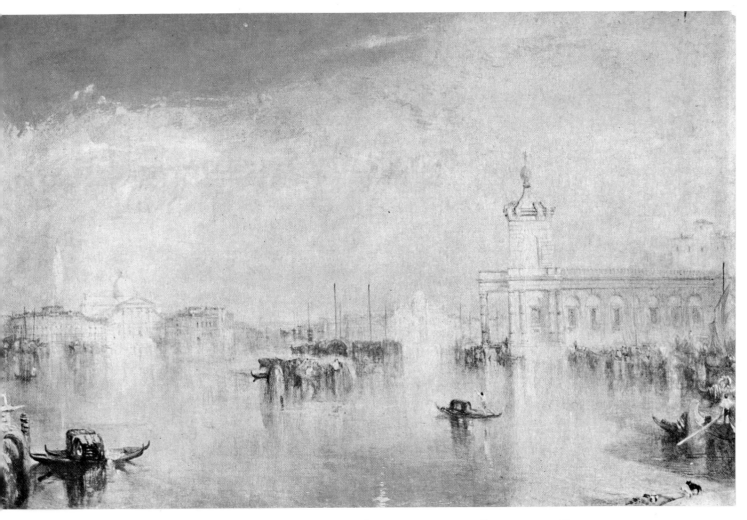

XXII. THE DOGANO, SAN GIORGIO, CITELLA, FROM THE STEPS OF THE EUROPA.
$24\frac{1}{4} \times 36\frac{1}{2}$ in. Exhibited 1842. Tate Gallery.

was one suited to the increasingly 'vorticist' (if the neologism may be allowed) form of his vision. His use of the vignette, as in his illustrations to Samuel Roger's poems in the 1820s and 30s, served to a certain extent as a preparation but there his compositions were static and pretty rather than forceful. At first his oils in this format, *Bacchus and Ariadne* (Tate Gallery), exhibited in 1840, and *Dawn of Christianity* (*Flight into Egypt*) (Ulster Museum, Belfast) and *Glaucus and Scylla* (private collection, U.S.A.), both exhibited in 1841, do indeed partake more of the quality of the vignettes than of the drama of his contemporary storm pictures, partly on account of their subjects. While *Glaucus and Scylla* appears, from a photograph, to have been painted right up to the corners, *Bacchus and Ariadne* was intended from the first to have the corners cut across to form an irregular octagon (this is shown by pencil-lines directly on top of the ground and underneath the paint), though the *Flight into Egypt*, which has similar underlying pencil-lines, was finally completed as a circle.

Burial at Sea was also painted as an irregular octagon but here the composition relies upon the rectangular implication of the format, the suggestion of dignity and mourning being assisted by the squareness of the picture. In the companion *War: the Exile and the Rock Limpet* and the subsequent works of this group, however, Turner once more based his compositions on curvilinear forces but with an energy through which the vortex found full expression in the format to which it was perhaps most suited. At the same time the cutting across or rounding off of the corners in most of these works may have reflected, as already suggested, Turner's appreciation of the characteristics of natural vision, clear at the centre and vague at the edges, of which his use of the vortex was a more positive result.

This is particularly evident in the pair of paintings exhibited in 1843, *Shade and Darkness — the Evening of the Deluge* (plate 121) and *Light and Colour* (*Goethe's Theory*) — *the Morning after the Deluge* — *Moses writing the Book of Genesis* (also in the Tate Gallery). The wayward treatment of Biblical history tends to distract attention from the far more important reference to Goethe's 'Theory of Colour', which had been translated into English by Eastlake in 1840 and of which Turner owned and annotated a copy (now in the possession of C. W. Mallord Turner). As already noted Turner had referred to Du Fresnoy's 'Art of Painting' in the title of a picture of 1831, but here he literally illustrates Goethe's theory of colour, which was based not upon the spectrum but upon a chromatic circle, divided into 'plus' and 'minus' colours. The former, the reds,

70

XXIII. STORMY SEA.
36 ×48 *in. Painted* circa 1840–5. *Tate Gallery.*

yellows and greens, which Goethe associated with gaiety, warmth and happiness, dominate *The Morning after the Deluge*, which is accompanied by a passage from 'The Fallacies of Hope' referring to hope (though to its delusive character), while *The Evening of the Deluge* is conversely dominated by the 'minus' colours, the blues, blue-greens and purples which Goethe considered as productive of 'restless, susceptible, anxious impressions'. The elliptical tendency of Turner's vision and his iridescent colour were ideally suited to illustrate this theory.

In 1846 Turner exhibited the two last of this series of square or octagonal pictures. One, *The Angel standing in the Sun* (plate 128), is a depiction of Apocalyptic catastrophe, by the elemental force not of tempest or avalanche but of light; the sun, which had played a predominant part in so many of Turner's pictures, becomes at last his principal subject. The other painting, *Undine giving the Ring to Masaniello, Fisherman of Naples* (Tate Gallery), is apparently unrelated in subject but with its predominantly blue colour it complements *The Angel standing in the Sun* as *The Evening of the Deluge* complements *The Morning after the Deluge*. In both these pairs of pictures Turner seems to have been uncertain once again how to treat the corners: in those of 1843 he eventually cut them across, but in the later pair of 1846 some of the corners were left empty, others he rounded off with sweeping brush-strokes, while the lower right-hand corners of both pictures he at the last moment filled with detailed forms, a fish and a flask, finally framing the pictures as squares. This indecision was perhaps another symptom of the failure of his powers noticeable in his final years.

The Angel standing in the Sun, exhibited in 1846, was Turner's last great picture but even this carries an intimation of incoherence and shows the heaviness of handling that marked his final decline. Among Venetian and whaler subjects exhibited in 1845 and 1846 only '*Hurrah! for the Whaler Erebus! Another Fish!*' (plate 125) of the latter year shows something of Turner's genius. The following year his sole exhibit was *The Hero of a Hundred Fights* (Tate Gallery) which ostensibly depicted the casting of the Wellington statue in 1845, but this fiery impression was painted over an old composition similar in character to *The Blacksmith's Shop* of some forty years earlier. The freely and thickly painted glow of the furnace remains uneasily detached from the dark, drily painted interior beneath, and the added foreground detail does nothing to reconcile the old style and the old paint with the new.

In 1848 there were no works by Turner at the Academy for the first time since 1824. The following year the *Wreck Buoy* (plate 126), a work of about

72

1809, was borrowed from Turner's friend and patron, Munro of Novar, repainted and exhibited together with the still earlier but fortunately untouched *Venus and Adonis* (plate 24). Finally, in 1850, Turner exhibited four new paintings of subjects concerned with Dido and Æneas and accompanied by quotations from 'The Fallacies of Hope', including *The Visit to the Tomb* (plate 127; two others are in the Tate Gallery and the fourth has perished). These are clumsily painted in hot colours and are all variations on the same composition. In 1851, although Turner attended the varnishing days, he had no works on view and in the December of the same year he died.

* * *

Three years before Turner's death, in 1848, the Pre-Raphaelite Brotherhood was founded. In spite of Ruskin's attempt to equate Turner's aims with those of the Brotherhood nothing could illustrate more clearly how anachronistic Turner's style had become. The foremost among his contemporaries, both friends and rivals, were dead—Lawrence, Constable, Wilkie, Chantrey. So was the oldest of his disciples, Callcott, and those who survived, such as Clarkson Stanfield and J. B. Pyne, merely exploited particular aspects of Turner's exhibited and most accessible works to produce light-toned, charming but superficial landscapes which reflect none of Turner's sense of the cosmic energies of nature. During Turner's lifetime his early dramatic paintings in the grand manner found parodies in the plagues, floods and Apocalyptic visions of John Martin and Francis Danby but again the emotion, though pushed to an extreme, is superficial, lacking the sure foundation of both Turner's splendid sense of form and his profound understanding of an immense range of natural phenomena.

During the second half of the nineteenth century and well into the twentieth Turner's influence was practically nil. Only with the growth of interest in his late unexhibited oil sketches (the first of these were not exhibited until 1906 and it was not until 1938 that any considerable number were placed on view) did he become a creative influence, inspiring among others the school of painters of romantic landscape which emerged about the time of the Second World War, and also seeming to offer a precedent for the emergence a decade or so later of the very different art, dependent upon the abstract qualities of colour, texture and the actual process of painting, of the action-painters (as it had for their English precursors of the 1930s, the 'abstract impressionists'); the latter's

enthusiasm, on the same grounds, for the late works of Monet has at last given some point to the association of Turner with the Impressionists, though one that has little to do with the conscious intentions of either.

But Turner's claim to fame rests, of course, on his own achievement, not on his place in art-historical development. In a remarkably short space of time he matured from the painter of accomplished but conventional watercolours and oils of local English interest to the creator of vast dramatic pictures in the main stream of the European tradition, only to return after a few years to the naturalistic depiction of the English landscape with a warmth and lyricism unprecedented in British painting, though never completely abandoning dramatic themes. Then came a much longer period of susceptibility to outside influences, partly again those of other painters but after 1819 above all that of the intoxicating impact of Italy; he painted many notable pictures during this period and the revolutionary character of his work was already plain in his oil sketches and some of his watercolours, but it was not until the Petworth paintings of the early 1830s and the Venetian paintings of the mid-1830s that he showed himself fully master of this new revelation of light and colour. Finally, before the decline of his final years, the distinction between form and content was dissolved in the visionary evocation of the cosmic forces of nature.

Turner's late masterpieces combine the passionate but at first sight conflicting preoccupations of much of his career, preoccupations which partook of the two poles of British painting, the intimate naturalism of Constable and the poetic vision of Blake, though Turner's very range prevented him from achieving the intensity in their own fields of either. The length and uncertainties of his highly complex evolution reflect the difficulty he had in reconciling the elements of his art, his devotion to observed reality, his exalting experience of light and colour and, perhaps most important in this respect, his desire to express something of significance about human destiny. This last was in tune with his early respect for the classical hierarchy of genres but Turner's tenacious interest in dramatic subjects from his early maturity right up to his death shows that it sprang from a much deeper impulse.

In his early subject-pictures he turned, in accord with contemporary taste, to history and mythology but, partly because of his training, partly because of an inability, perhaps psychological, to depict the human figure except in a most summary and detached way, his medium was the figure in landscape, and even so the most expressive of these pictures are those dominated by some destructive

XXIV. Sunrise, with a Boat between Headlands.
36 × 48¼ in. *Painted* circa 1840–5. *Tate Gallery*.

natural phenomenon, some plague or tempest, while the majority of his most successful early works are pure landscapes. In the 1820s, when much of his work reflects a more optimistic if rather superficial mood, he developed a greater mastery over the figure and, particularly under the influence of Rembrandt, found a way of approaching closer to individual human beings, a development culminating in the works made at Petworth. Even among these, however, it is in the obliquely approached figure seen from behind in *The Letter* (plate 93) rather than in the directly portrayed *Woman reclining on a Couch* (plate 89) that he is most successful. Indeed the only direct large-scale portrayal of a human being that can be looked at without embarrassment, is the wonderfully sensitive and searching early *Self-Portrait* (plate 1), which may itself give a significant clue to his personality, suggesting that the only human being with whom Turner could bear to identify himself fully was his own self.

Turner did not succeed in fully expressing his preoccupation with human destiny until his mastery of technique made it possible for him to realize his most deeply pondered theme, man's relationship to nature, solely in the field in which he had always been most accomplished, the representation of the elemental forces of the natural world. Already in such works as *Hannibal crossing the Alps* (plate 49) or even *Calais Pier* (colour plate I) his real subject had been man's battle against the elements rather than the specific event shown, but now he was able to omit the human figure entirely without diminution, and indeed to the enhancement, of the human significance of his themes; though he stood aside from the individual's predicament this very detachment strengthened the universal significance of his message. Natural forces, both those that he had inherited from the Sublime as images of horror, such as fire and storm, and those, of light and colour, that he had discovered for himself, became the very essence of his art, embodying in their forms alone the emotions he wished to communicate. The former, fire and storm, conveyed his sense of the insignificance of man in the face of the immensity and destructiveness of nature; the latter, light and colour, were hymns of praise to the life-giving essences of the physical world.

Turner was one of the greatest landscape painters of any age. In addition he was a key figure in the evolution of the Romantic conception of nature, that evolution being exemplified in his own career: nature, from being subordinate to the depiction of man's relationship to man or God, became both the object and the medium of his innermost beliefs.

76

Biographical Notes

Note. During the period under review the annual exhibition of the Royal Academy normally opened in the last week of May and that of the British Institution in February, with an *Old Masters* exhibition in the summer; Turner's own gallery was usually open from late April or early May to June or July. Turner sometimes exhibited the same work at more than one of these places. For a complete list of the works exhibited in his lifetime, with titles and catalogue numbers, see A. J. Finberg's *Life of J. M. W. Turner*, Oxford, 2nd ed., 1961, pp. 456–561.

1775 23 April. Joseph Mallord William Turner born at 21 Maiden Lane, Covent Garden, London, the eldest son of a barber and wig-maker. By 25 March 1776 the family had moved to another home near by.

1785 Sent to live with his uncle at Brentford, Middlesex.

1787 First signed and dated drawings, all probably copies from topographical engravings.

1789 Probable date of first extant sketch-book from nature, made in London and the neighbourhood of his uncle's house in Sunningwell, near Oxford.
11 December. Admitted as a student of the Royal Academy Schools after a term's probation. Probably began to study with the topographical watercolourist Thomas Malton at about the same time.

1790 Exhibited one watercolour at the Royal Academy; living with his parents at 26 Maiden Lane.

1791 Two watercolours at the Royal Academy.
September. Sketched at Bristol, Bath, Malmesbury, etc.

1792 Two watercolours at the Royal Academy.
Summer. First sketching tour in South and Central Wales.

1793 27 March. Awarded the 'Greater Silver Pallet' for landscape drawing by the Society of Arts.
Three watercolours at the Royal Academy.

1794 May. Publication of first engraving from one of his drawings.

Five watercolours at the Royal Academy, attracting the attention of the press for the first time.

First Midland tour, largely to make drawings for engraving.

His employment in winter evenings, together with Girtin, Dayes and others, by Dr Munro to copy drawings by J. R. Cozens and others, probably began in this year, and lasted for a period of three years.

1795 Eight watercolours at the Royal Academy.

4 June. First mention in Farington's Diary.

Tour in South Wales c. June–July and the Isle of Wight c. August–September, in part to execute private commissions for topographical drawings as well as for engravings.

1796 First oil painting (?) at the Royal Academy, together with ten watercolours.

1797 Two oils and four watercolours at the Royal Academy.

Summer. First tour in the North of England, including the Lake District.

1798 Four oils and six watercolours at the Royal Academy.

Summer. Trip to Malmesbury, Bristol, and thence to North Wales.

1799 April. Recommended to Lord Elgin to make topographical drawings at Athens. Failed to agree on salary.

Four oils and seven watercolours at the Royal Academy.

August–September. Stayed for three weeks with William Beckford at Fonthill.

(?) September–October. To Lancashire and North Wales.

4 November. Elected an Associate of the Royal Academy.

November. Took rooms at 64 Harley Street.

1800 Two oils, including his first history-painting, and six watercolours at the Royal Academy.

27 December. Turner's mother admitted to Bethlehem Hospital; discharged uncured in 1801.

1801 Two oils and four watercolours at the Royal Academy, sent in from 75 Norton Street, Portland Road.

June–August. First tour of Scotland, returning through the Lakes.

1802 12 February. Elected a full member of the Royal Academy.

Five (or four) oils and three (or four) watercolours at the Royal Academy.

15 July–October. First visit to France and Switzerland; sketches and notes after pictures in the Louvre.

1803 Five oils and two watercolours at the Royal Academy.

1804 c. 15 April. Death of Turner's mother in a private asylum in Islington.

April. Completed a gallery at 64 Harley Street for the permanent exhibition of twenty to thirty of his own works.

Two oils and one watercolour at the Royal Academy; some of the verses in the catalogue probably by himself for the first time.

1805 Own exhibition at Harley Street; no works at the Royal Academy.

First large subscription engraving from one of his paintings, *The Shipwreck* (published 1807).

1806 Two oils at the first exhibition of the British Institution; one oil and one watercolour at the Royal Academy; his own gallery open.

Late summer and autumn. Stayed at Knockholt, Kent, with W. F. Wells, who suggested the 'Liber Studiorum'.

c. October. Took a house at 6 West End, Upper Mall, Hammersmith, retaining his gallery in Harley Street.

1807 Turner's gallery open; two oils at the Royal Academy.

11 June. First volume of 'Liber Studiorum' published.

Summer. Almost certainly made sketches, including oils, on the Thames between Windsor and Walton in this year.

2 November. Elected Professor of Perspective at the Royal Academy.

1808 Two oils at the British Institution, one at the Royal Academy; Turner's gallery open.

July (?). Stayed at Sir John Leicester's seat, Tably Hall, Cheshire. Also sketched on the River Dee.

1809 Turner's gallery open: first surviving catalogue, listing sixteen oils and two watercolours. One oil at the British Institution, four at the Royal Academy.

Summer. First (?) visit to Petworth House, the home of Lord Egremont.

1810 7 May–9 June. Turner's gallery open; catalogue lists seventeen works, two probably watercolours. Three oils at the Royal Academy.

Late summer. First recorded visit to Walter Fawkes of Farnley Hall, Yorkshire, repeated nearly every year till 1824.

Before 12 December. His town address changed to 47 Queen Ann Street West, round the corner from 64 Harley Street.

1811 7 January. First lecture as Professor of Painting of the Royal Academy.

Four oils and five watercolours at the Royal Academy.

July–September. Tour of Dorset, Devon, Cornwall and Somerset in connection with first big series of topographical engravings to be published in book form.

Gave up Hammersmith home, and had temporary residence at Sun Ferry House, Isleworth, while building house at Twickenham.

1812 Four oils at the Royal Academy (first quotation from the 'Fallacies of Hope'). Turner's gallery open with seven new landscapes in addition to pictures previously exhibited.

1813 Two oils at the Royal Academy, sent in from Solus (later Sandycombe) Lodge, Twickenham. Turner's gallery open.

Summer. Toured Devon.

1814 One oil at the British Institution, entered for the premium for a landscape painting fit in subject and manner to be a companion to the works of Claude or Poussin. One oil at the Royal Academy. Turner's gallery open for the 'last season but two'.

1815 Four (or three) oils and three (or four) watercolours at the Royal Academy; Turner's gallery probably open.

1816 Two oils at the Royal Academy; Turner's gallery probably open.

July–September. Visited Farnley Hall and travelled in the north of England, in part preparing for Yorkshire engravings.

1817 One oil at the Royal Academy.

10 August–*c.* 15 September. First visit to Belgium, the Rhine (between Cologne and Mainz) and Holland.

September–early December. Toured Durham, etc., and stayed at Farnley Hall.

1818 Three oils and one watercolour at the Royal Academy.

October–November. Visited Edinburgh in connection with Walter Scott's 'The Provincial Antiquities of Scotland'.

1819 March. Eight of his oils on view in Sir John Leicester's London gallery.

April–June. Sixty or more watercolours on view in Walter Fawkes' London house, and again in 1820.

Two oils at the Royal Academy.

August–1 February 1820. First visit to Italy, encouraged by Lawrence: Turin, Como, Venice, Rome, Naples; returned from Rome via Florence and Turin.

1820 One oil at the Royal Academy.

Enlarged and transformed his Queen Anne Street House, building a new gallery, 1819–21.

1821 No works at the Royal Academy.

Late summer or autumn. Visit to Paris, Rouen, Dieppe, etc.

1822 1 February–August. Twenty-four watercolours included in exhibition organized by the publisher W. B. Cooke. One oil at the Royal Academy; Turner's new gallery open.

August. Visited Edinburgh for George IV's State Visit, going by sea up the east coast.

1823 Eleven watercolours in Cooke's second exhibition. One oil at the Royal Academy. Sketched along the south-east coast.

Commissioned to paint the *Battle of Trafalgar* for St James' Palace; in place by May 1824.

1824 No works at the Royal Academy. Fifteen watercolours in Cooke's third exhibition. Summer and autumn. Visited east and south-east England.

November–December. Last visit to Farnley Hall.

1825 One oil and one watercolour at the Royal Academy.

28 August. Set out on tour of Holland, the Rhine and Belgium.

25 October. Death of Walter Fawkes.

1826 Four oils at the Royal Academy.

10 August–early November. Visited the Meuse, the Moselle, Brittany and the Loire.

1827 Five oils at the Royal Academy.

18 June. Death of Lord de Tabley (Sir John Leicester).

Late July–September. Stayed with John Nash at East Cowes Castle, Isle of Wight, probably returning via Petworth.

1828 January–February. Turner's last lectures as Professor of Perspective.

Four oils at the Royal Academy.

August–February 1829. Second visit to Italy: Paris, Lyons, Avignon, Florence, Rome (where he showed three oils), returning via Loreto, Ancona, Bologna, Turin and Lyons.

1829 Three oils and one watercolour at the Royal Academy; one oil at the Manchester Institution.

Early June–18 July. About forty watercolours for the 'England and Wales' engravings exhibited at the Egyptian Hall; some later shown at Birmingham.

August–early September. Visited Paris, Normandy and Brittany.

21 September. Death of Turner's father.

1830 Six oils and one watercolour at the Royal Academy.

Late August–September. Toured the Midlands.

December–January 1831. Probably at Petworth; a regular visitor from this time until 1837.

1831 Seven oils at the Royal Academy.

July–September. Toured Scotland, staying at Abbotsford in connection with his illustrations to Scott's poems.

1832 March. Twelve illustrations to Scott exhibited at Messrs. Moon, Boys and Graves, Pall Mall.

Six oils at the Royal Academy.

1833 Six oils at the Royal Academy.

8 June–6 July. Seventy-eight watercolours exhibited at Moon's.

August. Visited Paris.

One oil and two watercolours lent to the winter exhibition of the Society of British Artists.

1834 Views on the Seine exhibited at Moon's, and illustrations to Byron's poems at Colnaghi's.

Five oils at the Royal Academy.

Late July. Set off on a tour of the Meuse, Moselle and Rhine.

Winter. Four of his early oils on view at the Society of British Artists.

1835 One oil at the British Institution; five at the Royal Academy. Turner's gallery open to the public.

Summer; almost certainly the year of Turner's second visit to Venice, going or returning (?) via the Baltic, Berlin, Dresden, Prague and Vienna.

1836 Two oils at the British Institution; three at the Royal Academy.

Summer. Toured France and the Val d'Aosta with H. A. J. Munro of Novar.

October. Ruskin's first letter to Turner, enclosing a reply to an attack in 'Blackwood's Magazine'.

1837 One oil at the British Institution; four at the Royal Academy; one oil in the British Institution 'Old Masters' Exhibition.

11 November. Death of Lord Egremont.

28 December. Resigned post of Professor of Perspective.

1838 One oil at the British Institution; three at the Royal Academy.

1839 One oil at the British Institution; five at the Royal Academy.

Took a cottage on the corner of Cremorne Road and Cheyne Walk, Chelsea, at about this time.

1840 One oil at the British Institution; seven at the Royal Academy.

22 June. Met Ruskin for the first time.

Early August–early October. Third visit to Venice, going via Rotterdam and the Rhine and returning through Munich and Coburg.

81

1841 Two oils at the British Institution; six at the Royal Academy.
August–October. Visited Switzerland: Lucerne, Constance and Zurich.

1842 March. Invited subscriptions through Thomas Griffith for large engravings of five of his oils; also sought commissions for ten finished watercolours of Swiss and Rhine subjects at eight guineas each; nine secured.
Five oils at the Royal Academy.
August–October. Visited Switzerland.

1843 Offered to make ten more finished watercolours of Swiss subjects but Griffith could only secure five commissions.
Six oils at the Royal Academy.
May. Publication of the first volume of Ruskin's 'Modern Painters', intended largely as a defence of Turner.

1844 Seven oils at the Royal Academy.
c. August–early October. Visited Switzerland, Rheinfelden, Heidelberg and the Rhine.

1845 Two of his oils on view at the Royal Scottish Academy; six oils at the Royal Academy; two oils lent to the Manchester Institution; *Walhalla* shown at the 'Congress of European Art' at Munich.
May. Short visit to Boulogne and neighbourhood.
14 July. As eldest Academician was chosen to carry out duties of President during Shee's illness.
September–October. Visit to Dieppe and the coast of Picardy (his last trip abroad).

1846 One oil at the British Institution, six at the Royal Academy; two oils lent to the Royal Scottish Academy.

1847 One oil, an earlier painting worked over, at the Royal Academy; two oils lent to the Royal Scottish Academy.

1848 January. One painting hung in the National Gallery to represent the Vernon Gift.
No works at the Royal Academy; one oil lent to the Royal Scottish Academy.

1849 Two oils, both early works belonging to Munro of Novar, at the Royal Academy; two works in the British Institution's 'Old Masters' exhibition; one oil lent to the Royal Scottish Academy.

1850 Four oils at the Royal Academy; one oil lent to the Liverpool Academy.

1851 No works at the Royal Academy; two oils lent to the Royal Scottish Academy.
19 December. Died at his cottage, 119 Cheyne Walk, Chelsea. Buried at St Paul's on 30 December.

Select Bibliography

JOSEPH FARINGTON, *Manuscript Diary*, 1793–1821, in the Royal Library, Windsor; selections published as *The Farington Diary*, edited by James Greig, 8 vols., London, 1922–8.

JOHN RUSKIN, *Modern Painters*, 5 vols., London, 1843–60.

> This and other writings on Turner are included in the *Works of Ruskin, Library Edition*, 39 vols., London, 1903–12; there is a full classified index in the last volume.

JOHN BURNET, *Turner and His Works*, London, 1852, with a 'Memoir' by Peter Cunningham; 2nd edition 1859.

ALARIC A. WATTS, 'Biographical Sketch', in Leitch Ritchie, *Liber Fluviorum; or River Scenery of France*, London, 1853.

THOMAS MILLER, 'Memoirs of Turner and Girtin', in *Turner and Girtin's Picturesque Views Sixty Years Since*, London, 1854.

WALTER THORNBURY, *Life of J. M. W. Turner, R.A.*, 2 vols., London, 1862; 2nd edition in 1 vol. 1877.

> The first full-length biography of Turner, full of distortions and fabrications which vitiate all subsequent biographies up to Finberg's *Life* of 1939, but valuable as embodying a number of reminiscences by Turner's contemporaries.

RICHARD AND SAMUEL REDGRAVE, *A Century of British Painters*, 2 vols., London, 1866.

PHILIP GILBERT HAMERTON, *The Life of J. M. W. Turner, R.A.*, London, 1879.

C. F. BELL, *The Exhibited Works of J. M. W. Turner, R.A.*, London, 1901.

> Contains details of provenance omitted from the lists in Finberg's *Life*, 1939.

WALTER ARMSTRONG, *Turner*, 2 vols., London, Manchester, Liverpool and New York, 1902.

> Contains lists of oils and of watercolours other than those in the Turner Bequest; these are now rather out of date.

D. S. MACCOLL, 'Joseph Mallord William Turner, 1775–1851', in *Nineteenth Century Art*, Glasgow, 1902.

E. T. Cook, *Hidden Treasures at the National Gallery*, London, 1905.

A good selection of plates, particularly of watercolours, in the Turner Bequest.

W. G. Rawlinson, *The Engraved Work of J. M. W. Turner, R.A.*, 2 vols., London, 1908 and 1913.

W. G. Rawlinson and A. J. Finberg, *The Watercolours of J. M. W. Turner*, London, 1908.

A. J. Finberg, *Turner's Sketches and Drawings*, London, 1910.

A. J. Finberg, *Turner's Watercolours at Farnley Hall*, London, Paris and New York, n.d. (1912).

A. J. Finberg, *The History of Turner's Liber Studiorum with a new Catalogue Raisonné*, London, 1924.

A. J. Finberg, *In Venice with Turner*, London, 1930.

Bernard Falk, *Turner the Painter: His Hidden Life*, London, 1938.

Contains a list of the contents of Turner's Library.

Charles Mauclair, *Turner*, Paris, 1938; English translation by Eveline Byam Shaw, London, 1939.

Contains a useful but irritatingly arranged collection of reproductions.

A. J. Finberg, *The Life of J. M. W. Turner, R.A.*, Oxford, 1939; 2nd edition 1961.

The first and only authoritative biography of Turner, superseding all previous lives. Includes a bibliography and a list of exhibited works with their owners in 1939 if known. A revised edition with an extended list of exhibited works by the author's widow, Hilda F. Finberg, was published in 1961.

Hans Vollmer, 'Turner, William', in Thieme-Becker, *Allgemeines Lexikon der Bildenden Künstler*, vol. xxxiii, Leipzig, 1939, pp. 493–6.

With extensive bibliography.

R. B. Beckett, ' "Kilgarren Castle": A Link between Turner and Wilson', in *The Connoisseur*, vol. cxx, 1947, pp. 10–15.

Kenneth Clark, *Landscape into Art*, London, 1949.

John Rothenstein, *Turner (1775–1851)*, London, 1949.

Charles Clare, *J. M. W. Turner, His Life and Work*, London, 1951.

Hilda F. Finberg, 'Turner's Gallery in 1810', in *The Burlington Magazine*, vol. xciii, London, 1951, pp. 383–6.

Kenneth Clark, 'Turner', lecture reprinted in catalogue of Arts Council exhibition, *J. M. W. Turner, R.A., 1775–1851*, 1952.

C. C. Cunningham, 'Turner's Van Tromp Paintings', in *The Art Quarterly*, vol. xv, Detroit, 1952, pp. 323–30.

Ann Livermore, 'J. M. W. Turner's Unknown Verse-Book', in *The Connoisseur Year Book*, 1957, pp. 78–86.

Ann Livermore, 'Turner and Music', in *Music and Letters*, vol. xxxviii, London, 1957, pp. 170–9.

T. S. R. Boase, 'Shipwrecks in English Romantic Painting', in *Journal of the Warburg and Courtauld Institutes*, vol. xxii, 1959, pp. 337–44.

Kenneth Clark, 'Turner, the Snowstorm', in *Looking at Art*, London, 1960.

John Rothenstein, *Turner (1775–1851)*, New York and London, 1960.

Martin Butlin, *Turner Watercolours*, London, Basle and Baden-Baden, 1962.

84

ADRIAN STOKES, 'The Art of Turner (1775–1851)', Part 3 of *Painting and the Inner World*, London, 1963.

JERROLD ZIFF, 'Turner and Poussin', in *The Burlington Magazine*, vol. CV, 1963, pp. 315–21.

JERROLD ZIFF, '"Backgrounds, Introduction of Architecture and Landscape": a lecture by J. M. W. Turner', in *Journal of the Warburg and Courtauld Institutes*, vol. XXVI, 1963, pp. 124–47.

CATALOGUES

A. J. FINBERG, *A Complete Inventory of the Drawings of the Turner Bequest, with which are included the twenty-three drawings bequeathed by Mr Henry Vaughan*, 2 vols., London, 1909.

C. H. COLLINS BAKER, *Catalogue of the Petworth Collection*, London, 1920.

National Gallery, Millbank (Tate Gallery), *Catalogue: Turner Collection*, London, 1920.

> A catalogue of all the oil-paintings in the Turner Bequest that had been placed on exhibition by 1920; 84 further oils are omitted. Oil-paintings acquired from other sources and a selection of watercolours from the Turner Bequest are also included.

Commemorative Catalogue of the Exhibition of British Art, Royal Academy of Arts, London, January–March, 1934, London, 1935.

MARTIN DAVIES, *National Gallery Catalogues: British School*, London, 1946; revised edition 1959.

> The first edition is more useful, containing entries on a number of paintings subsequently transferred to the Tate Gallery and an appendix on the 1854 schedule of the Turner Bequest.

Exhibition Catalogue, *The First Hundred Years of the Royal Academy 1769–1868*, Royal Academy, London, 1951–2, and separate *Illustrated Souvenir*.

Exhibition Catalogue, *J. M. W. Turner, R.A., 1775–1851*, Whitechapel Art Gallery, London, 1953.

Exhibition Catalogue, *Turner in America*, John Herron Art Museum, Indianapolis, 1955.

Exhibition Catalogue, *The Romantic Movement*, Tate Gallery and Arts Council Gallery, London, 1959.

List of Colour Plates

87

88

List of Monochrome Plates

1. SELF-PORTRAIT. *Oil on canvas, 29 × 23 in.* *(73·5 × 58·5cm.).* *Painted* circa 1798. *Turner Bequest, Tate Gallery, London* (458).

2. (*a*) VIEW ON THE RIVER AVON NEAR WALLIS'S WALL, BRISTOL. *Ink and watercolour, 9½ × 11½ in.* (*24 × 29·5 cm.*). *Painted* 1791. *Turner Bequest, British Museum, London* (VII–B).
 (*b*) OLD LONDON BRIDGE. *Watercolour, 10¼ × 14¼ in.* (*26 × 36 cm.*). *Painted* circa 1796–7. *Turner Bequest, British Museum, London* (XXXIII–U).

3. (*a*) THE WESTERN TOWER, ELY CATHEDRAL. *Pencil and watercolour, 8¼ × 11 in.* (*21 × 28 cm.*). *Painted* 1794. *Turner Bequest, British Museum, London* (XXI–Y).
 (*b*) WELSH VALLEY, WITH RIVER AND DISTANT MOUNTAINS. *Watercolour, 9 × 13 in.* (*23 × 33 cm.*). *Painted* 1798. *Turner Bequest, British Museum, London* (XXXVIII–95).

4. (*a*) TOM TOWER, CHRIST CHURCH, OXFORD. *Watercolour, 10¾ × 8¼ in.* (*27·5 × 21·5 cm.*). *Painted* circa 1793. *Turner Bequest, British Museum, London* (XIV–B).
 (*b*) WATERFALL NEAR BETTWS-Y-COED, NORTH WALES. *Watercolour, 13 × 9 in.* (*33 × 23 cm.*). *Painted* 1798. *Turner Bequest, British Museum, London* (XXXVIII–71).

5. FISHERMEN AT SEA. *Oil on canvas, 36 × 48 in.* (*91·5 × 122 cm.*). *Exhibited at the Royal Academy* 1796. *F. W. A. Fairfax-Cholmeley, Paris (on loan to Tate Gallery, London).*

6. MOONLIGHT, A STUDY AT MILLBANK. *Oil on panel, 11½ × 15½ in.* (*29 × 39·5 cm.*). *Ex-*

hibited at the Royal Academy 1797. *Turner Bequest, Tate Gallery, London* (459).

7. BUTTERMERE LAKE WITH PART OF CROMACK-WATER, CUMBERLAND, A SHOWER. *Oil on canvas, 35 × 47 in.* (*89 × 119 cm.*). *Exhibited at the Royal Academy* 1798. *Turner Bequest, Tate Gallery, London* (460).

8. MOUNTAIN SCENE, WALES. *Oil on canvas, 17 × 21 in.* (*43 × 53·5 cm.*). *Painted* circa 1798. *Turner Bequest, Tate Gallery, London* (465).

9. DUNSTANBURGH CASTLE. N.E. COAST OF NORTHUMBERLAND. SUN-RISE AFTER A SQUALLY NIGHT. *Oil on canvas, 35½ × 47½ in.* (*90 × 120·5 cm.*). *Exhibited at the Royal Academy* 1798. *National Gallery of Victoria, Melbourne.*

10. MORNING AMONGST THE CONISTON FELLS, CUMBERLAND. *Oil on canvas, 47 × 35 in.* (*119·5 × 89 cm.*). *Exhibited at the Royal Academy* 1798. *Turner Bequest, Tate Gallery, London* (461).

11. DOLBADERN CASTLE, NORTH WALES. *Oil on canvas, 47 × 35½ in.* (*119·5 × 90 cm.*). *Exhibited at the Royal Academy* 1800. *Royal Academy, London.*

12. ÆNEAS AND THE SIBYL. *Oil on canvas, 30 × 39 in.* (*76 × 99 cm.*). *Painted* circa 1798–1800. *Turner Bequest, Tate Gallery, London* (463).

13. CLAPHAM COMMON. *Oil on canvas, 12 × 17 in.* (*30·5 × 43 cm.*). *Painted* circa 1800–5. *Turner Bequest, Tate Gallery, London* (468).

14. THE FIFTH PLAGUE OF EGYPT. *Oil on canvas, 49 × 72 in.* (*124·5 × 183 cm.*). *Exhibited at*

the *Royal Academy* 1800. *John Herron Art Museum, Indianapolis, Indiana.*

15. DUTCH BOATS IN A GALE: FISHERMEN ENDEAVOURING TO PUT THEIR FISH ON BOARD. *Oil on canvas,* $64 \times 87\frac{1}{2}$ *in.* $(162 \cdot 5 \times 222 \cdot 5$ *cm.). Exhibited at the Royal Academy* 1801. *The Earl of Ellesmere, Mertoun, Roxburghshire.*

16. (*a*) EDINBURGH FROM ST. MARGARET'S LOCH. *Watercolour,* $5 \times 7\frac{3}{4}$ *in.* $(12 \cdot 5 \times 19 \cdot 5$ *cm.). Painted* 1801. *Turner Bequest, British Museum, London* (LV–10).
(*b*) NORTH-EAST VIEW OF THE GOTHIC ABBEY (SUN-SET) NOW BUILDING AT FONTHILL, THE SEAT OF W. BECKFORD, ESQ. *Watercolour,* $27 \times 40\frac{1}{2}$ *in.* $(68 \cdot 5 \times 103$ *cm.). Exhibited at the Royal Academy* 1800 (?). *The National Trust for Scotland, Brodick Castle, Isle of Arran.*

17. (*a*) GLACIER AT THE FOOT OF MONT BLANC. *Watercolour,* $12\frac{1}{4} \times 18\frac{1}{2}$ *in.* $(31 \times 47$ *cm.). Painted* 1802. *Turner Bequest, British Museum, London* (LXXV–21).
(*b*) LOCH LONG: MORNING. *Watercolour,* $13\frac{1}{2} \times 19\frac{1}{4}$ *in.* $(34 \cdot 5 \times 49$ *cm.). Painted* 1801. *Turner Bequest, British Museum, London* (LX–F).

18. SHIPS BEARING UP FOR ANCHORAGE. *Oil on canvas,* 47×71 *in.* $(119 \cdot 5 \times 180 \cdot 5$ *cm.). Exhibited at the Royal Academy* 1802. *National Trust, Petworth, Sussex (lent by H.M. Government).*

19. THE TENTH PLAGUE OF EGYPT. *Oil on canvas,* $57\frac{1}{2} \times 93\frac{1}{2}$ *in.* $(146 \times 237 \cdot 5$ *cm.). Exhibited at the Royal Academy* 1802. *Turner Bequest, Tate Gallery, London* (470).

20. CONWAY CASTLE. *Oil on canvas,* 41×55 *in.* $(104 \times 139 \cdot 5$ *cm.). Painted circa* 1802–3. *The Trustees of the Grosvenor Estates, London.*

21. CHATEAUX DE ST. MICHAEL, BONNEVILLE, SAVOY. *Oil on canvas,* $34\frac{1}{2} \times 47$ *in.* $(67 \cdot 5 \times 119 \cdot 5$ *cm.). Exhibited at the Royal Academy* 1803. *Sir Stephen Courtauld, Southern Rhodesia.*

22. THE FESTIVAL UPON THE OPENING OF THE VINTAGE AT MACON. *Oil on canvas,* 57×92 *in.* $(145 \times 233 \cdot 5$ *in.). Exhibited at the Royal Academy* 1803. *Graves Art Gallery, Sheffield.*

23. THE SHIPWRECK. *Oil on canvas,* $67\frac{1}{2} \times 95$ *in.* $(171 \cdot 5 \times 241 \cdot 5$ *cm.). Exhibited at Turner's Gallery* 1805. *Turner Bequest, Tate Gallery, London* (476).

24. VENUS AND ADONIS. *Oil on canvas,* 59×47 *in.* $(150 \times 119 \cdot 5$ *cm.). Painted circa* 1803–5. *Huntington Hartford, New York.*

25. (*a*) PARK SCENE, CHEVENING, KENT. *Oil* (?) *on sized paper,* $11 \times 14\frac{3}{4}$ *in.* $(28 \times 37 \cdot 5$ *cm.). Painted* 1806 (?). *Turner Bequest, British Museum, London* (XCVa–B).
(*b*) THE EAST FRONT OF WORCESTER COLLEGE, OXFORD. *Watercolour,* 12×17 *in.*

($32 \times 44 \cdot 5$ *cm.). Engraved* 1804. *Ashmolean Museum, Oxford.*

26. WINDSOR CASTLE FROM THE THAMES. *Oil on canvas,* 35×47 *in.* $(89 \times 119 \cdot 5$ *cm.). Painted circa* 1805. *National Trust, Petworth, Sussex (lent by H.M. Government).*

27. THE GODDESS OF DISCORD CHOOSING THE APPLE OF CONTENTION IN THE GARDEN OF THE HESPERIDES. *Oil on canvas,* $59\frac{1}{2} \times 84$ *in.* $(151 \times 213 \cdot 5$ *cm.). Exhibited at the British Institution* 1806. *Turner Bequest, Tate Gallery, London* (477).

28. SUN RISING THROUGH VAPOUR; FISHERMEN CLEANING AND SELLING FISH. *Oil on canvas,* $53 \times 70\frac{1}{2}$ *in.* $(134 \cdot 5 \times 179$ *cm.). Exhibited at the Royal Academy* 1807. *Turner Bequest, National Gallery, London* (479).

29. A COUNTRY BLACKSMITH DISPUTING UPON THE PRICE OF IRON, AND THE PRICE CHARGED TO THE BUTCHER FOR SHOEING HIS PONEY. *Oil on panel,* $22\frac{1}{2} \times 30\frac{1}{2}$ *in.* $(57 \times 77 \cdot 5$ *cm.). Exhibited at the Royal Academy* 1807. *Turner Bequest, Tate Gallery, London* (478).

30. FALL OF THE RHINE AT SCHAFFHAUSEN. *Oil on canvas,* $58\frac{1}{2} \times 94$ *in.* $(149 \times 239$ *cm.). Exhibited at the Royal Academy* 1806. *Museum of Fine Arts, Boston.*

31. THE BATTLE OF TRAFALGAR, AS SEEN FROM THE MIZEN STARBOARD SHROUDS OF THE VICTORY. *Oil on canvas,* $67\frac{1}{4} \times 94$ *in.* $(171 \times 238 \cdot 5$ *cm.). Exhibited at Turner's Gallery* 1806 (*unfinished*) *and at the Royal Academy* 1808. *Turner Bequest, Tate Gallery, London* (480).

32. (*a*) SCENE ON THE FRENCH (?) COAST (FOR THE 'LIBER STUDIORUM'). *Pen and sepia,* $7\frac{1}{4} \times 10\frac{1}{8}$ *in.* $(18 \cdot 5 \times 25 \cdot 5$ *cm.). Painted* 1806. *Turner Bequest, British Museum, London* (CXVI–C).
(*b*) TEMPLE OF MINERVA MEDICA (FOR THE 'LIBER STUDIORUM'). *Pen and sepia,* $8 \times 10\frac{3}{4}$ *in.* $(20 \cdot 5 \times 27 \cdot 5$ *cm.). Painted circa* 1807. *Turner Bequest, British Museum, London* (CXVII–A).

33. (*a*) SCENE ON THE THAMES WITH BARGES AND FIGURES. *Watercolour,* $10 \times 14\frac{1}{4}$ *in.* $(25 \cdot 5 \times 36 \cdot 5$ *cm.). Painted* 1807 (?). *Turner Bequest, British Museum, London* (XCV–49).
(*b*) BENSON (OR BENSINGTON) NEAR WALLINGFORD. *Watercolour,* $10 \times 14\frac{1}{4}$ *in.* $(25 \cdot 5 \times 36 \cdot 5$ *cm.). Painted* 1807 (?). *Turner Bequest, British Museum, London* (XCV–13).

34. TREE TOPS AND SKY. *Oil on veneer,* 11×29 *in.* $(28 \times 73 \cdot 5$ *cm.). Painted* 1807 (?). *Turner Bequest, Tate Gallery, London* (2309).

35. THE THAMES NEAR WALTON BRIDGES. *Oil on veneer,* 14×29 *in.* $(35 \times 73 \cdot 5$ *cm.). Painted* 1807 (?). *Turner Bequest, Tate Gallery, London* (2680).

36. HAMPTON COURT FROM THE THAMES. *Oil on canvas*, $33\frac{1}{2} \times 47$ *in.* (85×119.5 *cm.*). *Painted* circa 1807–8. *Turner Bequest, Tate Gallery, London* (2693).

37. ETON COLLEGE FROM THE RIVER. *Oil on canvas*, $23\frac{1}{2} \times 35\frac{1}{2}$ *in.* (59.5×90 *cm.*). *Exhibited at Turner's Gallery* 1808. *National Trust, Petworth, Sussex* (*lent by H.M. Government*).

38. MOUTH OF THE THAMES. *Oil on canvas*, $33\frac{1}{2} \times 45\frac{1}{2}$ *in.* (85×115.5 *cm.*). *Painted* circa 1807–8. *Turner Bequest, Tate Gallery, London* (2702).

39. TWO OF THE DANISH SHIPS WHICH WERE SEIZED AT COPENHAGEN ENTERING PORTSMOUTH HARBOUR *or* SPITHEAD: BOAT'S CREW RECOVERING AN ANCHOR. *Oil on canvas*, $67\frac{1}{2} \times 92$ *in.* (171.5×233.5 *cm.*). *Exhibited at Turner's Gallery* 1808 (*unfinished*) *and at the Royal Academy* 1809. *Turner Bequest, Tate Gallery, London* (481).

40. LONDON [FROM GREENWICH.] *Oil on canvas*, $34\frac{1}{2} \times 46\frac{1}{2}$ *in.* (87.5×118 *cm.*). *Exhibited at Turner's Gallery* 1809. *Turner Bequest, Tate Gallery, London* (483).

41. PLOUGHING UP TURNIPS, NEAR SLOUGH. [WINDSOR.] *Oil on canvas*, $40 \times 51\frac{1}{4}$ *in.* (102×130 *cm.*). *Exhibited at Turner's Gallery* 1809. *Turner Bequest, Tate Gallery, London* (486).

42. SKETCH OF A BANK WITH GIPSIES. *Oil on canvas*, 24×33 *in.* (61×84 *cm.*). *Exhibited at Turner's Gallery* 1809. *Turner Bequest, Tate Gallery, London* (467).

43. CALDER BRIDGE, CUMBERLAND. *Oil on canvas*, 36×48 *in.* (91.5×122 *cm.*). *Exhibited at Turner's Gallery* 1810. *Robert Emmons, Southampton*.

44. FISHING UPON THE BLYTHE-SAND, TIDE SETTING IN. *Oil on canvas*, 35×47 *in.* (89×119.5 *cm.*). *Exhibited at Turner's Gallery* 1809. *Turner Bequest, Tate Gallery, London* (496).

45. WRECK OF A TRANSPORT SHIP. *Oil on canvas*, 68×95 *in.* (172.5×241 *cm.*). *Painted* circa 1810. *Fundação Calouste Gulbenkian, Lisbon*.

46. PETWORTH, SUSSEX, THE SEAT OF THE EARL OF EGREMONT: DEWY MORNING. *Oil on canvas*, $35\frac{1}{2} \times 47\frac{1}{2}$ *in.* (90×120.5 *cm.*). *Dated* 1810. *Exhibited at the Royal Academy* 1810. *Lord Egremont, Petworth, Sussex*.

47. ABINGDON, MORNING. *Oil on canvas*, $39\frac{1}{2} \times 50\frac{1}{2}$ *in.* (100.5×128.5 *cm.*). *Exhibited at Turner's Gallery* 1810 (?) (*as* 'Dorchester Mead, Oxfordshire'). *Turner Bequest, Tate Gallery, London* (485).

48. THE FALL OF AN AVALANCHE IN THE GRISONS. *Oil on canvas*, $35\frac{1}{2} \times 47\frac{1}{2}$ *in.* (90×120.5 *cm.*). *Exhibited at Turner's Gallery* 1810. *Turner Bequest, Tate Gallery, London* (489).

49. SNOWSTORM: HANNIBAL AND HIS ARMY CROSSING THE ALPS. *Oil on canvas*, 57×93 *in.* (145×236 *cm.*). *Exhibited at the Royal Academy* 1812. *Turner Bequest, Tate Gallery, London* (490).

50. HULKS ON THE TAMAR. *Oil on canvas*, $35\frac{1}{2} \times 47\frac{1}{2}$ *in.* (90×120.5 *cm.*). *Exhibited at Turner's Gallery* 1812 (?) (*as* 'The River Plym'). *National Trust, Petworth, Sussex* (*lent by H.M. Government*).

51. FROSTY MORNING. *Oil on canvas*, $44\frac{1}{2} \times 68\frac{1}{2}$ *in.* (113×174 *cm.*). *Exhibited at the Royal Academy* 1813. *Turner Bequest, Tate Gallery, London* (492).

52. (*a*) ON THE WASHBURN, UNDER FOLLY HILL. *Watercolour*, $11 \times 15\frac{1}{2}$ *in.* (28×39.5 *cm.*). *Painted* circa 1810. *British Museum, London* (1910-2-12-287).
(*b*) LOCH FYNE. *Watercolour*, $11 \times 15\frac{1}{2}$ *in.* (28×39 *cm.*). *Dated* 1815. *British Museum, London* (1910-2-12-275).

53. (*a*) AN ABBEY NEAR COBLENZ. *Watercolour*, $7\frac{1}{2} \times 12\frac{1}{2}$ *in.* (19×32 *cm.*). *Painted* 1817. *British Museum* (1958-7-12-412).
(*b*) VALLEY OF THE WHARFE NEAR CALEY PARK. *Watercolour*, $13 \times 17\frac{1}{4}$ *in.* (33×44 *cm.*). *Painted* circa 1816–18. *Major Le G. G. W. Horton-Fawkes, Farnley Hall, Yorkshire*.

54. APULLIA IN SEARCH OF APPULLUS LEARNS FROM THE SWAIN THE CAUSE OF HIS METAMORPHOSIS. VIDE OVID. *Oil on canvas*, 57×93 *in.* (145×236 *cm.*). *Inscribed with title. Exhibited at the British Institution* 1814. *Turner Bequest, Tate Gallery, London* (495).

55. ENGLAND: RICHMOND HILL, ON THE PRINCE REGENT'S BIRTHDAY. *Oil on canvas*, 70×132 *in.* (178×335.5 *cm.*). *Exhibited at the Royal Academy* 1819. *Turner Bequest, Tate Gallery, London* (502).

56. DIDO BUILDING CARTHAGE; OR THE RISE OF THE CARTHAGINIAN EMPIRE—1ST BOOK OF VIRGIL'S ÆNEID. *Oil on canvas*, $61\frac{1}{4} \times 91\frac{1}{4}$ *in.* (155.5×232 *cm.*). *Exhibited at the Royal Academy* 1815. *Turner Bequest, National Gallery, London* (498).

57. VIEW OF THE TEMPLE OF JUPITER PANELLENIUS, IN THE ISLAND OF ÆGINA, WITH THE GREEK NATIONAL DANCE OF THE ROMAIKA: THE ACROPOLIS OF ATHENS IN THE DISTANCE. PAINTED FROM A SKETCH TAKEN BY H. GALLY KNIGHT, ESQ. IN 1810. *Oil on canvas*, $46\frac{1}{4} \times 70$ *in.* (117.5×178 *cm.*). *Dated* 1814. *Exhibited at the Royal Academy* 1816. *The Dowager Duchess of Northumberland, Albury Park, Guildford*.

58. RABY CASTLE, THE SEAT OF THE EARL OF DARLINGTON. *Oil on canvas*, $46\frac{3}{4} \times 71$ *in.* (119×180.5 *cm.*). *Exhibited at the Royal Academy* 1818. *Walters Art Gallery, Baltimore*.

59. DORT OR DORDRECHT: THE DORT PACKET-BOAT FROM ROTTERDAM BECALMED. *Oil on*

canvas, 62×92 in. (157·5×233·5 cm.). *Painted 1817–18. Exhibited at the Royal Academy 1818. Major Le G. G. W. Horton-Fawkes, Farnley Hall, Yorkshire.*

60. (a) ON LAKE COMO. *Watercolour,* 8¾×11¼ *in.* (22·5×29 cm.). *Painted 1819. Turner Bequest, British Museum, London* (CLXXXI–1).
(b) MONTE GENNARO, NEAR ROME. *Watercolour,* 10×16 *in.* (25·5×40·5 cm.). *Painted 1819. Turner Bequest, British Museum, London* (CLXXXVII–41).

61. (a) VESUVIUS IN ERUPTION. *Watercolour,* 5×7 *in.* (12·5×17·5 cm.). *Painted 1819. Miss Armide Oppé and Mr D. L. T. Oppé, London.*
(b) THE NYMPHÆUM OF ALEXANDER SEVERUS. *Watercolour,* 9×14½ *in.* (23×37 cm.). *Painted 1819. Turner Bequest, British Museum, London* (CLXXXIX–35).

62. ROME, FROM THE VATICAN. RAFFAELLE, ACCOMPANIED BY LA FORNARINA, PREPARING HIS PICTURES FOR THE DECORATION OF THE LOGGIA. *Oil on canvas,* 69½×131 *in.* (176·5×333 cm.). *Exhibited at the Royal Academy 1820. Turner Bequest, Tate Gallery, London* (503).

63. FORUM ROMANUM, FOR MR SOANE'S MUSEUM. [ARCH OF TITUS.] *Oil on canvas,* 57¼×93½ *in.* (145·5×237·5 cm.). *Exhibited at the Royal Academy 1826. Turner Bequest, Tate Gallery, London* (504).

64. THE BAY OF BAIÆ, WITH APOLLO AND THE SIBYL. *Oil on canvas,* 57½×93½ *in.* (146×237·5 cm.). *Exhibited at the Royal Academy 1823. Turner Bequest, Tate Gallery, London* (505).

65. GEORGE IV AT A BANQUET IN EDINBURGH. *Oil on panel,* 26¼×36½ *in.* (66×90 cm.). *Painted 1822. Turner Bequest, Tate Gallery, London* (2858).

66. THE SEAT OF WILLIAM MOFFAT, ESQ., AT MORTLAKE. EARLY (SUMMER'S) MORNING. *Oil on canvas,* 35×47½ *in.* (89×120·5 cm.). *Exhibited at the Royal Academy 1826. Frick Collection, New York.*

67. PORT RUYSDAEL. *Oil on canvas,* 36¼×48¼ *in.* (92×122·5 cm.). *Exhibited at the Royal Academy 1827. Mr and Mrs Paul Mellon, Upperville, Virginia.*

68. (a) NEWCASTLE. *Body colour,* 6×8½ *in.* (15×22 cm.). *Painted and engraved 1823. Turner Bequest, British Museum, London* (CCVIII–K).
(b) RICHMOND BRIDGE — PLAY. *Watercolour,* 11¼×17¼ *in.* (28·5×44 cm.). *Engraved 1832. British Museum, London* (1958–7–12–435).

69. (a) TOWN FROM THE RIVER, CASTLE BEYOND. *Body colour on blue paper,* 5½×7½ *in.* (14×19 cm.). *Painted circa 1826. Turner Bequest, British Museum, London* (CCXXI–U).
(b) SCENE ON THE LOIRE. *Body colour on*

grey paper, 5½×7½ *in.* (14×19 cm.). *Painted circa 1826* (?); *engraved 1833. Ashmolean Museum, Oxford.*

70. YACHT RACING IN THE SOLENT — II. *Oil on canvas,* 18×24 *in.* (45·5×61 cm.). *Painted 1827. Turner Bequest, Tate Gallery, London* (1994).

71. EAST COWES CASTLE, THE SEAT OF J. NASH, ESQ.; THE REGATTA BEATING TO WINDWARD. *Oil on canvas* 36¼×48 *in.* (92×122 cm.). *Exhibited at the Royal Academy 1828. Mr and Mrs Nicholas H. Noyes, Indianapolis.*

72. HILL TOWN ON EDGE OF PLAIN. *Oil on linen on millboard,* 16¼×23½ *in.* (41×60 cm.). *Painted 1828* (?). *Turner Bequest, Tate Gallery, London* (5526).

73. RIVER WITH TREES. *Oil on millboard,* 16¼×23½ *in.* (41·5×59·5 cm.). *Painted 1828* (?). *Turner Bequest, Tate Gallery, London* (5525).

74. CARTHAGINIAN SUBJECT. *Oil on canvas,* 23½×36 *in.* (59·5×91·5 cm.). *Painted 1828* (?). *Turner Bequest, Tate Gallery, London* (3382).

75. ITALIAN HILL TOWN, PROBABLY TIVOLI. *Oil on canvas,* 23¾×30⅜ *in.* (60·5×77 cm.). *Painted 1828* (?). *Turner Bequest, Tate Gallery, London* (3388).

76. ROCKY BAY WITH FIGURES. *Oil on canvas,* 35½×48½ *in.* (90×123 cm.). *Painted circa 1828–30. Turner Bequest, Tate Gallery, London* (1989).

77. ULYSSES DERIDING POLYPHEMUS — HOMER'S ODYSSEY. *Oil on canvas,* 52¼×80½ *in.* (132·5×203·5 cm.). *Exhibited at the Royal Academy 1829. Turner Bequest, National Gallery, London* (508).

78. WHAT YOU WILL! *Oil on canvas,* 19×20½ *in.* (48×52 cm.). *Exhibited at the Royal Academy 1822. Private collection, Great Britain.*

79. JESSICA. *Oil on canvas,* 47×35 *in.* (119·5×89 cm.). *Painted 1828. Exhibited at the Royal Academy 1830. National Trust, Petworth, Sussex* (lent by H.M. Government).

80. THE LORETTO NECKLACE. *Oil on canvas,* 52×69 *in.* (132×175·5 cm.). *Painted and exhibited at the Royal Academy 1829. Turner Bequest, Tate Gallery, London* (509).

81. WATTEAU STUDY BY FRESNOY'S RULES. *Oil on panel,* 15½×27½ *in.* (39·5×70 cm.). *Exhibited at the Royal Academy 1831. Turner Bequest, Tate Gallery, London* (514).

82. THE EVENING STAR. *Oil on canvas,* 36¼×48¼ *in.* (92·5×123 cm.). *Painted circa 1830. Turner Bequest, National Gallery, London* (1991).

83. CALAIS SANDS, LOW WATER, POISSARDS COLLECTING BAIT. *Oil on canvas,* 28½×42 *in.* (72·5×106·5 cm.). *Exhibited at the Royal Academy 1830. Bury Art Gallery, Lancashire.*

84. THE CHAIN PIER, BRIGHTON. *Oil on canvas,* $27\frac{1}{4} \times 53\frac{1}{4}$ *in.* $(69 \times 133.5$ *cm.). Painted* circa 1830–1. *Turner Bequest, Tate Gallery, London* (2064).

85. THE CHAIN PIER, BRIGHTON, *Oil on canvas,* 25×52 *in.* $(63.5 \times 132$ *cm.). Painted* circa 1830–1. *National Trust, Petworth, Sussex* (*lent by H.M. Government*).

86. CHICHESTER CANAL. *Oil on canvas,* $25\frac{3}{4} \times 53$ *in.* $(65.5 \times 134.5$ *cm.). Painted* circa 1830–1. *Turner Bequest, Tate Gallery, London* (560).

87. THE LAKE, PETWORTH: SUNSET, FIGHTING BUCKS. *Oil on canvas,* $24\frac{1}{4} \times 57\frac{1}{2}$ *in.* $(61.5 \times 146$ *cm.). Painted* circa 1830–1. *National Trust, Petworth, Sussex* (*lent by H.M. Government*).

88. A SHIP AGROUND. *Oil on canvas,* $27\frac{1}{4} \times 53\frac{1}{4}$ *in.* $(69 \times 135.5$ *cm.). Painted* circa 1830–1. *Turner Bequest, Tate Gallery, London* (2065).

89. WOMAN RECLINING ON A COUCH. *Oil on canvas,* $68\frac{3}{4} \times 98$ *in.* $(174.5 \times 249$ *cm.). Painted* circa 1830–1. *Turner Bequest, Tate Gallery, London* (5498).

90. (*a*) EVENING, PETWORTH PARK. *Body colour on blue paper,* $5\frac{1}{2} \times 7\frac{1}{2}$ *in.* $(14 \times 19$ *cm.). Painted* circa 1830–1. *Turner Bequest, British Museum, London* (CCXLIV–1).
(*b*) PETWORTH CHURCH AND TOWN FROM THE EAST. *Body colour on blue paper,* $5\frac{1}{2} \times 7\frac{1}{2}$ *in.* $(14 \times 19$ *cm.). Painted* circa 1830–1. *Turner Bequest, British Museum, London* (CCXLIV–5).

91. (*a*) THE ARTIST AND HIS ADMIRERS IN THE OLD LIBRARY, PETWORTH. *Body colour on blue paper,* $5\frac{1}{2} \times 7\frac{1}{2}$ *in.* $(14 \times 19$ *cm.). Painted* circa 1830–1. *Turner Bequest, British Museum, London* (CCXLIV–102).
(*b*) THE PICTURE GALLERY AT PETWORTH HOUSE. *Body colour on blue paper,* $5\frac{1}{2} \times 7\frac{1}{2}$ *in.* $(14 \times 19$ *cm.). Painted* circa 1830–1. *Turner Bequest, British Museum, London* (CCXLIV–13).

92. MUSIC AT PETWORTH. *Oil on canvas,* $48 \times 35\frac{1}{2}$ *in.* $(121.5 \times 90$ *cm.). Painted* circa 1833. *Turner Bequest, Tate Gallery, London* (3550).

93. THE LETTER. *Oil on canvas,* $48 \times 35\frac{3}{4}$ *in.* $(121.5 \times 91$ *cm.). Painted* circa 1835. *Turner Bequest, Tate Gallery, London* (5501).

94. VAN TROMP'S SHALLOP, AT THE ENTRANCE OF THE SCHELDT. *Oil on canvas,* 35×47 *in.* $(89 \times 119.5$ *cm.). Exhibited at the Royal Academy 1832. Wadsworth Atheneum, Hartford, Connecticut.*

95. BRIDGE OF SIGHS, DUCAL PALACE AND CUSTOM-HOUSE, VENICE: CANALETTI PAINTING. *Oil on panel,* 20×32 *in.* $(51 \times 81.5$ *cm.). Exhibited at the Royal Academy 1833. Tate Gallery, London* (370).

96. A ROUGH SEA. *Oil on canvas,* $36 \times 48\frac{1}{4}$ *in.* $(91.5 \times 122.5$ *cm.). Painted* circa 1830–2.

Turner Bequest, Tate Gallery, London (1980).

97. MOUTH OF THE SEINE, QUILLE-BOEUF. THIS ESTUARY IS SO DANGEROUS FROM ITS QUICKSANDS, THAT ANY VESSEL TAKING THE GROUND IS LIABLE TO BE SANDED AND OVERWHELMED BY THE RISING TIDE, WHICH RUSHES IN IN ONE WAVE. *Oil on canvas,* $36 \times 48\frac{1}{4}$ *in.* $(91.5 \times 123$ *cm.). Exhibited at the Royal Academy 1833. Fundação Calouste Gulbenkian, Lisbon.*

98. VENICE: [THE DOGANA AND S. GIOVANNI MAGGIORE]. *Oil on canvas,* 36×48 *in.* $(91.5 \times 122$ *cm.). Exhibited at the Royal Academy 1834* (?). *National Gallery of Art, Washington.*

99. KEELMAN HEAVING IN COALS BY NIGHT. *Oil on canvas,* $36\frac{1}{4} \times 48\frac{1}{4}$ *in.* $(92 \times 122.5$ *cm.). Exhibited at the Royal Academy 1835. National Gallery of Art, Washington.*

100. (*a*) ENTRANCE TO THE GRAND CANAL. *Chalks and watercolour on grey paper,* $7\frac{1}{2} \times 10\frac{3}{4}$ *in.* $(19 \times 17.5$ *cm.). Painted 1835. Turner Bequest, British Museum, London* (CCCXVII –5).
(*b*) INTERIOR OF A WINE SHOP, VENICE. *Body colour on brown paper,* $9\frac{1}{2} \times 12$ *in.* $(24 \times 30.5$ *cm.). Painted 1835. Turner Bequest, British Museum, London* (CCCXVIII–21).

101. (*a*) STORM AT SUNSET, VENICE. *Watercolour,* $8\frac{1}{2} \times 12\frac{1}{2}$ *in.* $(21.5 \times 32$ *cm.). Painted 1835. Fitzwilliam Museum, Cambridge, England.*
(*b*) STORM IN THE PIAZZETTA. *Body colour on brown paper,* $8\frac{1}{2} \times 12\frac{1}{2}$ *in.* $(21.5 \times 32$ *cm.). Painted 1835. National Gallery of Scotland, Edinburgh.*

102. JULIET AND HER NURSE. *Oil on canvas,* $35 \times 47\frac{1}{2}$ *in.* $(89 \times 120.5$ *cm.). Exhibited at the Royal Academy 1836. Mrs Flora Whitney Miller, New York.*

103. SNOW-STORM, AVALANCHE, AND INUNDATION — A SCENE IN THE UPPER PART OF VAL D'AOUT, PIEDMONT. *Oil on canvas,* $36\frac{1}{4} \times 48$ *in.* $(92 \times 122$ *cm.). Exhibited at the Royal Academy 1837. Art Institute of Chicago.*

104. (*a*) RAINBOW. *Watercolour,* $11\frac{1}{2} \times 17\frac{1}{4}$ *in.* $(29 \times 44$ *cm.). Painted* circa 1835–40. *Turner Bequest, British Museum, London* (CCCLXV–12).
(*b*) PAESTUM IN A STORM. *Watercolour,* $8\frac{1}{2} \times 12$ *in.* $(21.5 \times 30.5$ *cm.). Painted* circa 1825–35. *Turner Bequest, British Museum, London* (CCCLXIV–224).

105. PHRYNE GOING TO THE PUBLIC BATH AS VENUS — DEMOSTHENES TAUNTED BY ÆSCHINES. *Oil on canvas,* 76×65 *in.* $(193 \times 165$ *cm.). Exhibited at the Royal Academy 1838. Turner Bequest, Tate Gallery, London* (522).

106. HEIDELBERG CASTLE IN OLDEN TIME. *Oil on canvas,* $52 \times 79\frac{1}{4}$ *in.* $(132 \times 201$ *cm.). Painted*

93

circa 1835–40. *Turner Bequest, Tate Gallery, London* (518).

107. CICERO AT HIS VILLA. *Oil on canvas, $35\frac{1}{2} \times 47\frac{1}{2}$ in. (90×120.5 cm.). Exhibited at the Royal Academy 1839. Evelyn de Rothschild, Ascott, Buckinghamshire.*

108. THE FIGHTING 'TEMERAIRE' TUGGED TO HER LAST BERTH TO BE BROKEN UP, 1838. *Oil on canvas, $35\frac{3}{4} \times 48$ in. (91×122 cm.). Exhibited at the Royal Academy 1839. Turner Bequest, National Gallery, London* (524).

109. SLAVERS THROWING OVERBOARD THE DEAD AND DYING — TYPHON COMING ON [THE SLAVE SHIP]. *Oil on canvas, $35\frac{3}{4} \times 48$ in. (91×122 cm.). Exhibited at the Royal Academy 1840. Museum of Fine Arts, Boston.*

110. BRIDGE AND TOWER. *Oil on canvas, 36×48 in. (91.5×122 cm.). Painted circa 1835–40. Turner Bequest, Tate Gallery, London* (2424).

111. THE ARCH OF CONSTANTINE, ROME. *Oil on canvas, $35\frac{1}{4} \times 47\frac{1}{4}$ in. (89.5×120 cm.). Painted circa 1840. Turner Bequest, Tate Gallery, London* (2066).

112. WAVES BREAKING ON A LEE SHORE. *Oil on canvas, $23\frac{1}{2} \times 37\frac{1}{4}$ in. (59.5×95 cm.). Painted circa 1840. Turner Bequest, Tate Gallery, London* (2882).

113. ROCKETS AND BLUE LIGHTS (CLOSE AT HAND) TO WARN STEAM-BOATS OF SHOAL WATER. *Oil on canvas, 35×48 in. (89×102 cm.). Exhibited at the Royal Academy 1840. Clark Institute, Williamstown, Massachusetts.*

114. (*a*) VENICE: ON THE GRAND CANAL. *Watercolour, $8\frac{3}{4} \times 12\frac{1}{2}$ in. (22×32 cm.). Painted 1840. Turner Bequest, British Museum, London* (CCCXV–21).
(*b*) APPROACH TO VENICE: SUNSET. *Watercolour, $9 \times 12\frac{1}{2}$ in. (23×32 cm.). Painted 1840. Turner Bequest, British Museum, London* (CCCXVI–16).

115. (*a*) RHEINFELDEN. *Watercolour, $9 \times 12\frac{3}{4}$ in. (23×32.5 cm.). Painted 1844. Turner Bequest, British Museum, London* (CCCXLIX–28).
(*b*) SCHAFFHAUSEN: MOONLIGHT. *Watercolour, $9 \times 11\frac{1}{4}$ in. (23×28.5 cm.). Dated 1841. National Gallery of Scotland, Edinburgh.*

116. CAMPO SANTO, VENICE. *Oil on canvas, $24\frac{1}{2} \times 36\frac{1}{2}$ in. (62.5×92.5 cm.). Exhibited at the Royal Academy 1842. Toledo Museum of Art, Ohio.*

117. THE SUN OF VENICE GOING TO SEA. *Oil on canvas, $24\frac{1}{2} \times 36\frac{1}{2}$ in. (62×93 cm.). Exhibited at the Royal Academy 1843. Turner Bequest, Tate Gallery, London* (535).

118. YACHT APPROACHING THE COAST. *Oil on canvas, $40\frac{1}{2} \times 56$ in. (103×142 cm.). Painted circa 1840–5. Turner Bequest, Tate Gallery, London* (4662).

119. PROCESSION OF BOATS WITH DISTANT SMOKE, VENICE (?). *Oil on canvas, $35\frac{1}{4} \times 47\frac{1}{4}$ in. (89.5×120 cm.). Painted circa 1842–3. Turner Bequest, Tate Gallery, London* (2068).

120. PEACE — BURIAL AT SEA. *Oil on canvas, $34\frac{3}{4} \times 34\frac{3}{4}$ in. (88×88 cm.). Exhibited at the Royal Academy 1842. Turner Bequest, Tate Gallery, London* (528).

121. SHADE AND DARKNESS — THE EVENING OF THE DELUGE. *Oil on canvas, $30\frac{1}{2} \times 30\frac{1}{2}$ in. (77.5×77.5 cm.). Exhibited at the Royal Academy 1843. Turner Bequest, Tate Gallery, London* (531).

122. RAIN, STEAM, AND SPEED — THE GREAT WESTERN RAILWAY. *Oil on canvas, $35\frac{3}{4} \times 48$ in. (91×122 cm.). Exhibited at the Royal Academy 1844. Turner Bequest, National Gallery, London* (538).

123. VAN TROMP, GOING ABOUT TO PLEASE HIS MASTERS, SHIPS A SEA, GETTING A GOOD WETTING—VIDE LIVES OF DUTCH PAINTERS. *Oil on canvas, 36×48 in. (91.5×122 cm.). Exhibited at the Royal Academy 1844. Royal Holloway College, Englefield Green, Surrey.*

124. NORHAM CASTLE. *Oil on canvas, 36×48 in. (91.5×122 cm.). Painted circa 1840–5. Turner Bequest, Tate Gallery, London* (1981).

125. 'HURRAH! FOR THE WHALER EREBUS! ANOTHER FISH!' — BEALE'S VOYAGE. *Oil on canvas, 36×48 in. (91.5×122 cm.). Exhibited at the Royal Academy 1846. Turner Bequest, Tate Gallery, London* (546).

126. THE WRECK BUOY. *Oil on canvas, $36\frac{1}{2} \times 48\frac{1}{2}$ in. (92.5×123 cm.). Originally painted circa 1809; repainted and exhibited at the Royal Academy 1849. Walker Art Gallery, Liverpool.*

127. THE VISIT TO THE TOMB. *Oil on canvas, 36×48 in. (91.5×122 cm.). Exhibited at the Royal Academy 1850. Turner Bequest, Tate Gallery, London* (555).

128. THE ANGEL STANDING IN THE SUN. *Oil on canvas, $30\frac{1}{2} \times 30\frac{1}{2}$ in. (77.5×77.5 cm.). Exhibited at the Royal Academy 1846. Turner Bequest, Tate Gallery, London* (550).

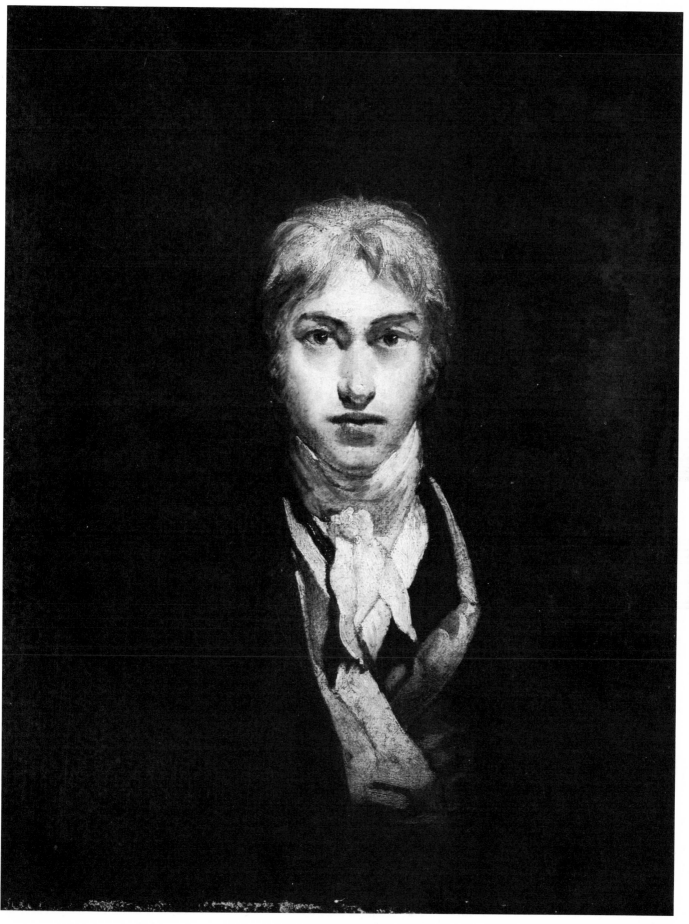

1. SELF-PORTRAIT.
29 × 23 *in. Painted* circa 1798. *Tate Gallery.*

2. (*a*) THE AVON NEAR WALLIS'S WALL, BRISTOL.
Ink and watercolour, $9\frac{1}{2} \times 11\frac{1}{2}$ in. Painted 1791. British Museum.

2. (*b*) OLD LONDON BRIDGE.
Watercolour, $10\frac{1}{4} \times 14\frac{1}{4}$ in. Painted circa 1796–7. British Museum.

3. (*a*) THE WESTERN TOWER, ELY CATHEDRAL.
Pencil and watercolour, 8¼ × 11 in. Painted 1794. British Museum.

3. (*b*) WELSH VALLEY.
Watercolour, 9 × 13 in. Painted 1798. British Museum.

4. (b) WATERFALL NEAR BETTWS-Y-COED.
Watercolour, 13 × 9 in. Painted 1798. British Museum.

4. (a) TOM TOWER, CHRIST CHURCH, OXFORD.
Watercolour, $10\frac{3}{4} \times 8\frac{1}{2}$ in. Painted circa 1793. British Museum.

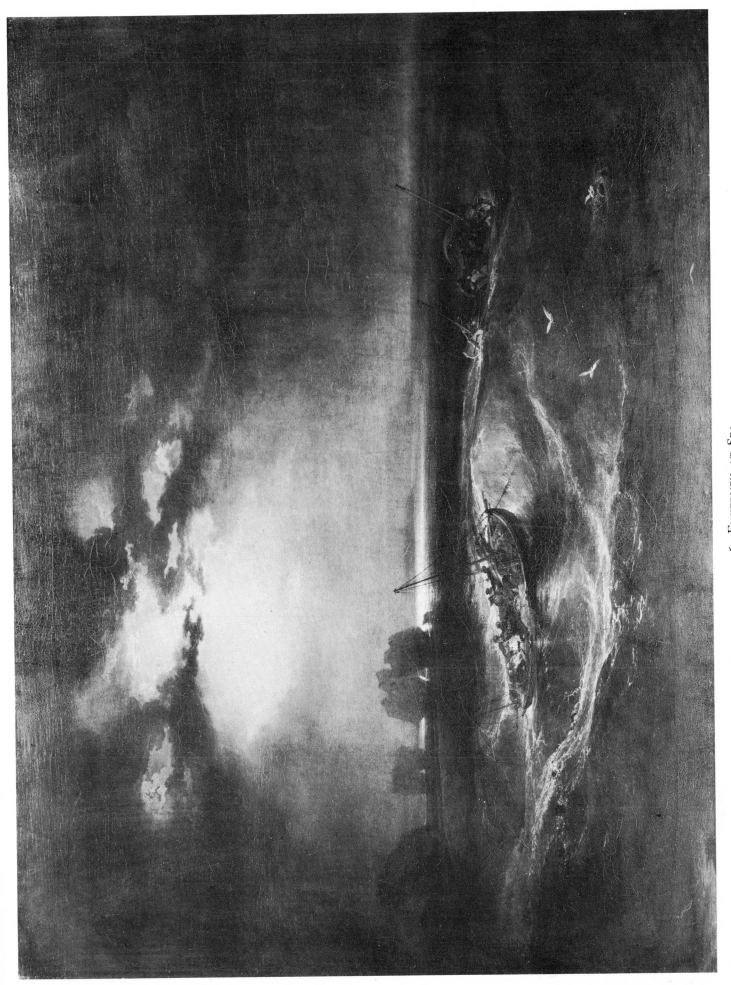

5. FISHERMEN AT SEA.

36 × 48 in. Exhibited 1796. F. W. A. Fairfax-Cholmeley (on loan to Tate Gallery).

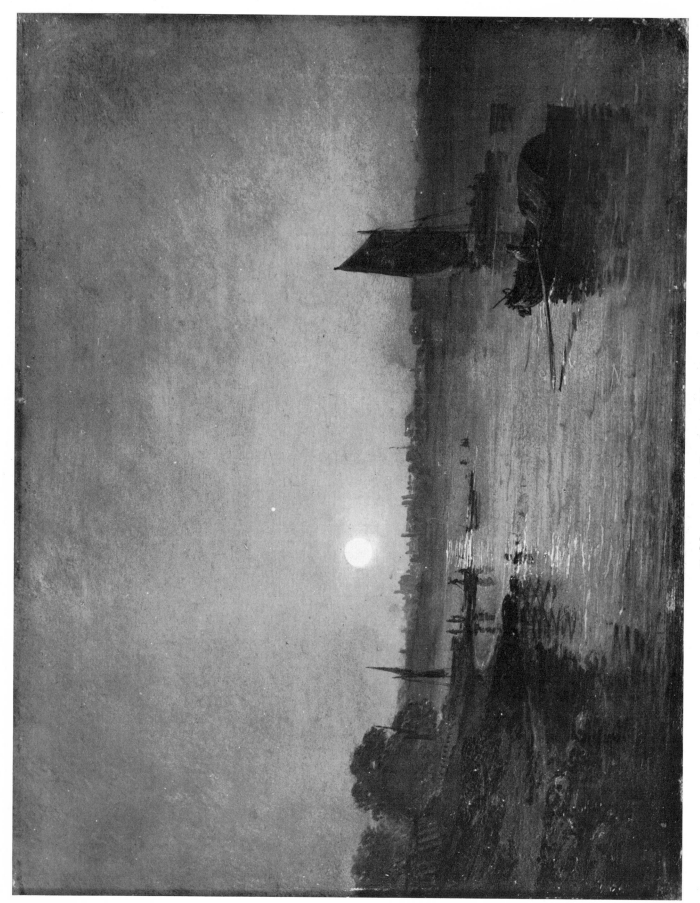

6. Moonlight, a Study at Millbank.
$11\frac{1}{2} \times 15\frac{1}{2}$ in. *Exhibited 1797. Tate Gallery.*

7. Buttermere Lake with Part of Cromack-water, Cumberland, a Shower. 35×47 in. Exhibited 1798. Tate Gallery.

8. MOUNTAIN SCENE, WALES.
17 × 21 in. *Painted circa 1798. Tate Gallery.*

9. Dunstanburgh Castle. Sun-rise after a Squally Night.
35½ × 47½ in. Exhibited 1798. *National Gallery of Victoria, Melbourne.*

10. Morning amongst the Coniston Fells.
47 × 35 *in. Exhibited* 1798. *Tate Gallery.*

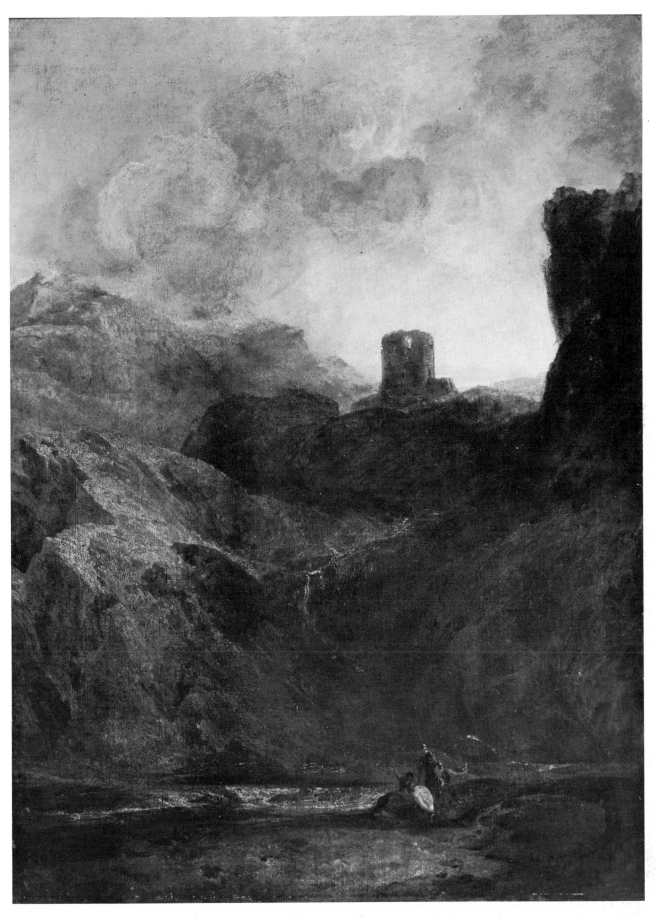

11. Dolbadern Castle.
47 × 35½ in. Exhibited 1800. Royal Academy, London.

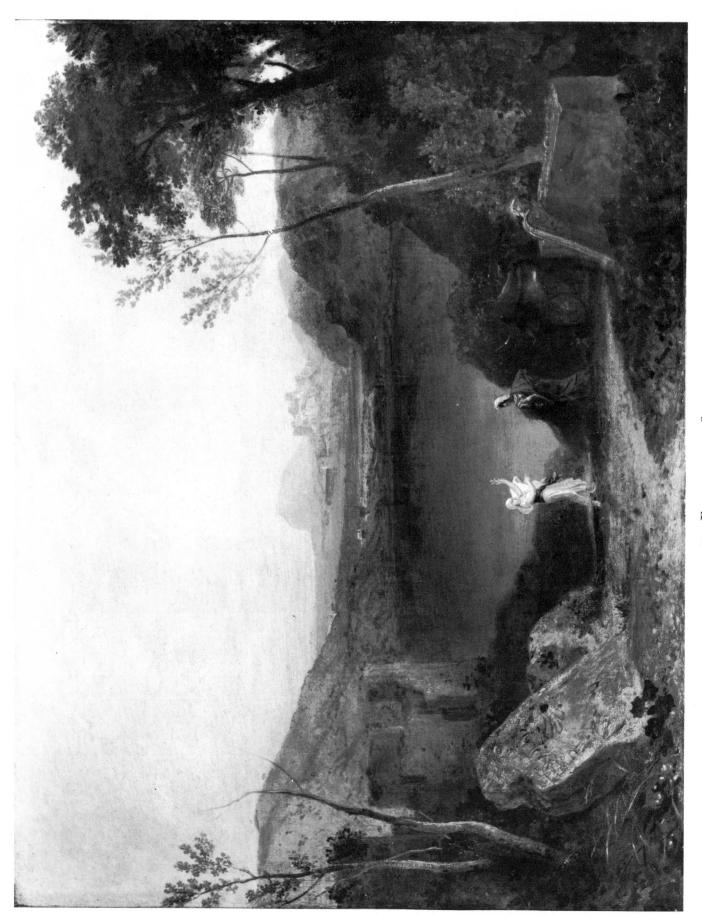

12. ÆNEAS AND THE SIBYL.

30 × 39 in. *Painted circa 1798–1800. Tate Gallery.*

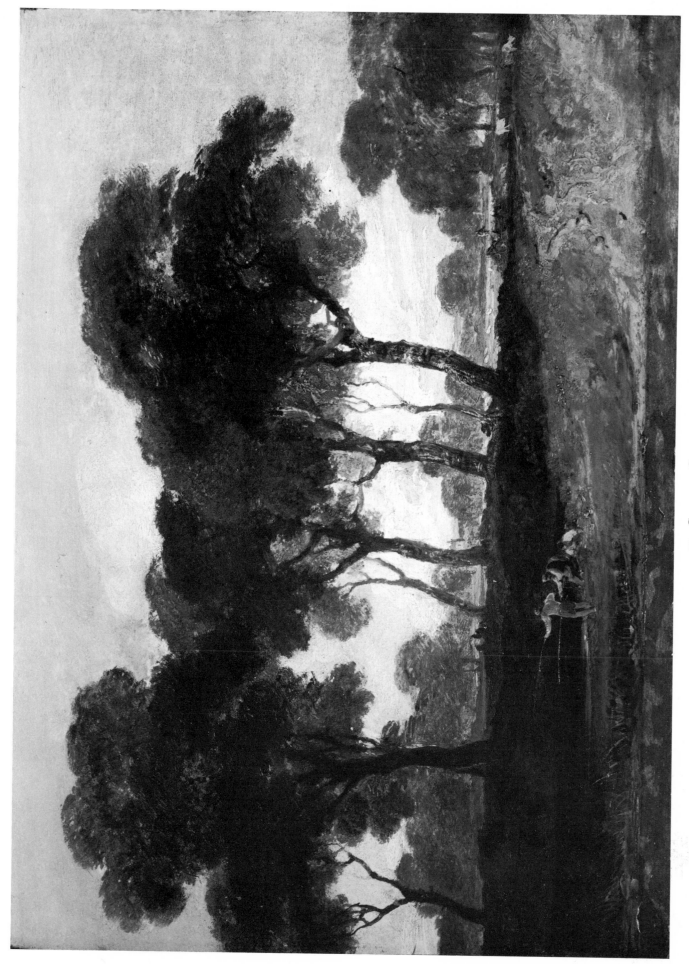

13. CLAPHAM COMMON.
12×17 in. *Painted circa 1800–5. Tate Gallery.*

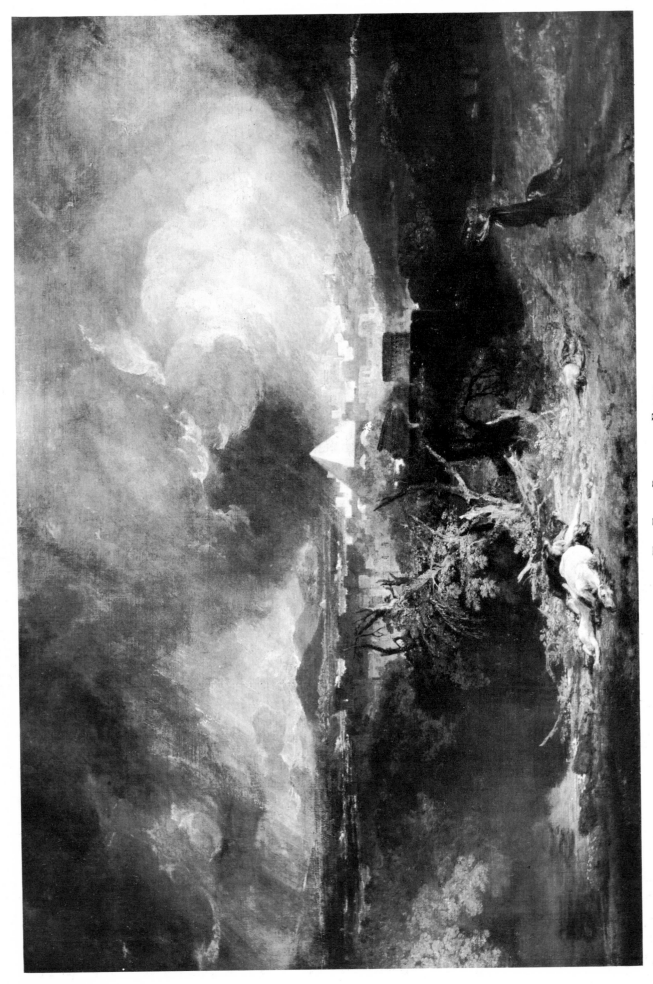

14. The Fifth Plague of Egypt.

49×72 in. Exhibited 1800. John Herron Art Museum, Indianapolis, Indiana.

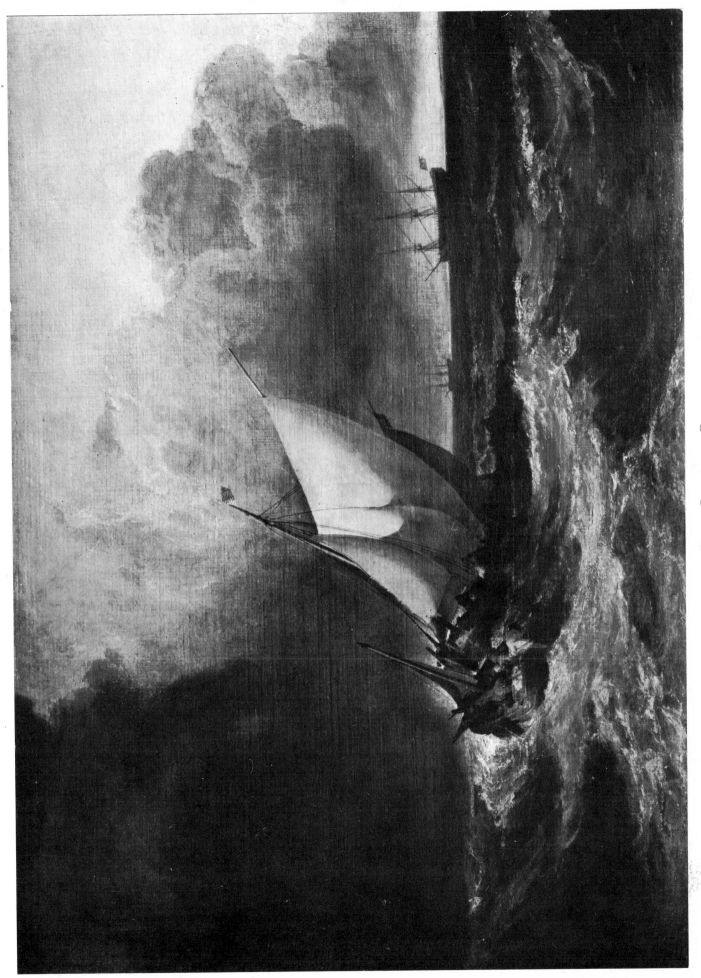

15. DUTCH BOATS IN A GALE.

64 × 87½ in. Exhibited 1801. The Earl of Ellesmere, Mertoun, Roxburghshire.

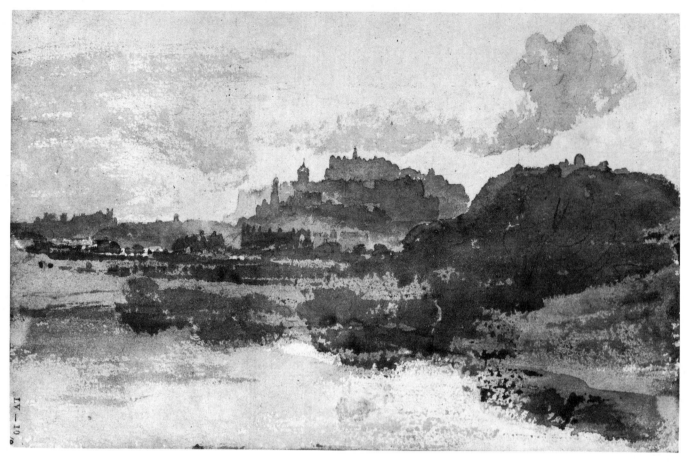

16. (*a*) EDINBURGH FROM ST. MARGARET'S LOCH.
Watercolour, 5 × 7¾ in. Painted 1801. British Museum.

16. (*b*) NORTH-EAST VIEW OF THE GOTHIC ABBEY (SUN-SET) AT FONTHILL.
Watercolour, 27 × 40½ in. Exhibited 1800 (?). National Trust for Scotland, Brodick Castle, Isle of Arran.

17. (*a*) Glacier at the Foot of Mont Blanc.
Watercolour, $12\frac{1}{4} \times 18\frac{1}{2}$ in. Painted 1802. British Museum.

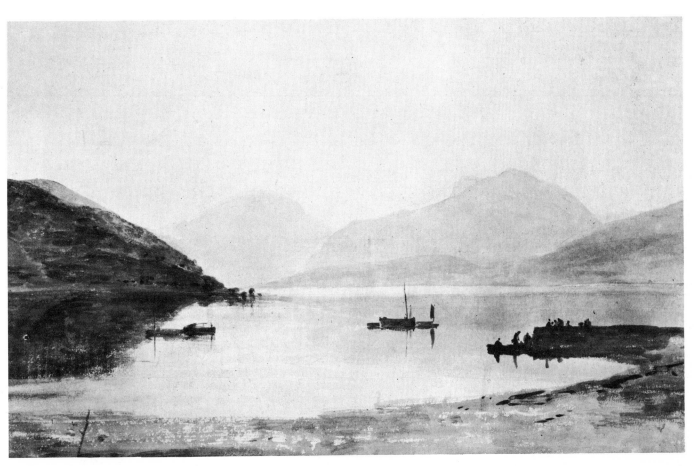

17. (*b*) Loch Long: Morning.
Watercolour, $13\frac{1}{2} \times 19\frac{1}{4}$ in. Painted 1801. British Museum.

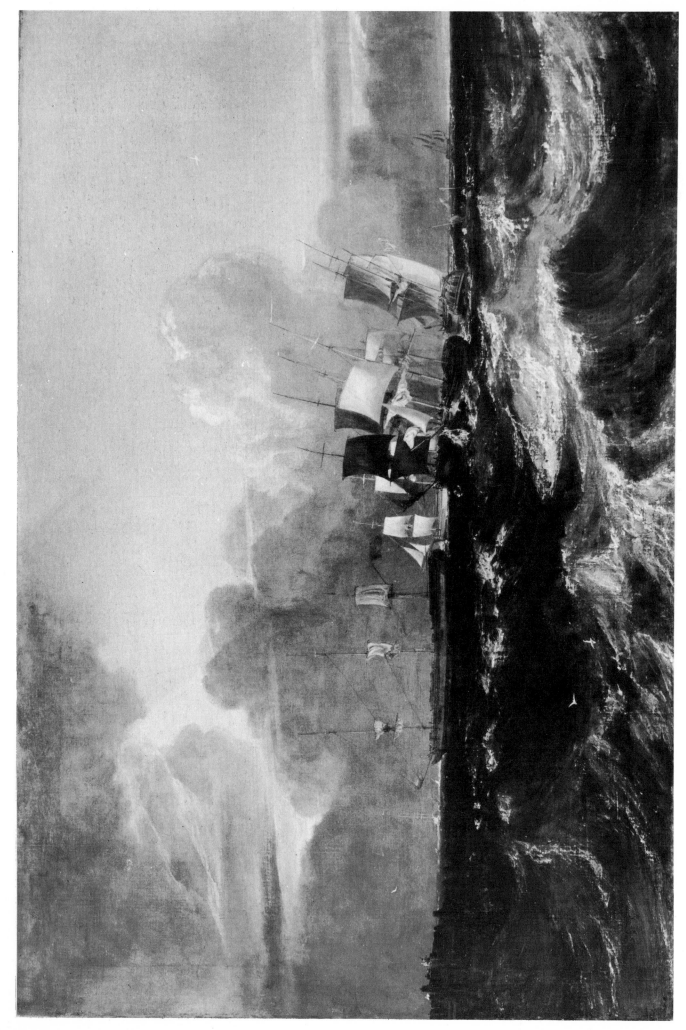

18. Ships Bearing up for Anchorage.

47×71 in. Exhibited 1802. National Trust, Petworth, Sussex (lent by H.M. Government).

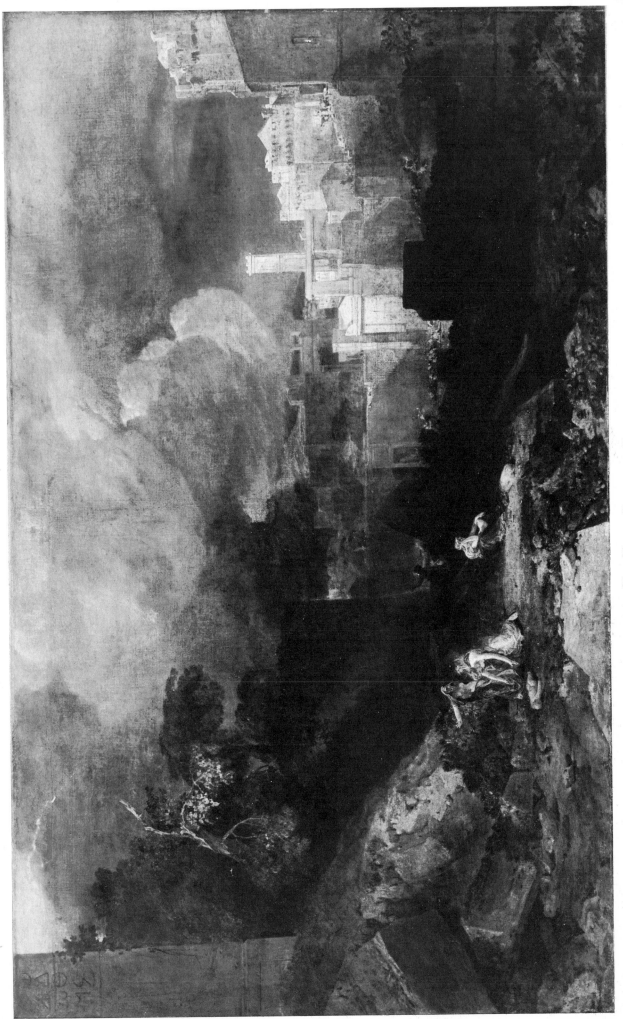

19. THE TENTH PLAGUE OF EGYPT.
57½×93½in. *Exhibited 1802. Tate Gallery.*

20. CONWAY CASTLE.

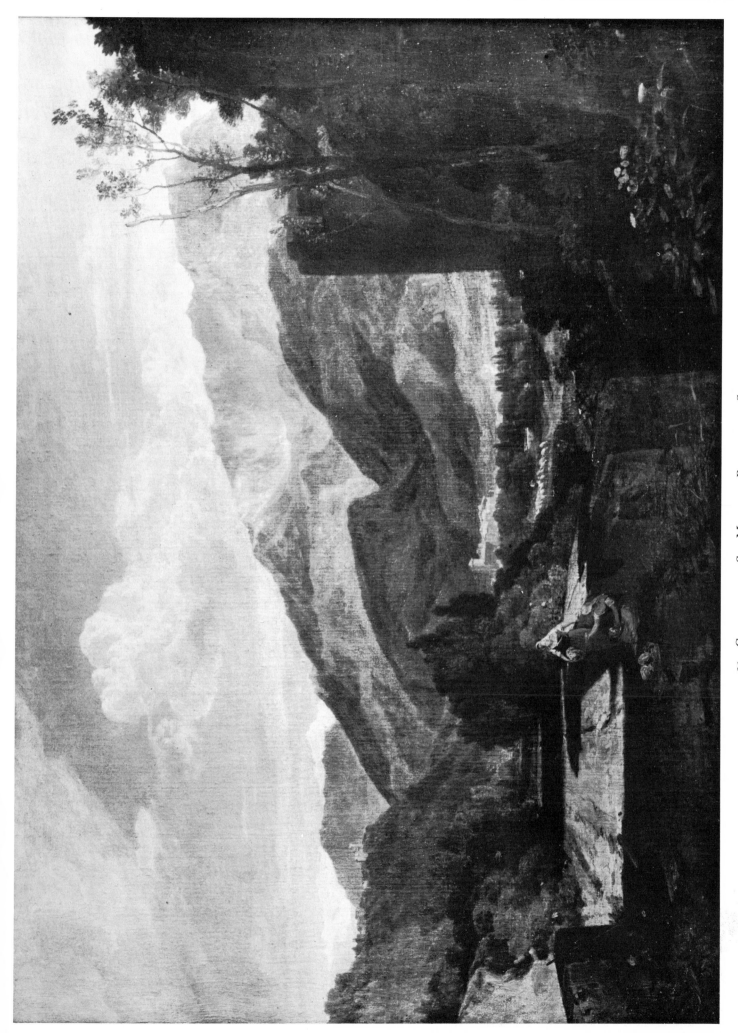

21. CHATEAUX DE ST. MICHAEL, BONNEVILLE, SAVOY.
$34\frac{1}{2} \times 47$ in. Exhibited 1803. Sir Stephen Courtauld, Southern Rhodesia.

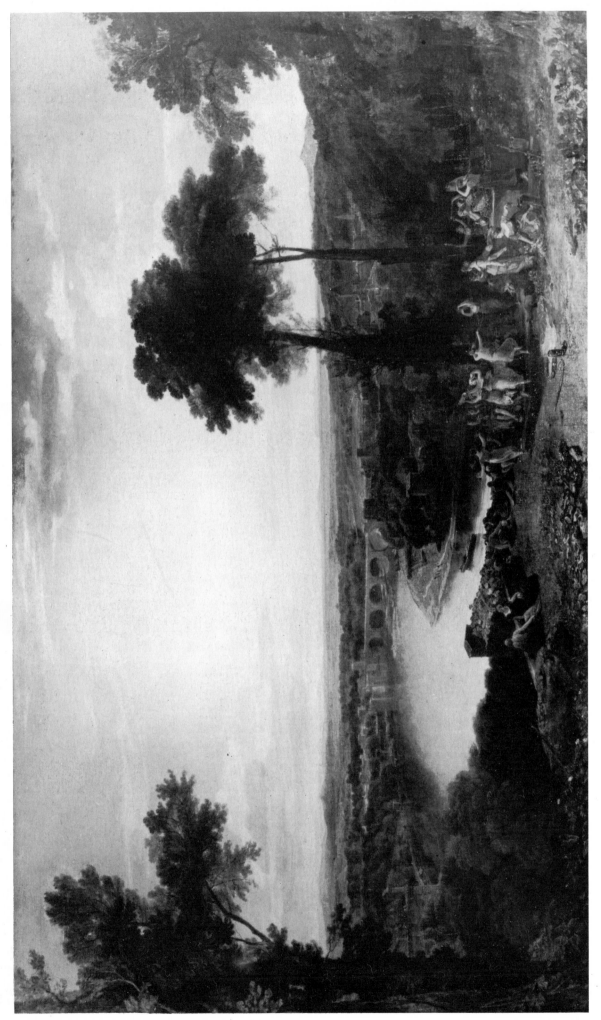

22. THE FESTIVAL UPON THE OPENING OF THE VINTAGE AT MACON.
57 × 92 in. Exhibited 1803. *Graves Art Gallery, Sheffield.*

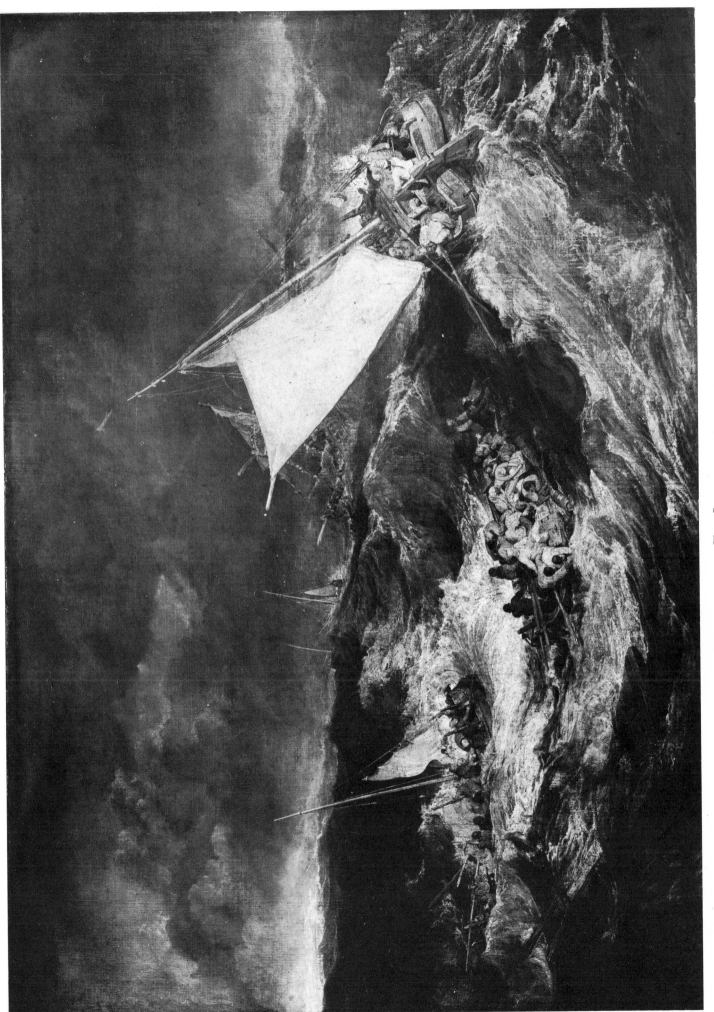

28. THE SHIPWRECK.
$67\frac{1}{2} \times 95$ in. Exhibited 1805. Tate Gallery.

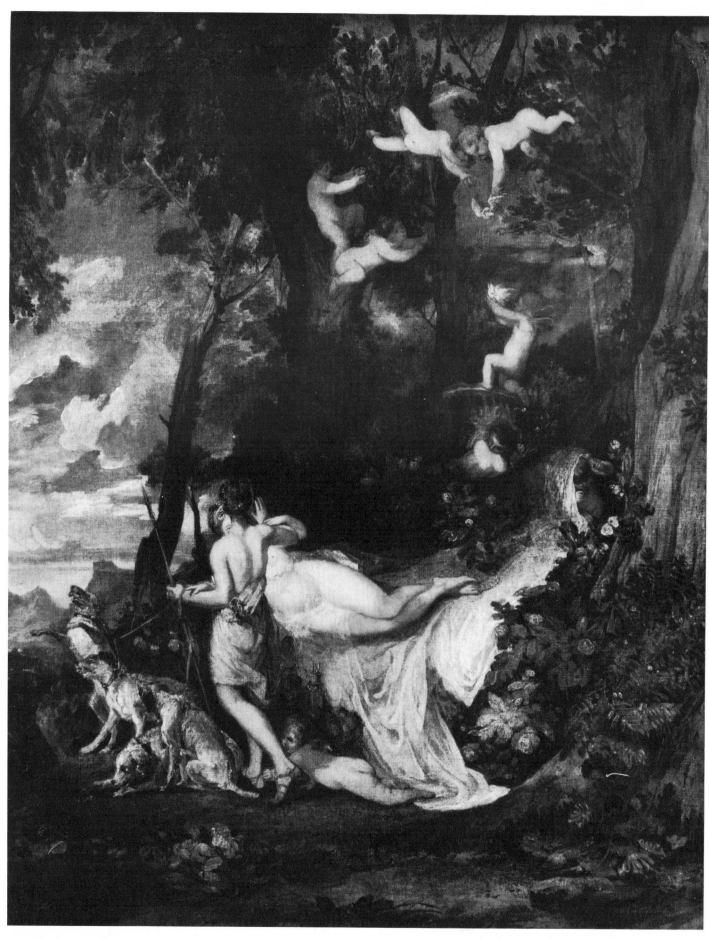

24. VENUS AND ADONIS.
59×47 *in. Painted* circa *1803–5. Huntington Hartford, New York.*

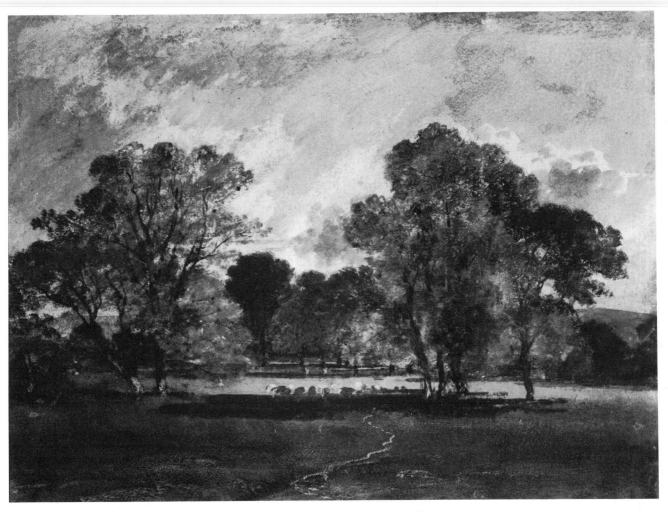

25. (*a*) Park Scene, Chevening, Kent.
Oil (?) on paper, $11 \times 14\frac{3}{4}$ in. Painted 1806 (?). British Museum.

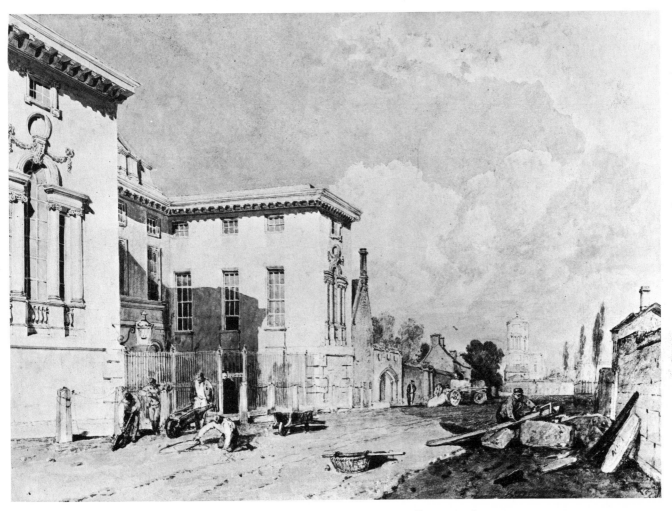

25. (*b*) The East Front of Worcester College, Oxford.
Watercolour, 12×17 in. Engraved 1804. Ashmolean Museum, Oxford.

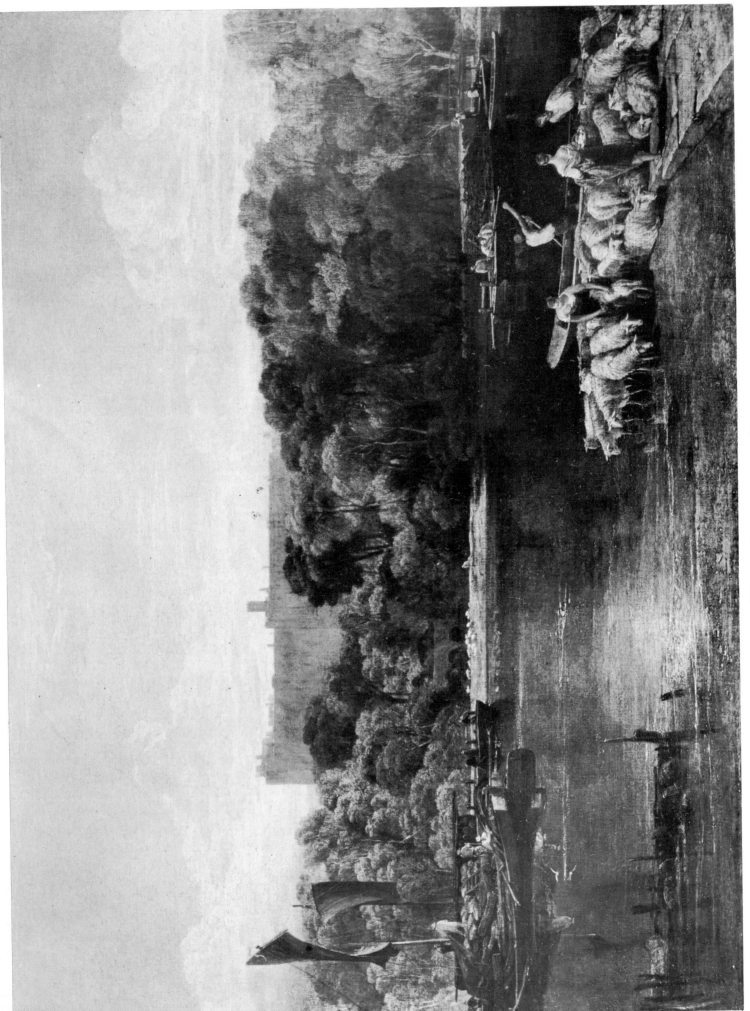

26. WINDSOR CASTLE FROM THE THAMES.

25 × 47 in. *Painted circa* 1805. *National Trust, Petworth, Sussex (lent by H.M. Government).*

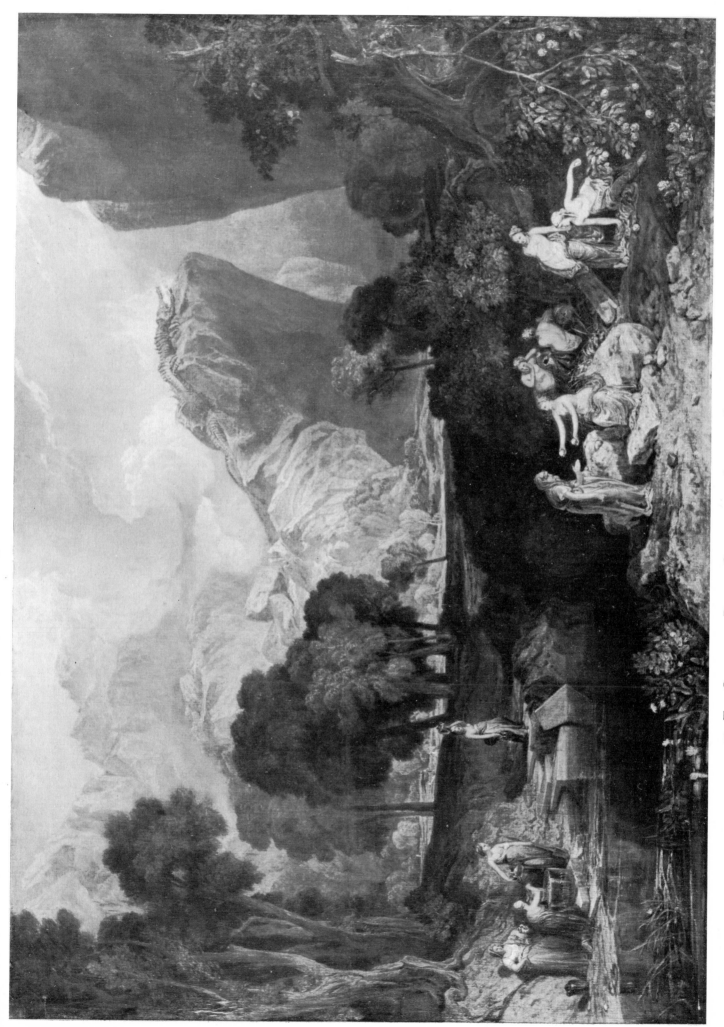

27. THE GODDESS OF DISCORD CHOOSING THE APPLE OF CONTENTION IN THE
GARDEN OF THE HESPERIDES.
$59\frac{1}{2} \times 84$ in. Exhibited 1806. Tate Gallery.

28. SUN RISING THROUGH VAPOUR.

53 × 70½ in. Exhibited 1807. National Gallery, London.

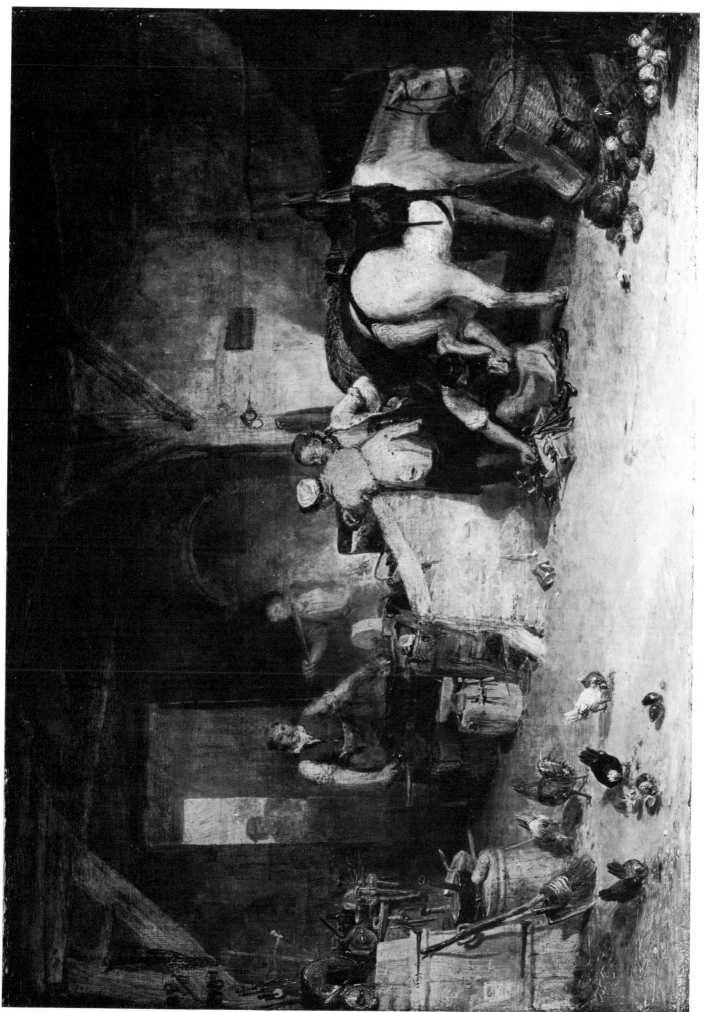

29. A Country Blacksmith Disputing upon the Price of Iron.
$22\frac{1}{2} \times 30\frac{1}{2}$ in. Exhibited 1807. *Tate Gallery.*

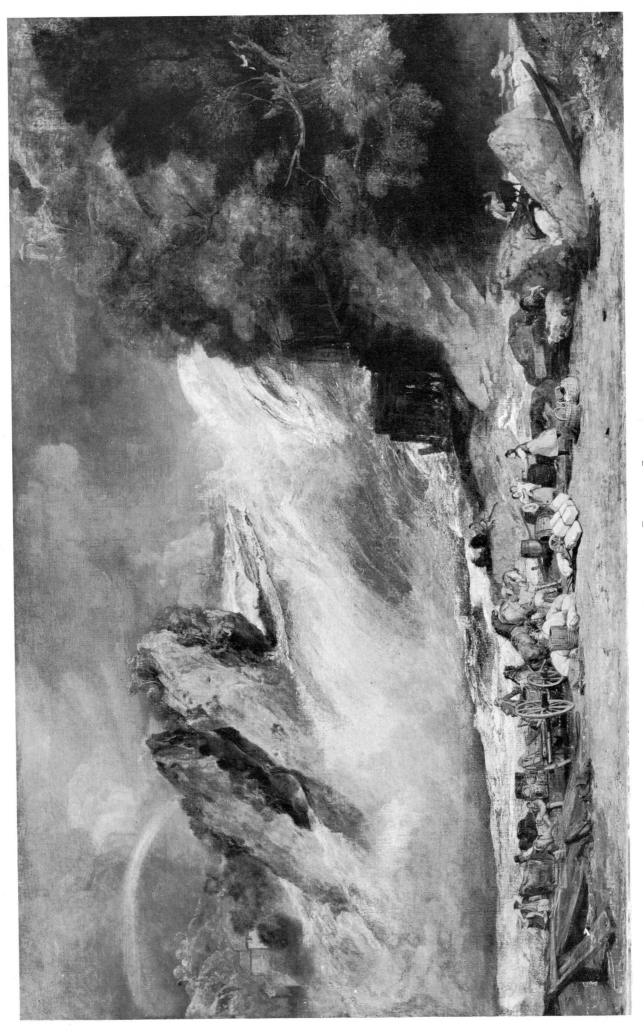

30. FALL OF THE RHINE AT SCHAFFHAUSEN.
$58\frac{1}{2} \times 94$ in. Exhibited 1806. *Museum of Fine Arts, Boston.*

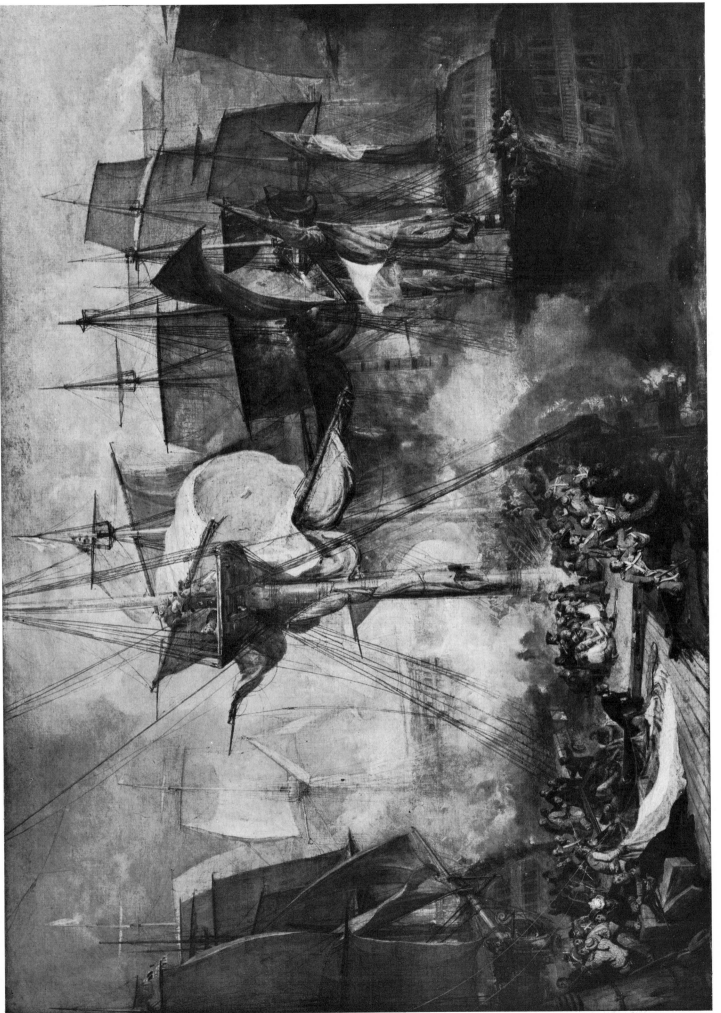

31. The Battle of Trafalgar.
$67\frac{1}{4} \times 94$ in. Exhibited 1806 (unfinished) and 1808. Tate Gallery.

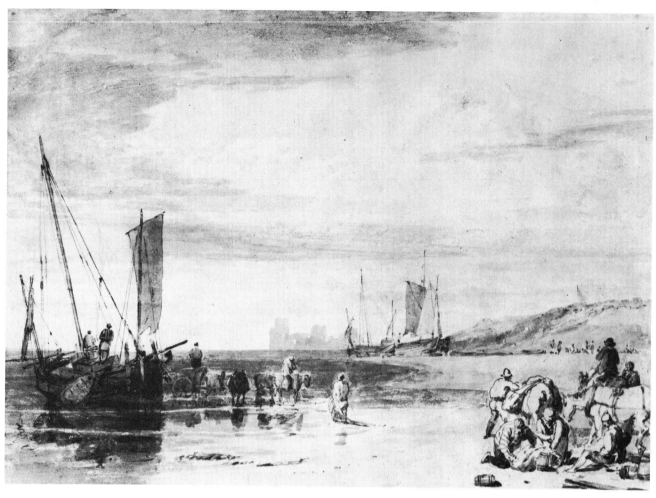

32. (a) SCENE ON THE FRENCH (?) COAST (FOR THE 'LIBER STUDIORUM').
Pen and sepia, 7¼ × 10⅛ in. Painted 1806. British Museum.

32. (b) TEMPLE OF MINERVA MEDICA (FOR THE 'LIBER STUDIORUM').
Pen and sepia, 8 × 10¾ in. Painted circa 1807. British Museum.

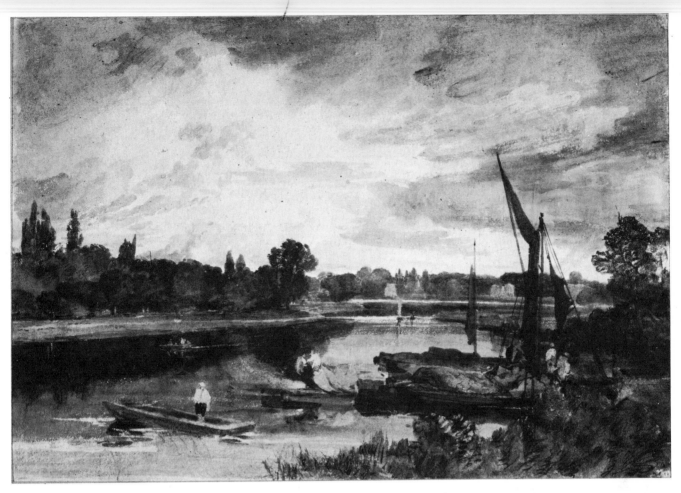

33. (*a*) SCENE ON THE THAMES.
Watercolour, 10 × 14¼ in. Painted 1807 (?). British Museum.

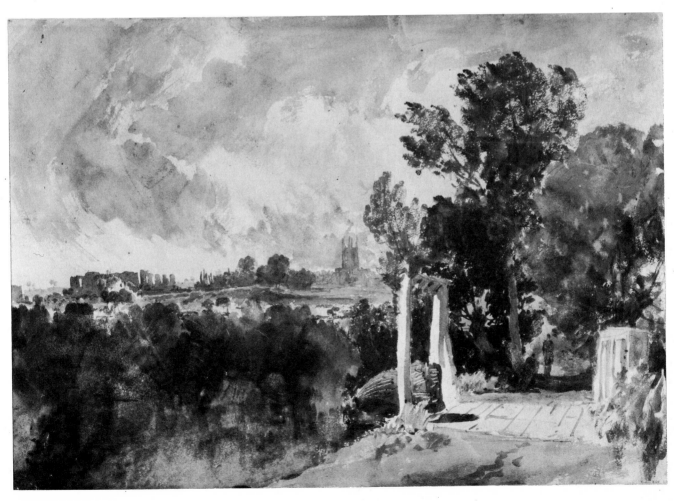

33. (*b*) BENSON NEAR WALLINGFORD.
Watercolour, 10 × 14¼ in. Painted 1807 (?). British Museum.

34. TREE TOPS AND SKY.
11 × 29 in. *Painted 1807 (?). Tate Gallery.*

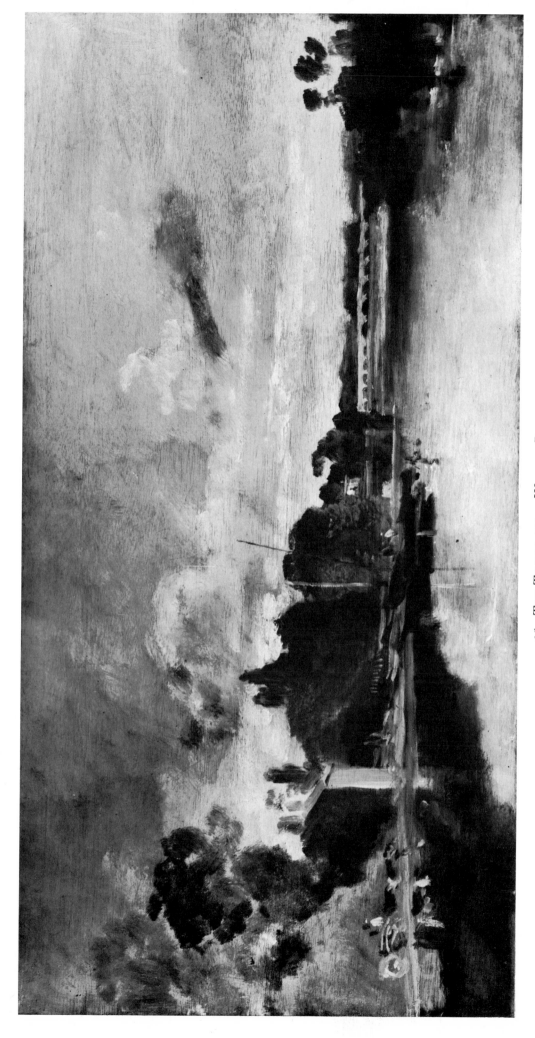

35. THE THAMES NEAR WALTON BRIDGES.
14 × 29 in. Painted 1807 (?). *Tate Gallery.*

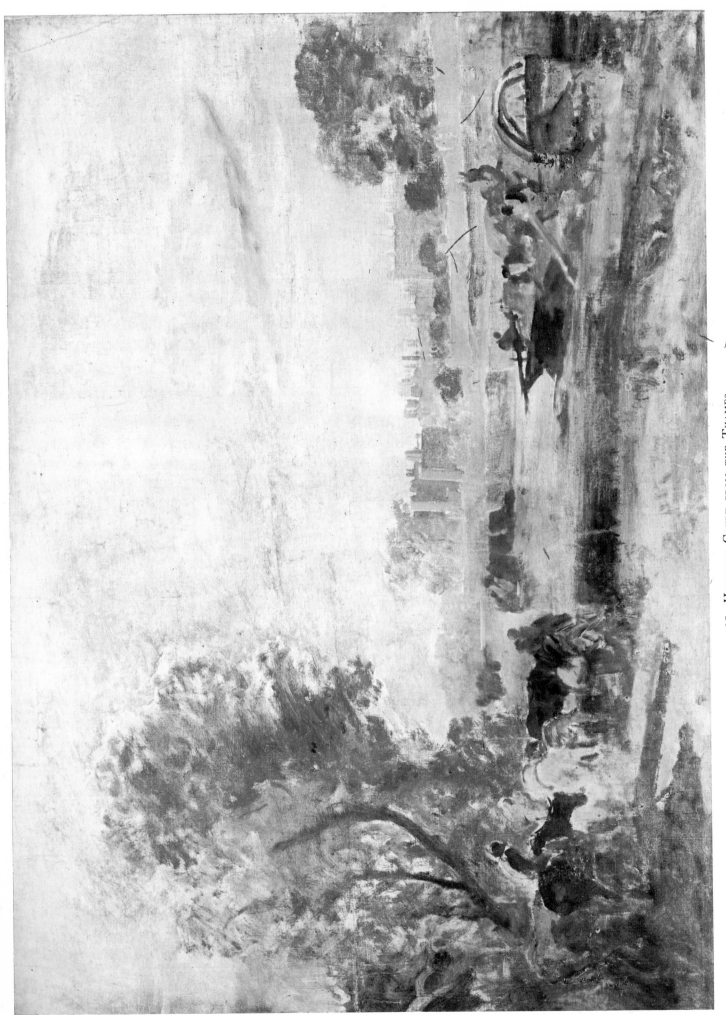

36. HAMPTON COURT FROM THE THAMES.
$33\frac{1}{2} \times 47$ in. *Painted circa 1807–8. Tate Gallery.*

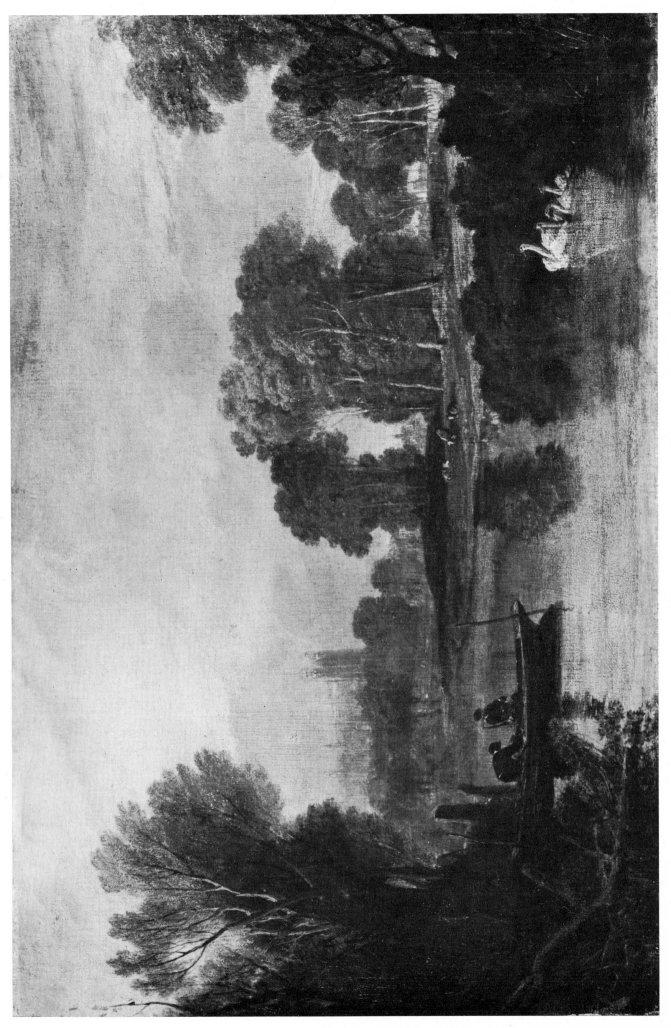

37. Eton College from the River.

$23\frac{1}{2} \times 35\frac{1}{2}$ in. Exhibited 1808. National Trust, Petworth, Sussex (lent by H.M. Government).

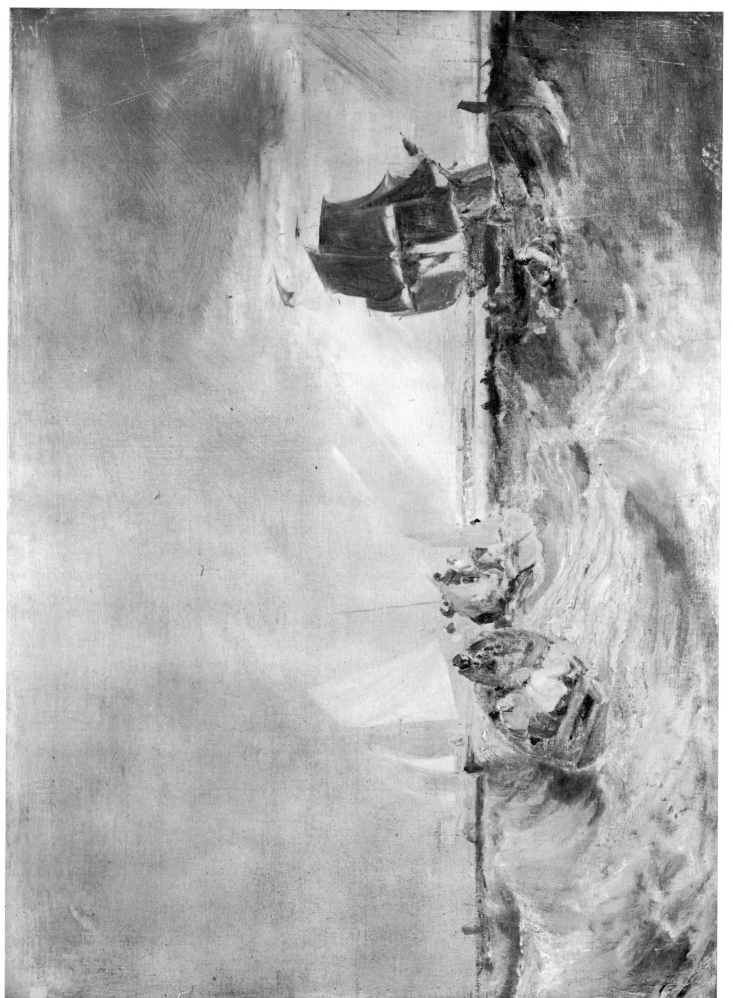

38. MOUTH OF THE THAMES.

$33\frac{1}{2} \times 45\frac{1}{2}$ in. *Painted circa 1807–8. Tate Gallery.*

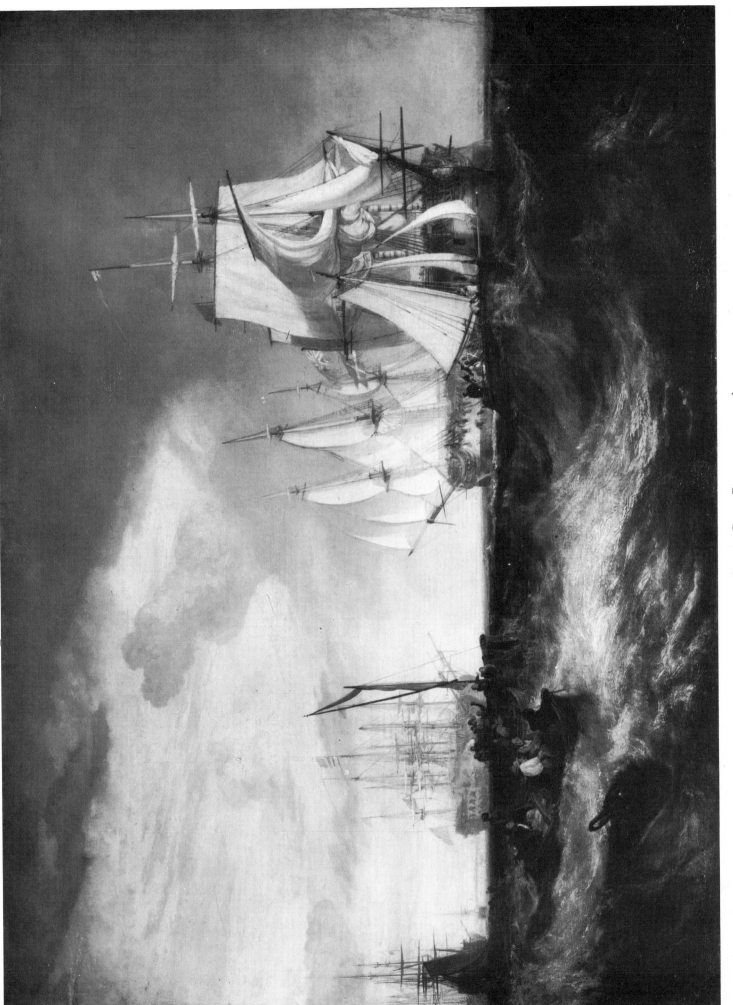

39. Spithead: Boat's Crew Recovering an Anchor.
$67\frac{1}{2} \times 92$ in. Exhibited 1808 (*unfinished*) and 1809. *Tate Gallery*.

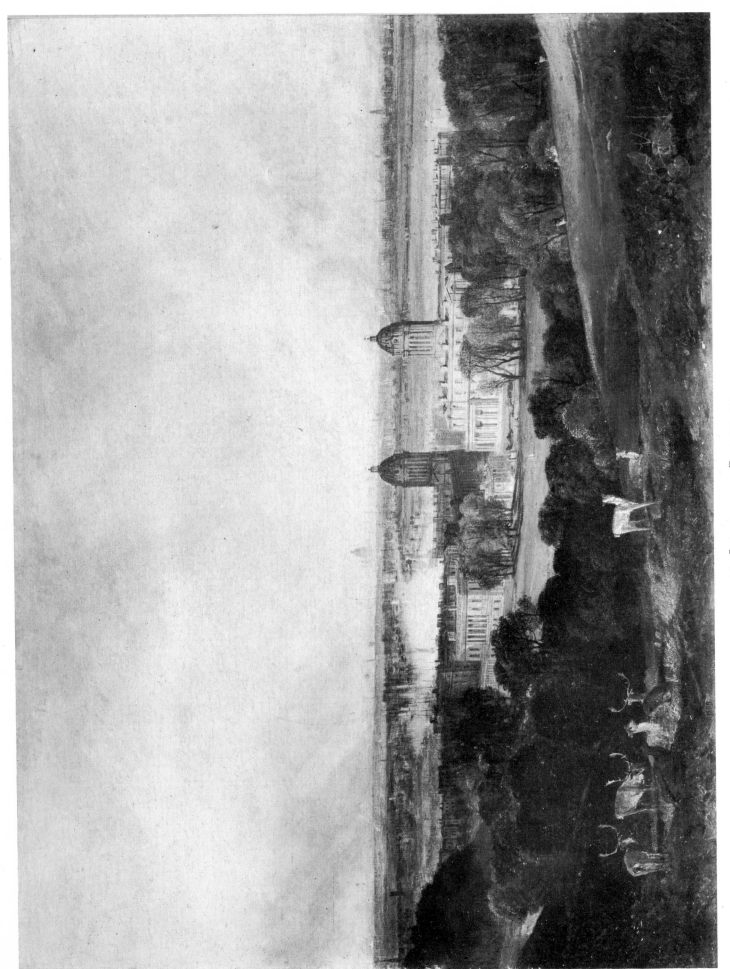

40. LONDON FROM GREENWICH.
$34\frac{1}{2} \times 46\frac{1}{2}$ in. Exhibited 1809. Tate Gallery.

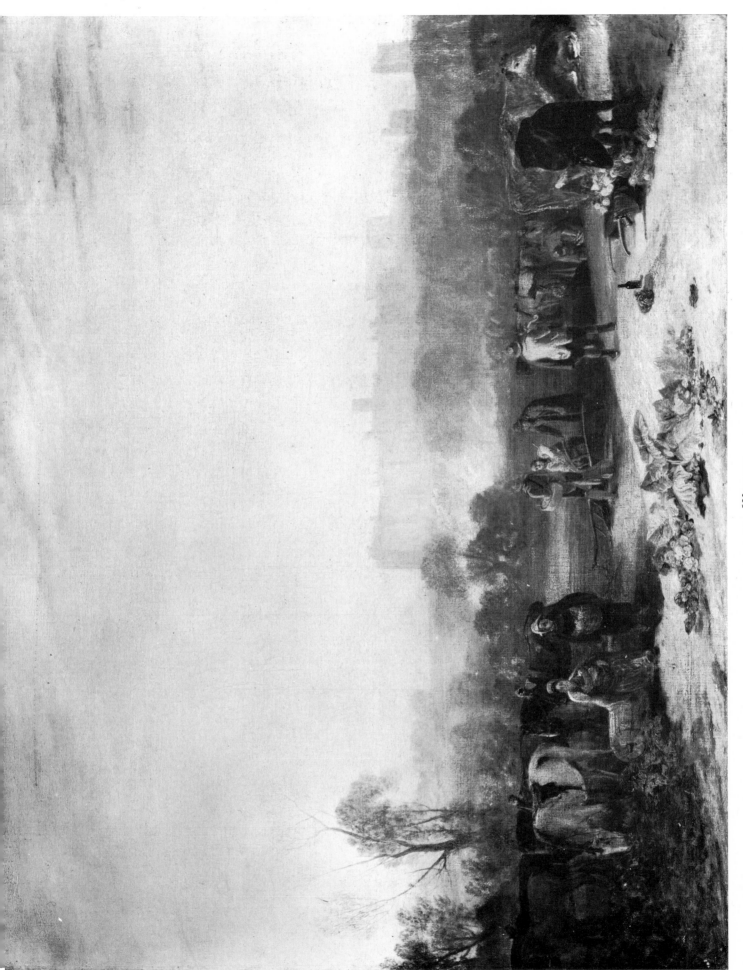

41. WINDSOR.

40 × 51¼ in. Exhibited 1809. Tate Gallery.

42. Sketch of a Bank with Gipsies.
24×33 in. Exhibited 1809. Tate Gallery.

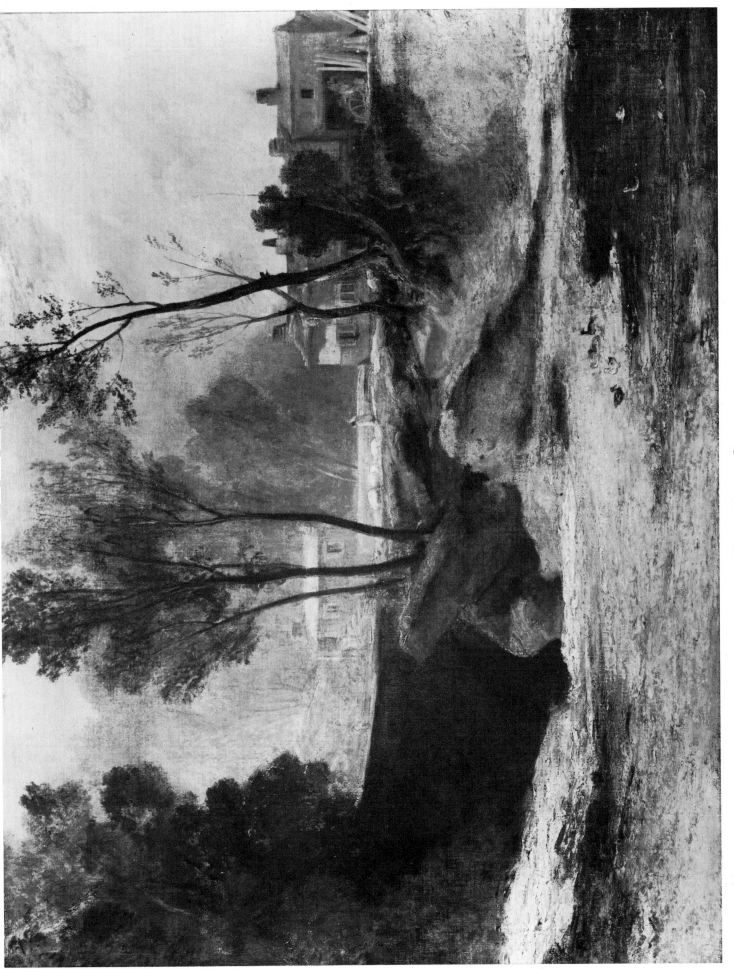

48. CALDER BRIDGE, CUMBERLAND.

36×48 in. Exhibited 1810. *Robert Emmons, Southampton.*

44. Fishing upon the Blythe-Sand, Tide Setting In.
35 × 47 in. Exhibited 1809. *Tate Gallery.*

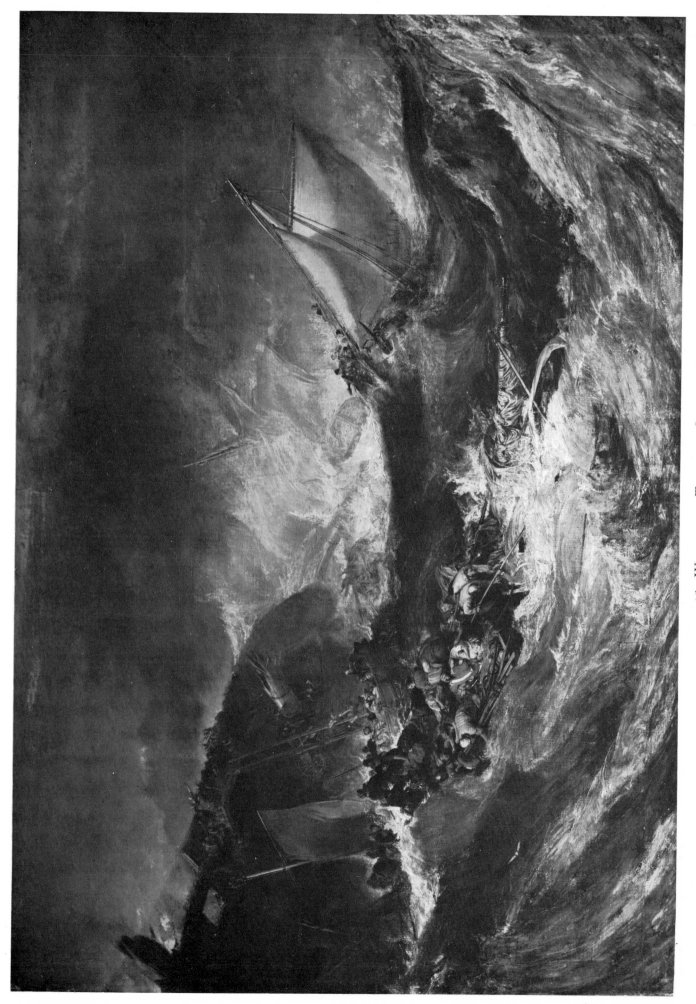

45. WRECK OF A TRANSPORT SHIP.

68 × 95 in. Painted circa 1810. Fundação Calouste Gulbenkian, Lisbon.

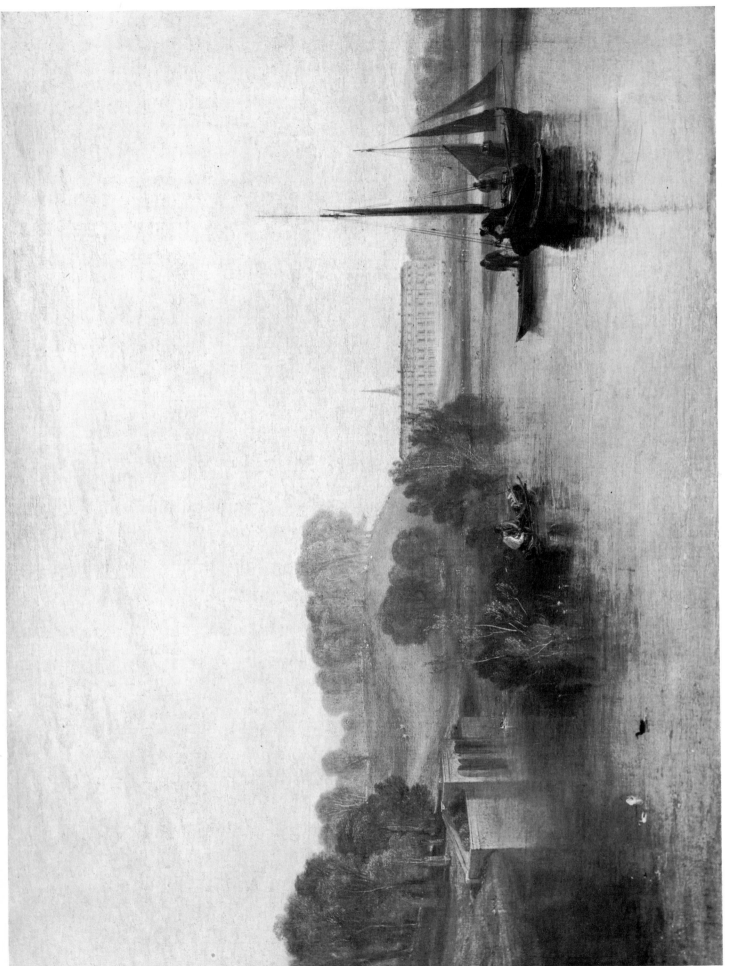

46. PETWORTH, SUSSEX: DEWY MORNING.

$35\frac{1}{2} \times 47\frac{1}{2}$ in. Dated 1810. Exhibited 1810. Lord Egremont, Petworth, Sussex.

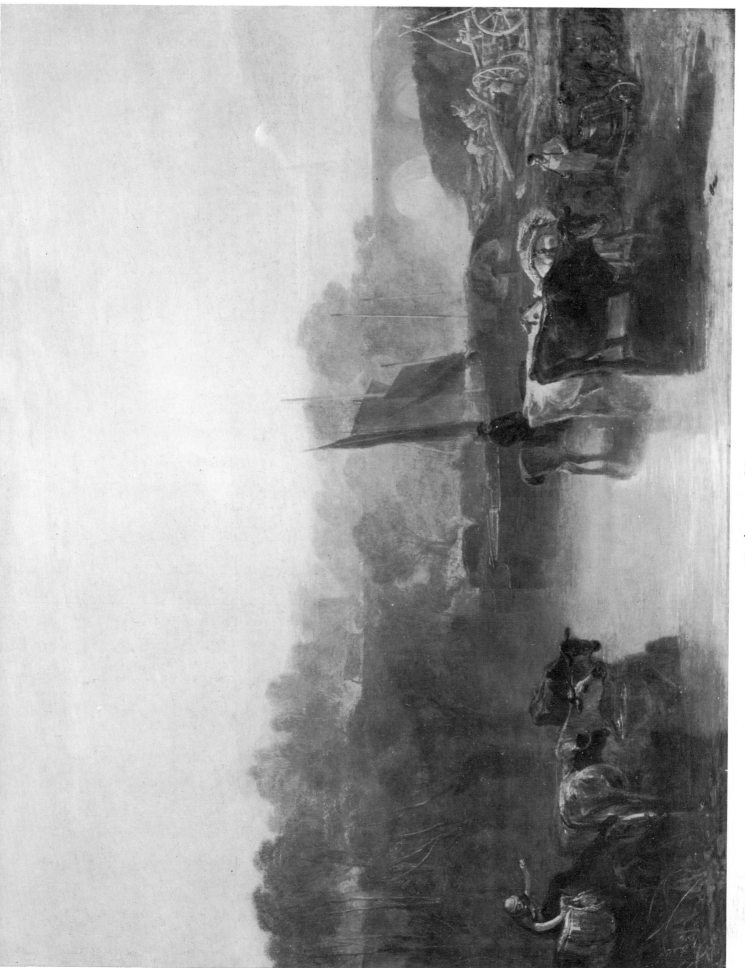

47. ABINGDON, MORNING.

39½ × 50½ in. Exhibited 1810 (?). Tate Gallery.

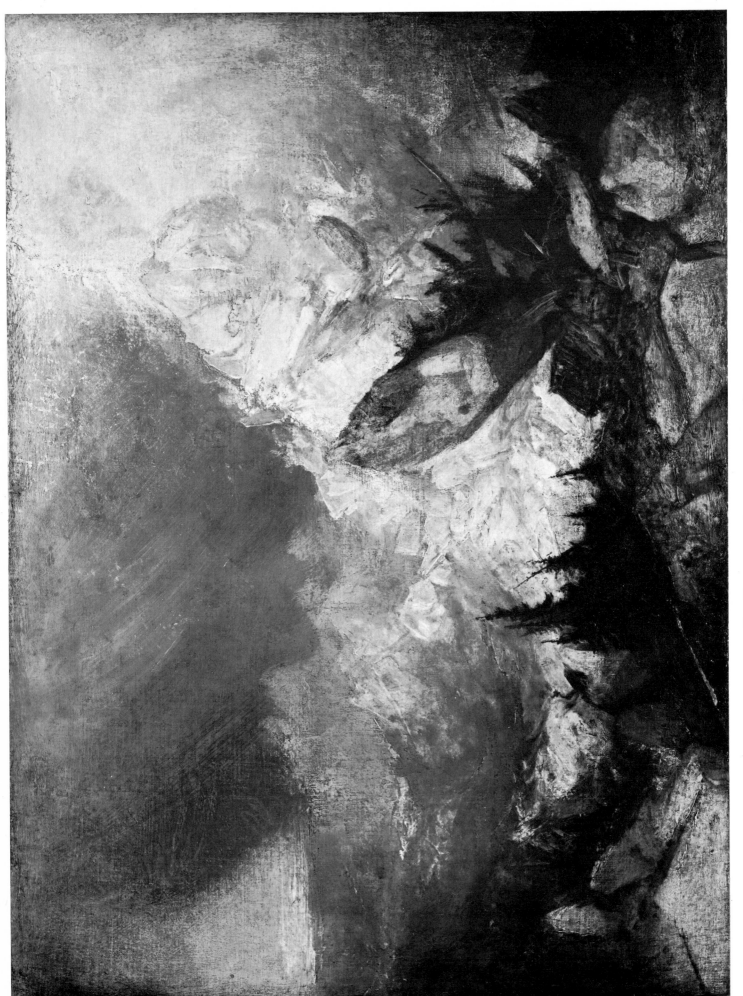

48. The Fall of an Avalanche in the Grisons. $35\frac{1}{2} \times 47\frac{1}{2}$ in. Exhibited 1810. Tate Gallery.

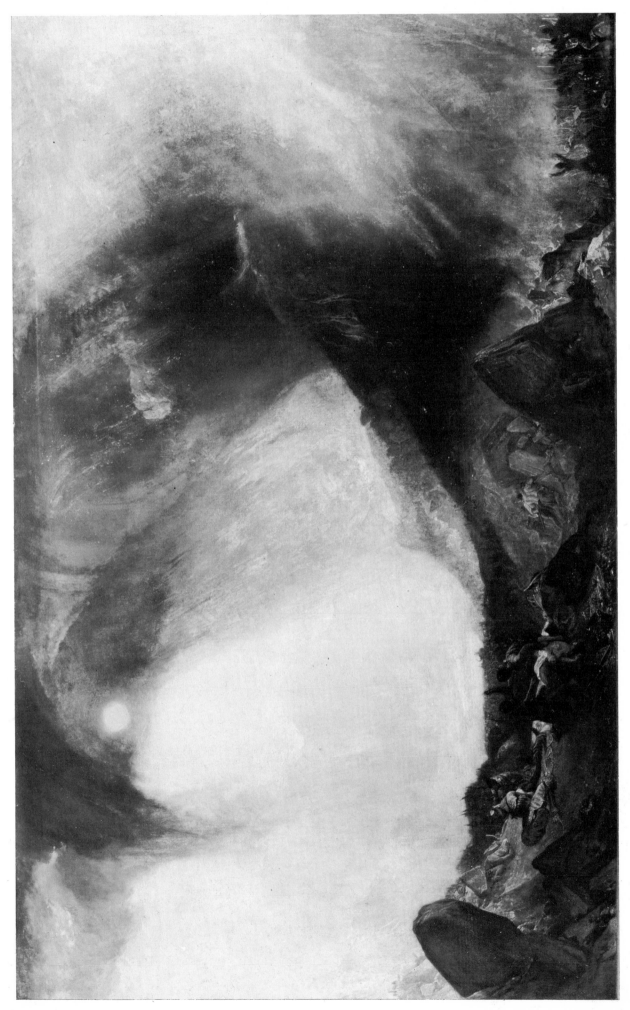

49. Snowstorm: Hannibal and his Army Crossing the Alps.
57 × 93 in. Exhibited 1812. Tate Gallery.

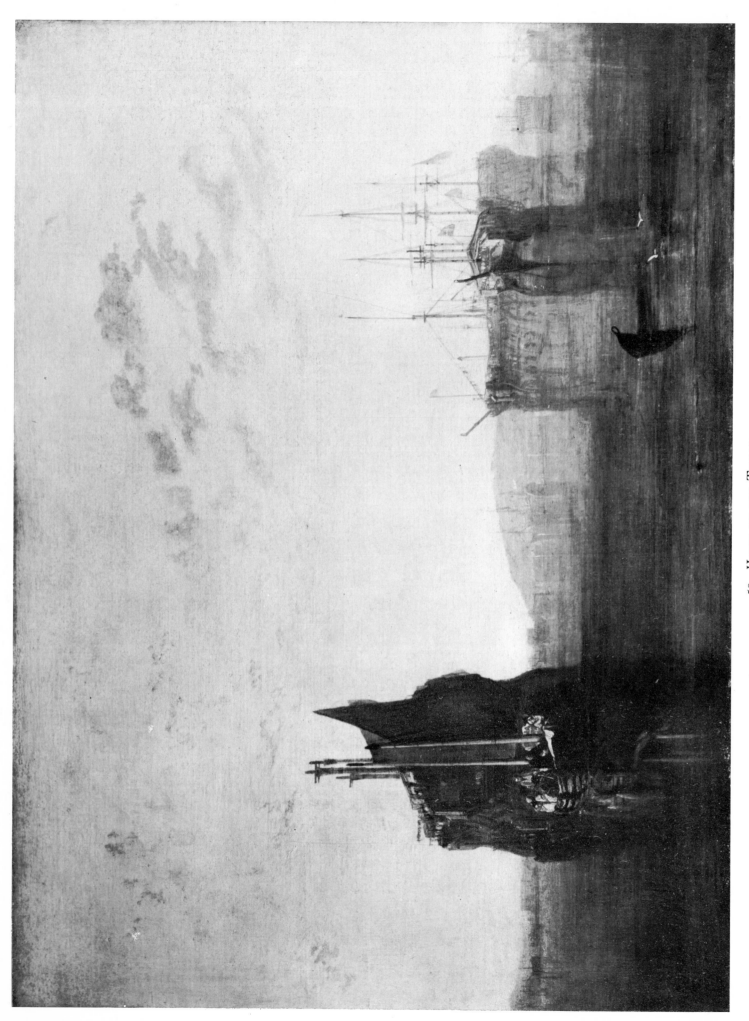

50. Hulks on the Tamar.

$35\frac{1}{2} \times 47\frac{1}{2}$ in. Exhibited 1812 (?). National Trust, Petworth, Sussex (lent by H.M. Government).

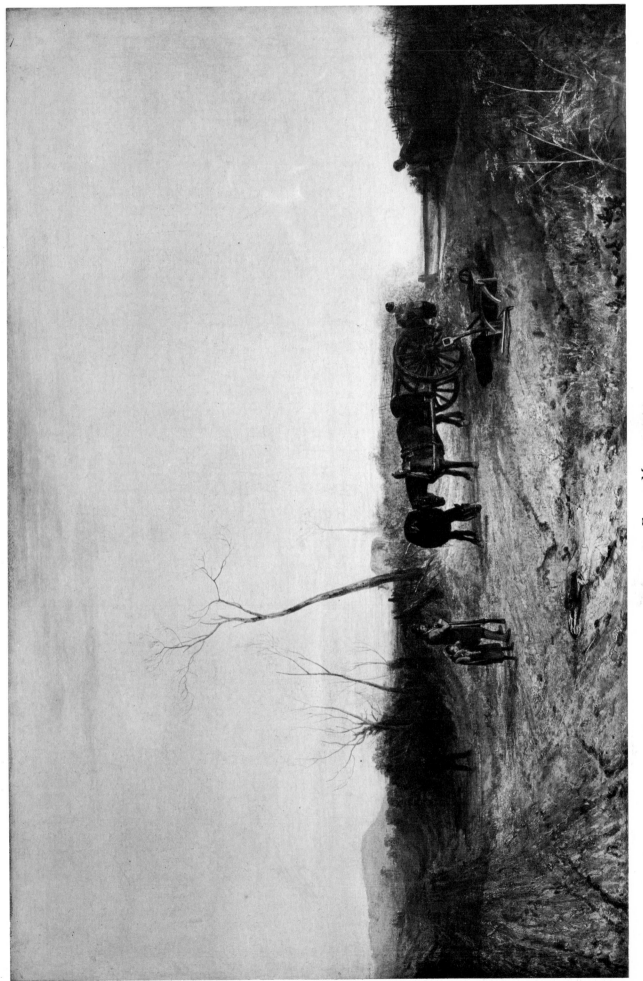

51. Frosty Morning.

44½ × 68½ in. Exhibited 1813. Tate Gallery.

52. (*a*) On the Washburn, under Folly Hill.
Watercolour, 11 × 15½ in. Painted circa 1810. *British Museum.*

52. (*b*) Loch Fyne.
Watercolour, 11 × 15½ in. Dated 1815. British Museum.

53. (*a*) AN ABBEY NEAR COBLENZ.
Watercolour, 7½ × 12½ in. Painted 1817. British Museum.

53. (*b*) VALLEY OF THE WHARFE NEAR CALEY PARK.
*Watercolour, 13 × 17¼ in. Painted circa 1816–18. Major Le G. G. W. Horton-Fawkes,
Farnley Hall, Yorkshire.*

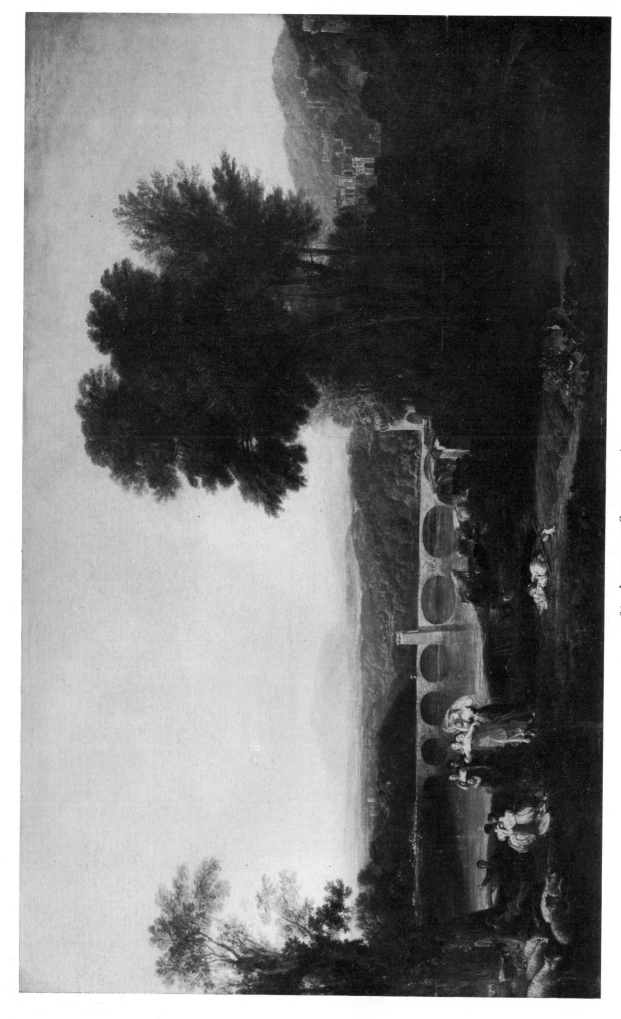

54. Apullia in Search of Appullus.
57 × 93 in. Exhibited 1814. Tate Gallery.

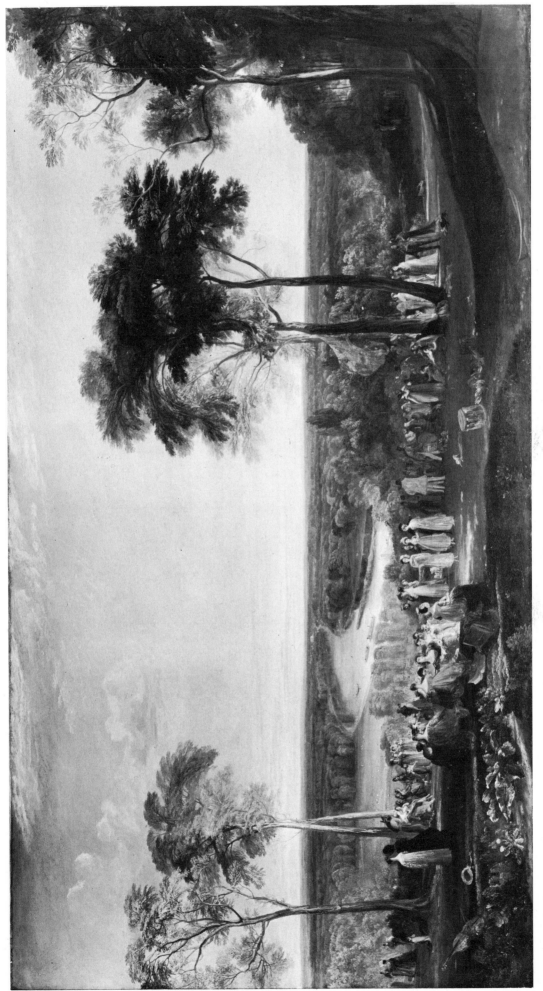

55. ENGLAND: RICHMOND HILL.
70×132 in. Exhibited 1819. Tate Gallery.

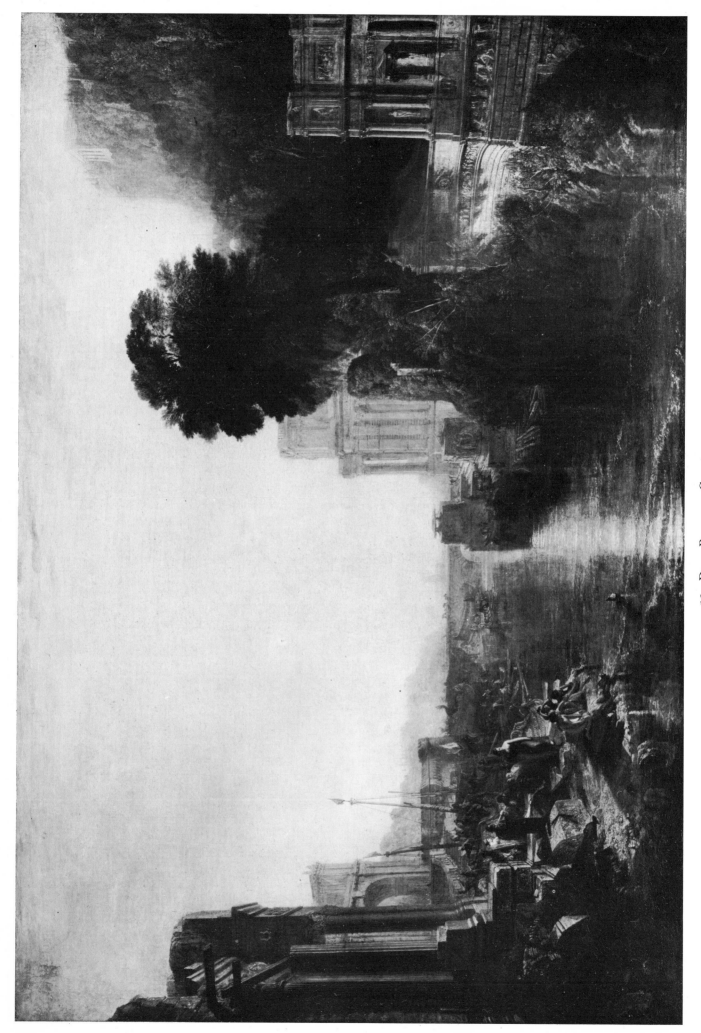

56. Dido Building Carthage.
$61\frac{1}{4} \times 91\frac{1}{4}$ in. Exhibited 1815. National Gallery, London.

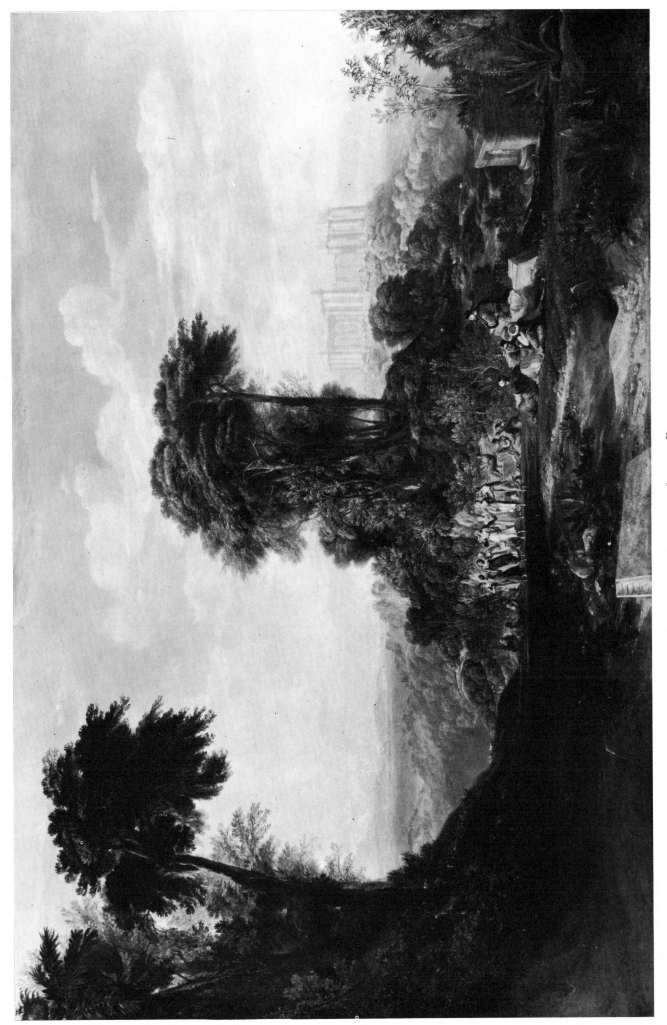

57. VIEW OF THE TEMPLE OF JUPITER PANELLENIUS.

$46\frac{1}{4} \times 70$ in. Dated 1814. Exhibited 1816. The Dowager Duchess of Northumberland,
Albury Park, Guildford.

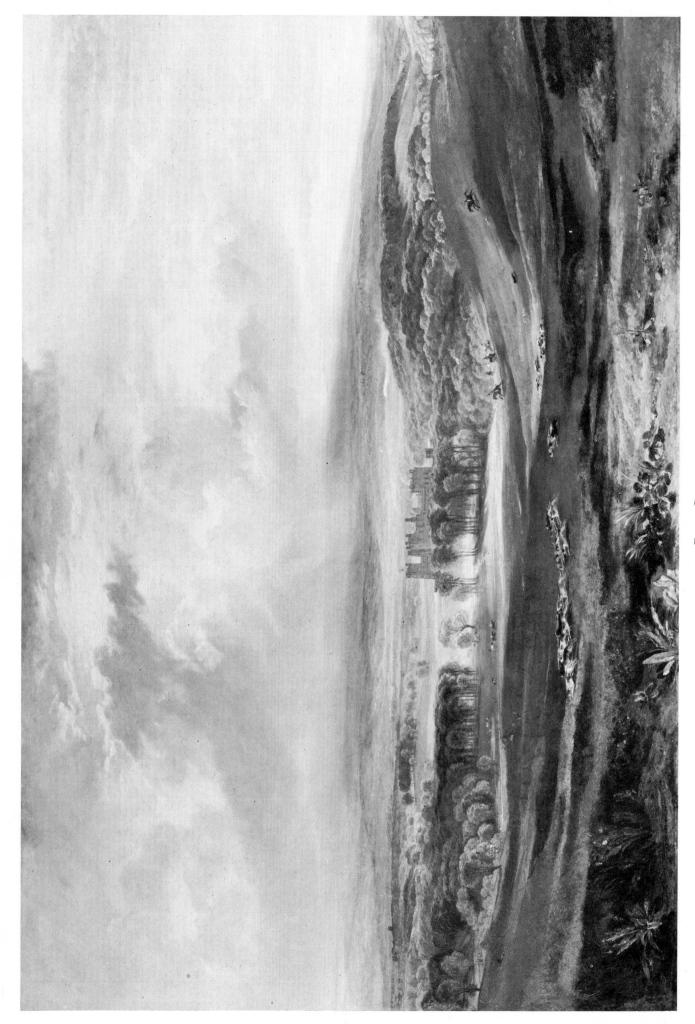

58. Raby Castle.

46¾ × 71 in. Exhibited 1818. *Walters Art Gallery, Baltimore.*

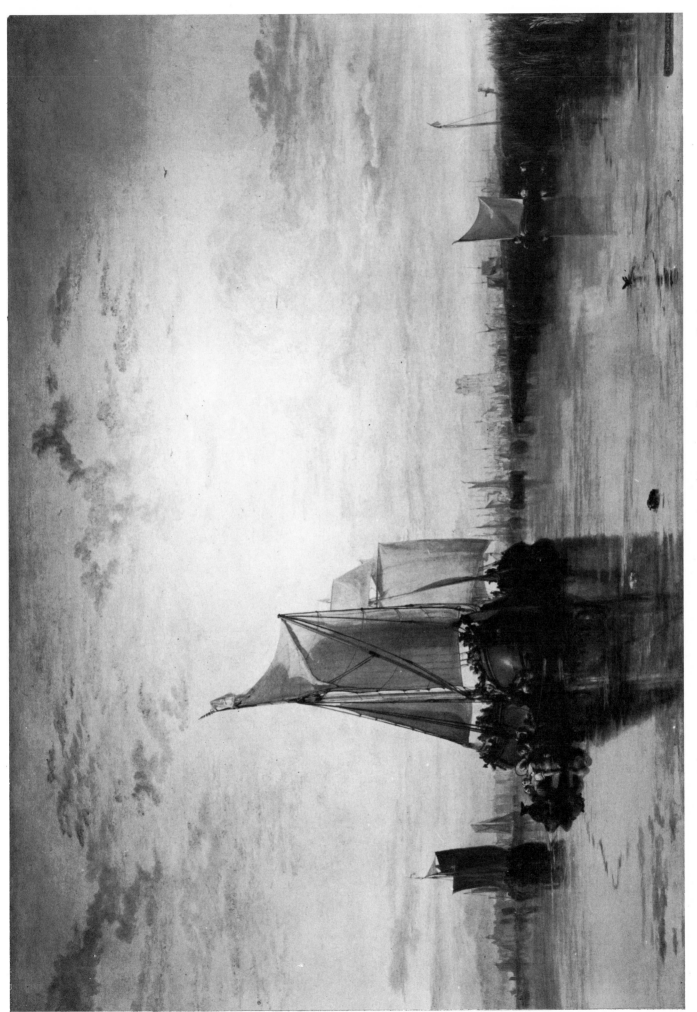

59. DORT OR DORDRECHT: THE DORT PACKET BOAT FROM ROTTERDAM BECALMED.
62 × 92 in. Exhibited 1818. Major Le G. G. W. Horton-Fawkes, Farnley Hall, Yorkshire.

60. (*a*) ON LAKE COMO.
Watercolour, $8\frac{3}{4} \times 11\frac{1}{4}$ in. Painted 1819. British Museum.

60. (*b*) MONTE GENNARO, NEAR ROME.
Watercolour, 10×16 in. Painted 1819. British Museum.

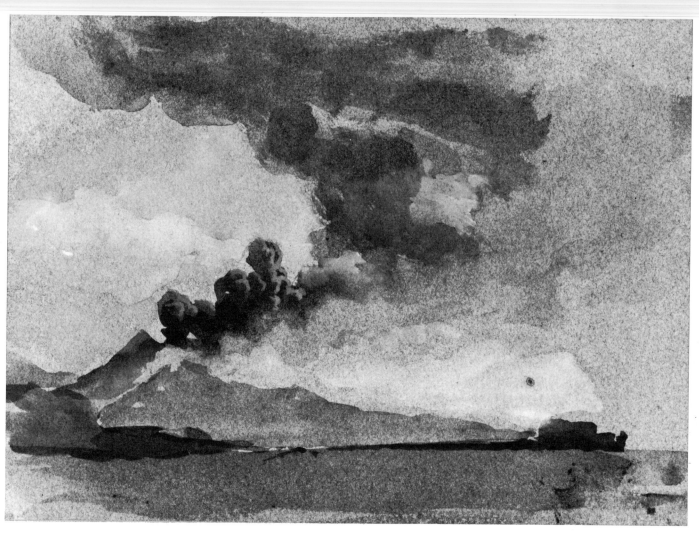

61. (*a*) VESUVIUS IN ERUPTION.
Watercolour, 5×7 in. Painted 1819. Miss Armide Oppé and Mr D. L. T. Oppé, London.

61. (*b*) THE NYMPHÆUM OF ALEXANDER SEVERUS.
Watercolour, 9 × 14½ in. Painted 1819. British Museum.

62. ROME, FROM THE VATICAN.

$69\frac{1}{2} \times 131$ in. Exhibited 1820. Tate Gallery.

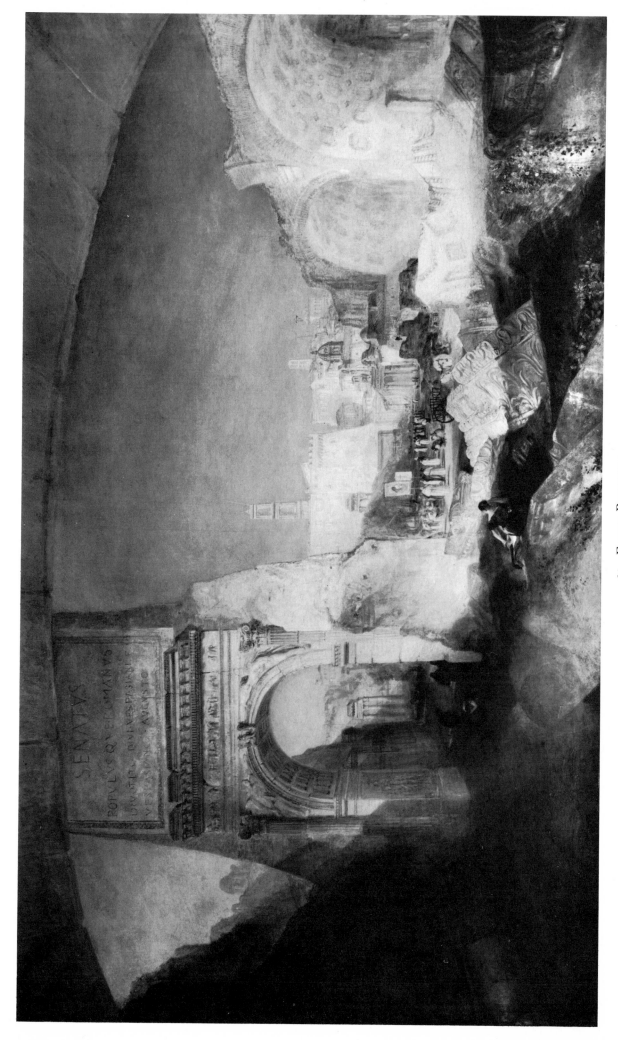

63. FORUM ROMANUM.
57¼ × 93½ in. Exhibited 1826. Tate Gallery.

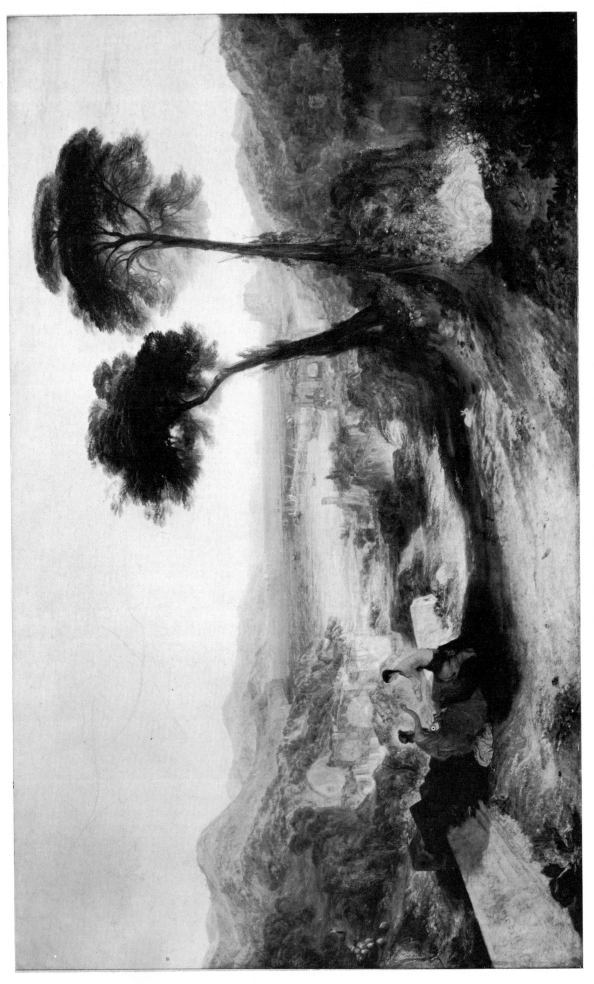

64. The Bay of Baiæ, with Apollo and the Sibyl.
$57\frac{1}{2} \times 93\frac{1}{2}$ in. Exhibited 1823. *Tate Gallery.*

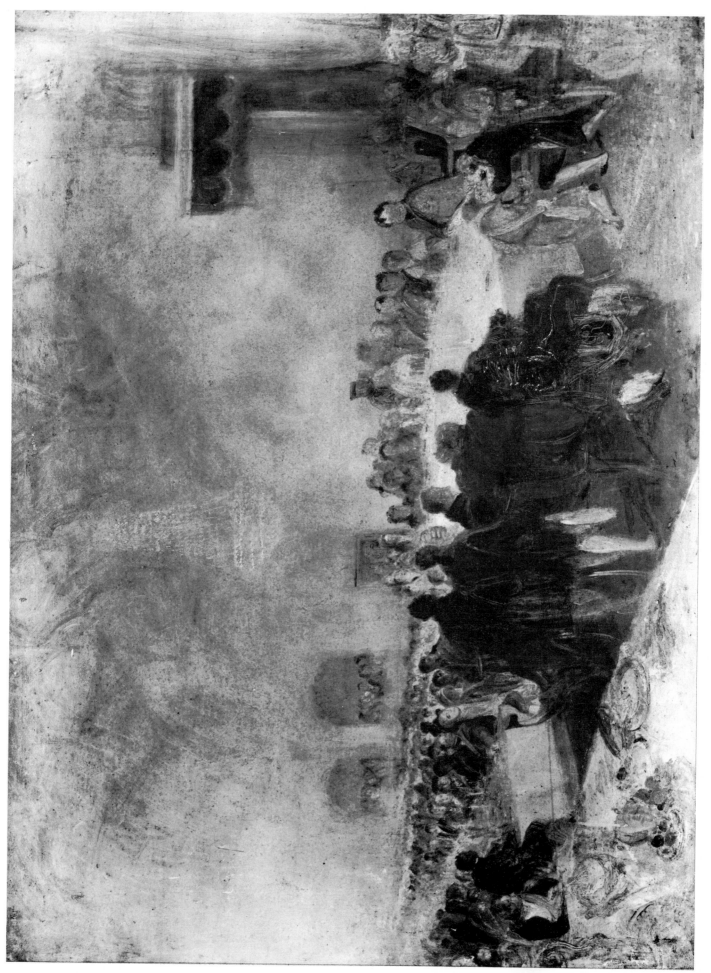

65. George IV at a Banquet in Edinburgh.
$26\frac{1}{4} \times 36\frac{1}{2}$ in. Painted 1822. *Tate Gallery.*

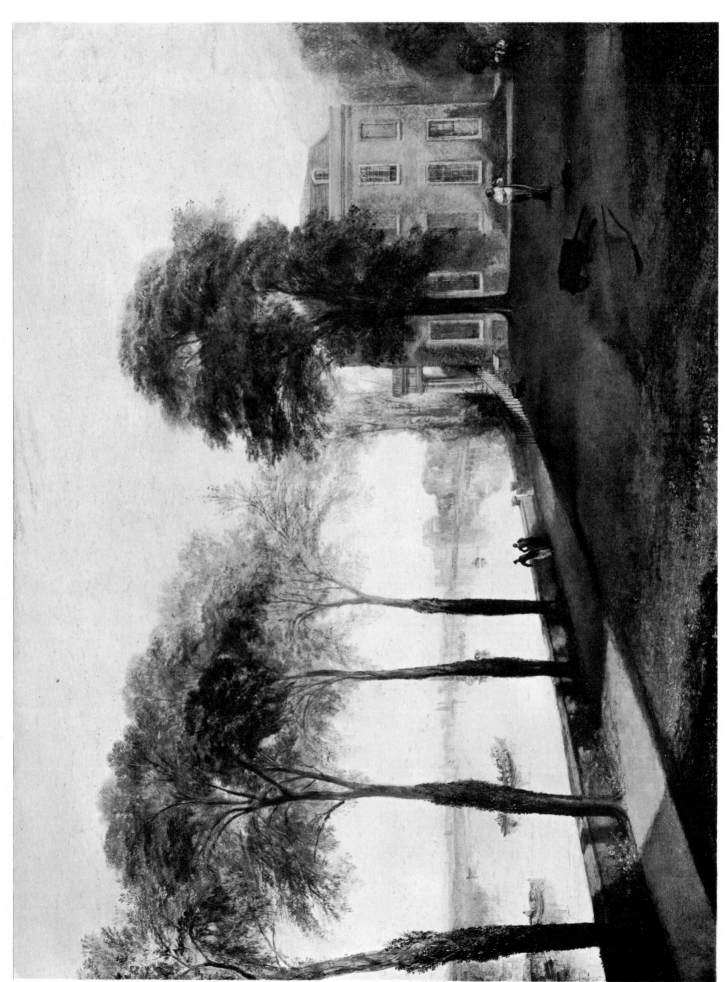

66. The Seat of William Moffat, Esq., at Mortlake. Early (Summer's) Morning.

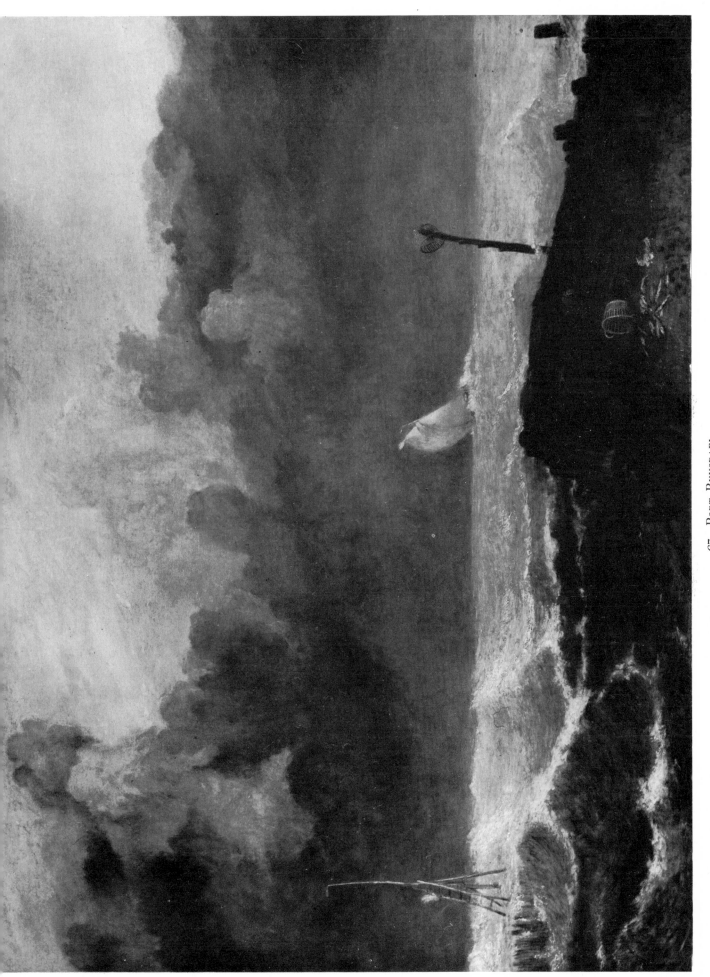

67. PORT RUYSDAEL.

$36\frac{1}{4} \times 48\frac{1}{4}$ in. Exhibited 1827. Mr and Mrs Paul Mellon, Upperville, Virginia.

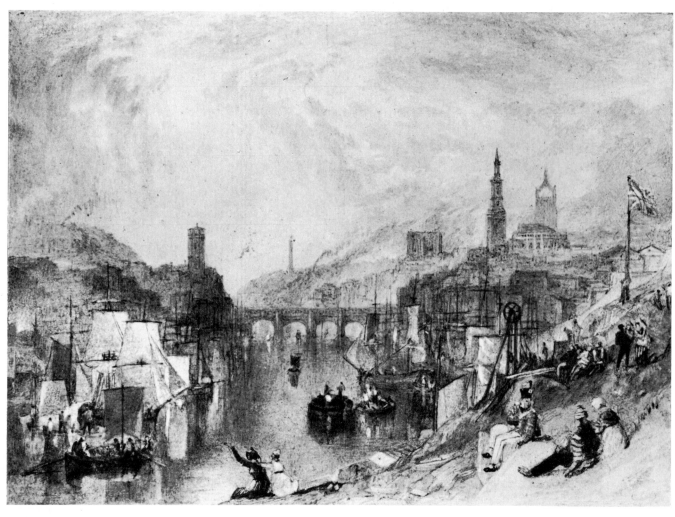

68. (*a*) NEWCASTLE.
Body colour, $6 \times 8\frac{1}{2}$ in. Painted and engraved 1823. British Museum.

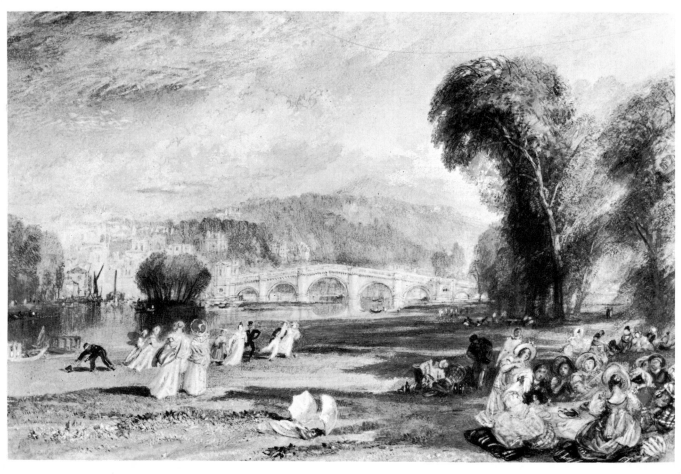

68. (*b*) RICHMOND BRIDGE — PLAY.
Watercolour, $11\frac{1}{4} \times 17\frac{1}{4}$ in. Engraved 1832. British Museum.

69. (a) Town from the River, Castle beyond.
Body colour, 5½ × 7½ in. Painted circa 1826. British Museum.

69. (b) Scene on the Loire.
Body colour, 5½ × 7½ in. Painted circa 1826 (?). Ashmolean Museum, Oxford.

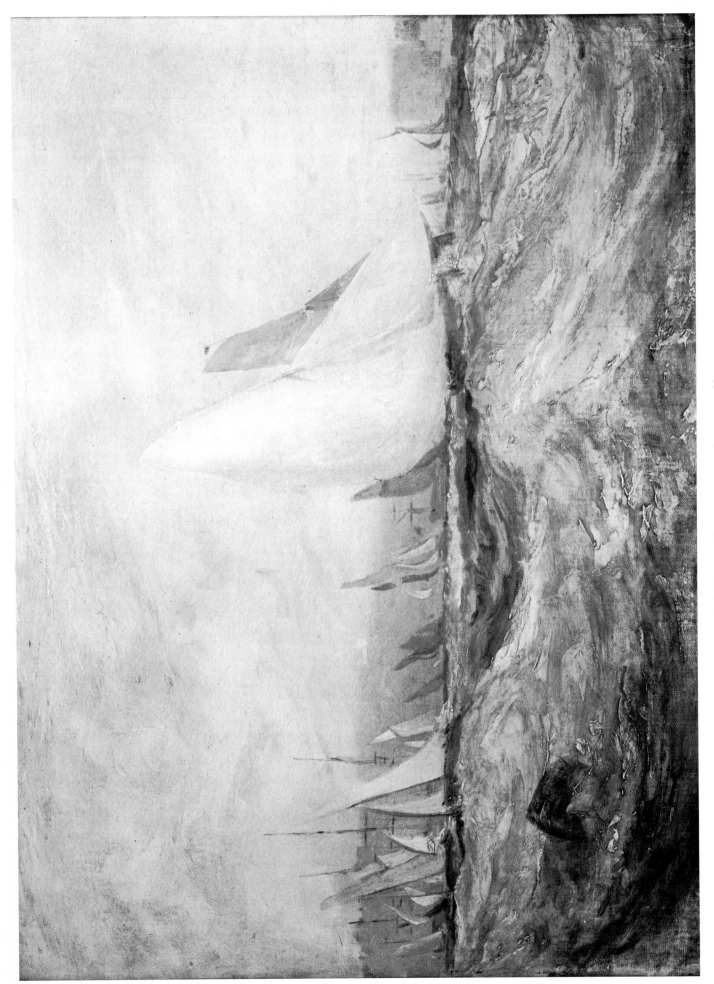

70. YACHT RACING IN THE SOLENT — II.
18 × 24 in. Painted 1827. Tate Gallery.

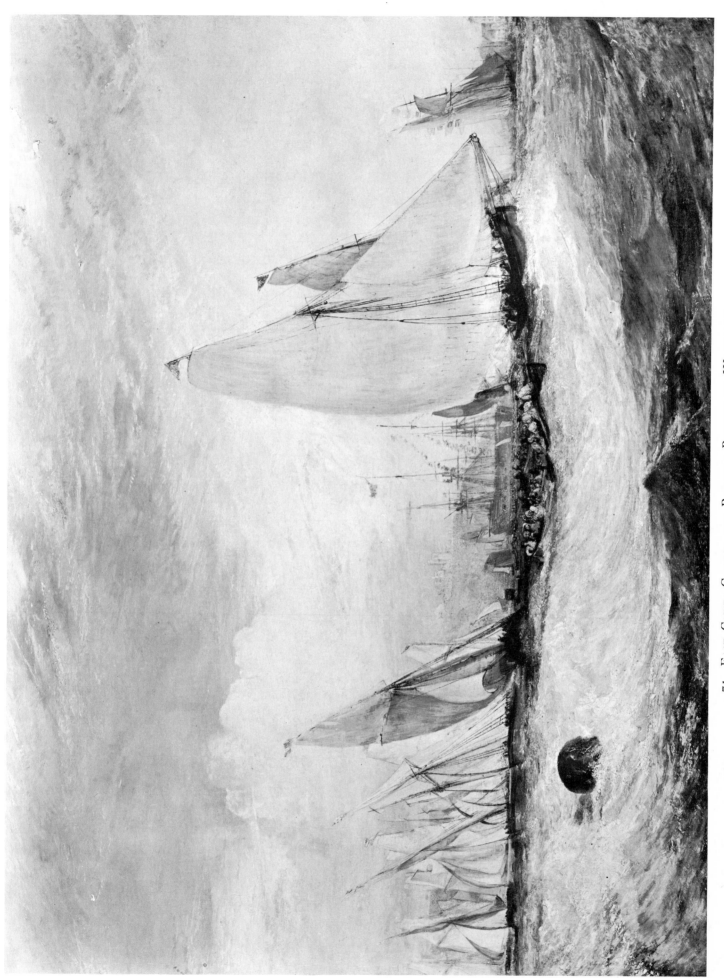

71. East Cowes Castle; the Regatta Beating to Windward.
$36\frac{1}{4} \times 48$ in. Exhibited 1828. *Mr and Mrs Nicholas H. Noyes, Indianapolis.*

72. Hill Town on Edge of Plain.
$16\frac{1}{4} \times 23\frac{1}{2}$ in. Painted 1828 (?). *Tate Gallery.*

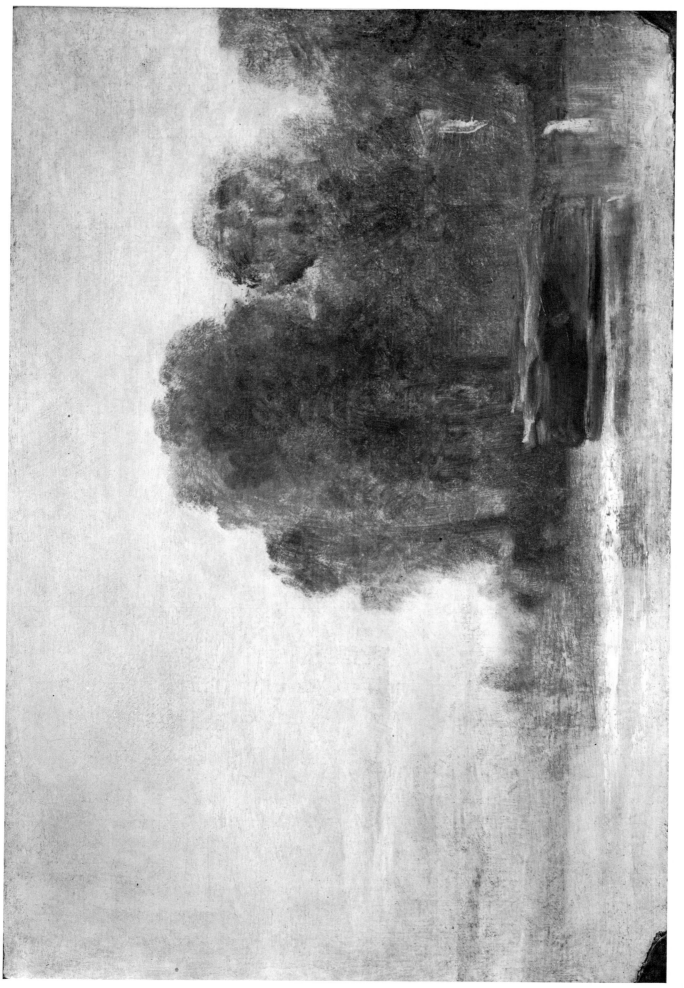

73. River with Trees.
$16\frac{1}{4} \times 23\frac{1}{2}$ in. *Painted* 1828 (?). *Tate Gallery.*

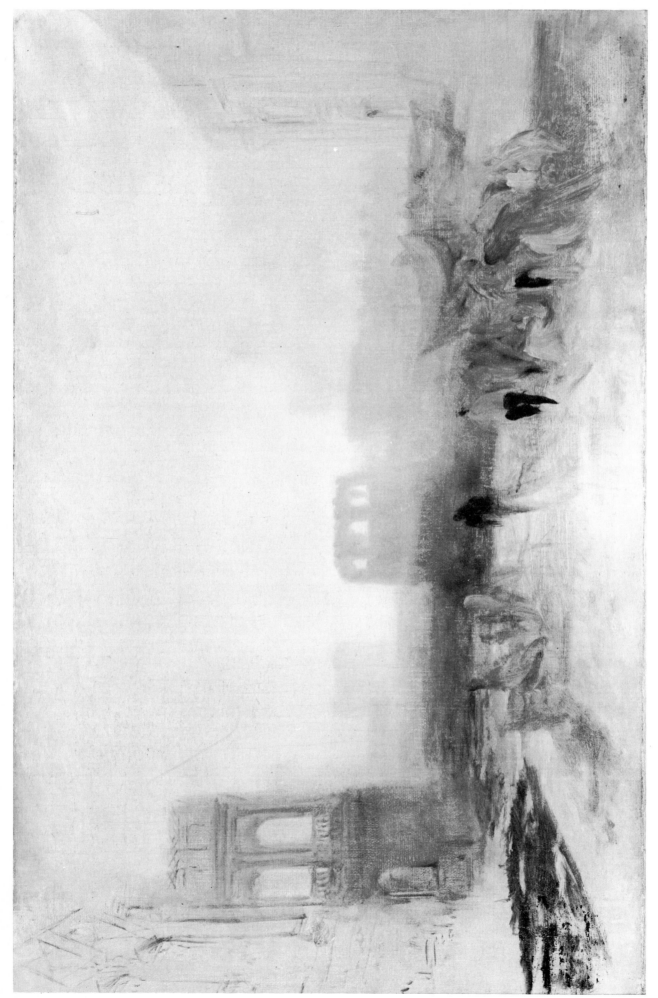

74. CARTHAGINIAN SUBJECT.
$23\frac{1}{2} \times 36$ in. Painted 1828 (?). Tate Gallery.

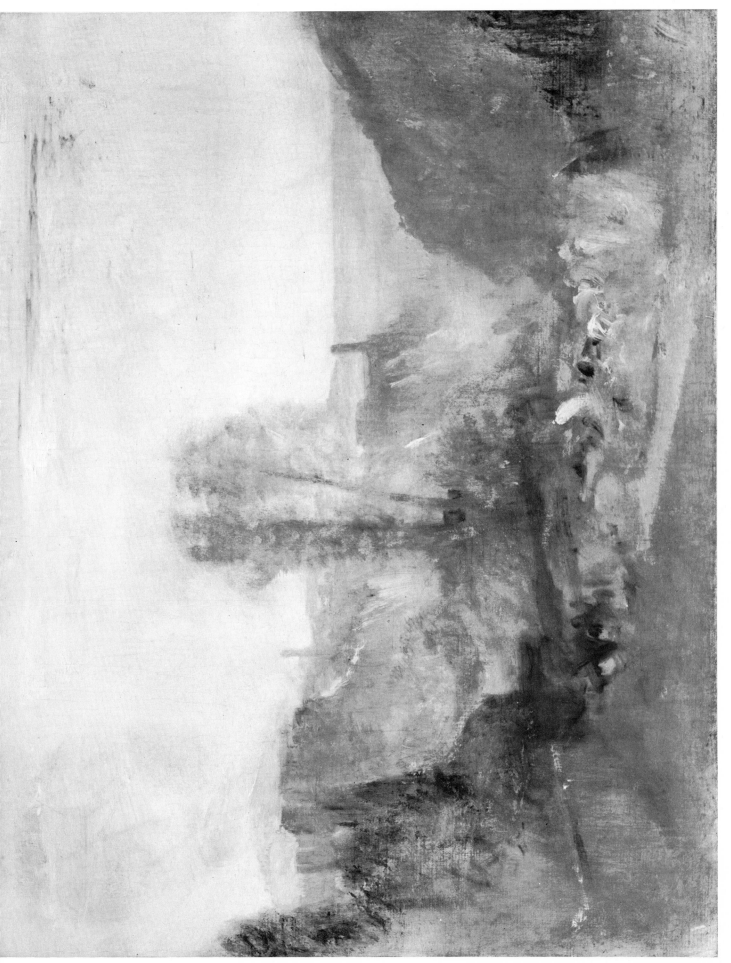

75. Italian Hill Town, probably Tivoli. $23\frac{3}{4} \times 30\frac{3}{8}$ in. Painted 1828 (?). Tate Gallery.

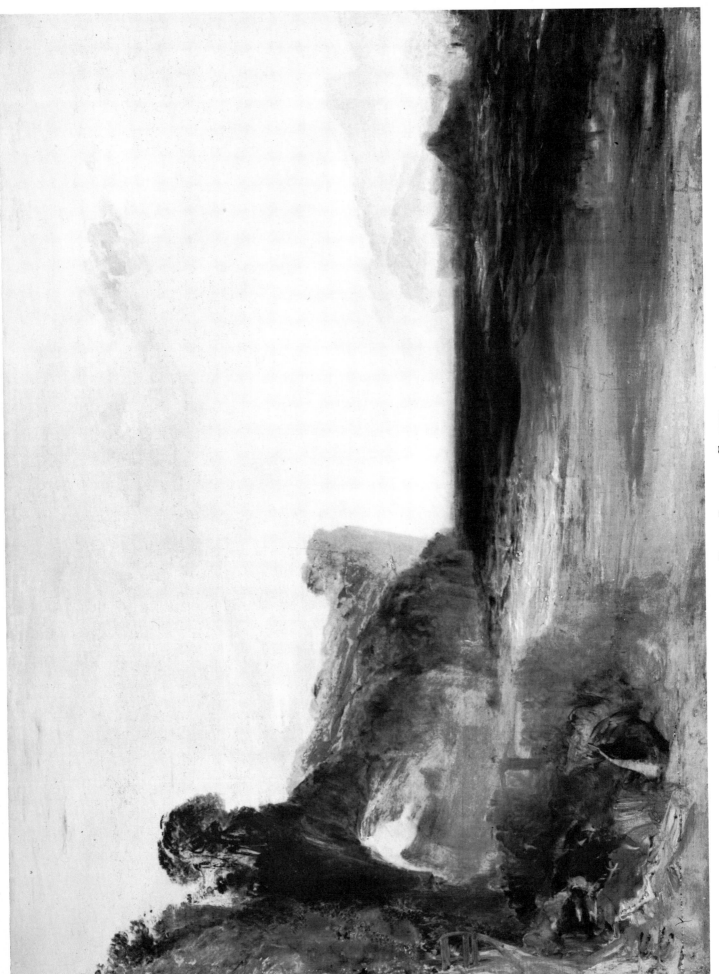

76. ROCKY BAY WITH FIGURES.
$35\frac{1}{2} \times 48\frac{1}{2}$ in. *Painted circa 1828–30. Tate Gallery.*

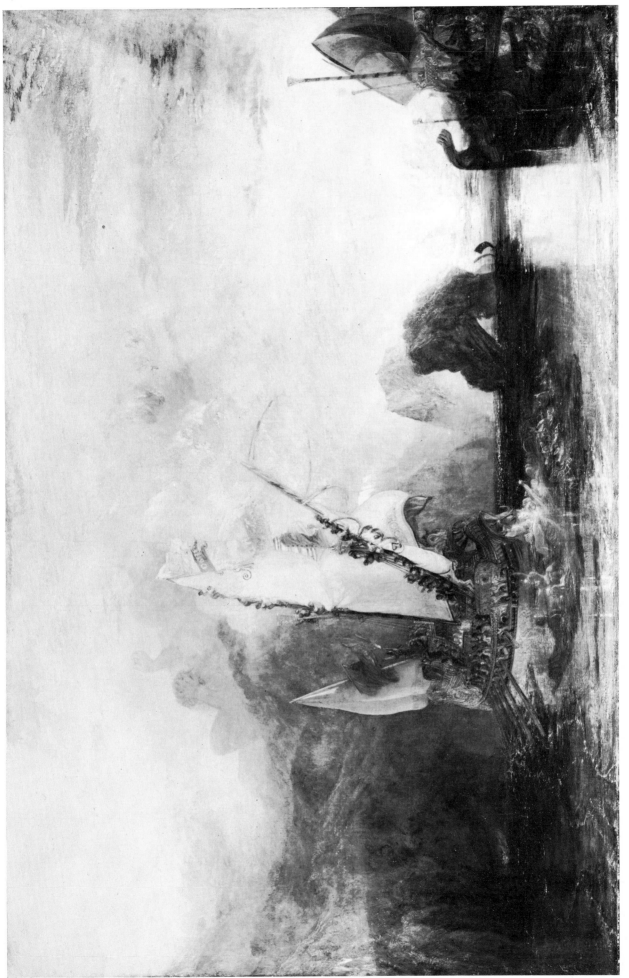

77. Ulysses Deriding Polyphemus.
$52\frac{1}{4} \times 80\frac{1}{2}$ in. Exhibited 1829. *National Gallery, London.*

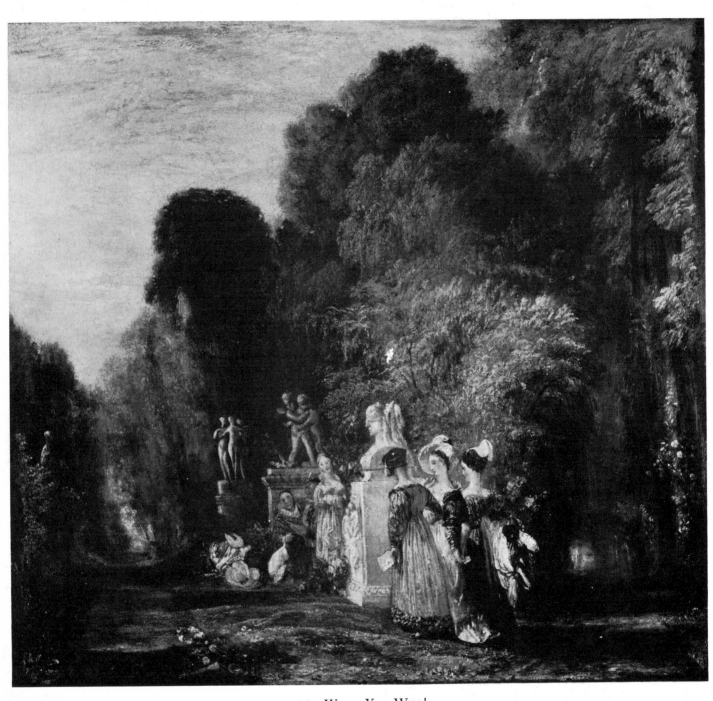

78. WHAT YOU WILL!
19 × 20½ in. *Exhibited* 1822. *Private collection, Great Britain.*

79. JESSICA.
47 × 35 in. Painted 1828. Exhibited 1830. National Trust, Petworth, Sussex (lent by H.M. Government).

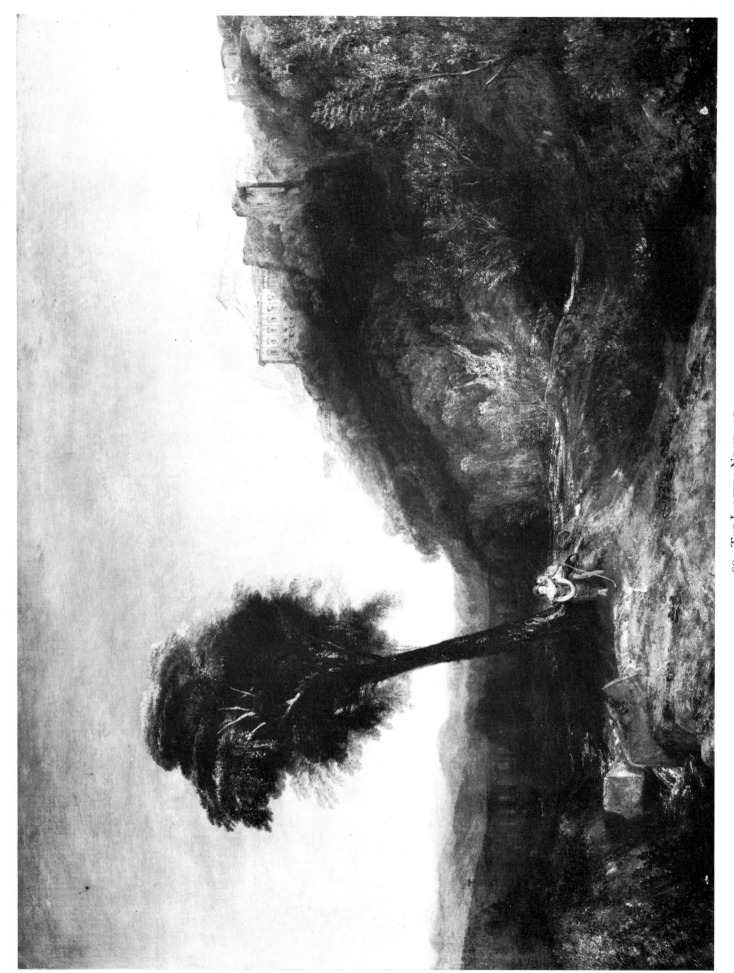

80. The Loretto Necklace.

52×69 in. Painted and exhibited 1829. Tate Gallery.

81. WATTEAU STUDY BY FRESNOY'S RULES.
$15\frac{1}{2} \times 27\frac{1}{2}$ in. Exhibited 1831. Tate Gallery.

82. The Evening Star.

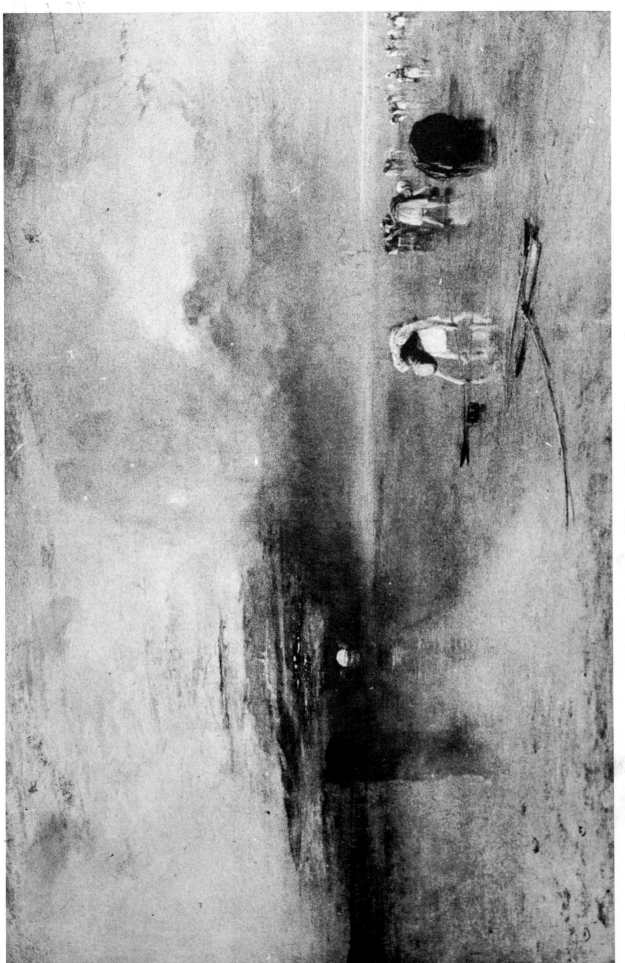

83. Calais Sands, Low Water, Poissards Collecting Bait.
28½ × 42 in. Exhibited 1830. *Bury Art Gallery, Lancashire.*

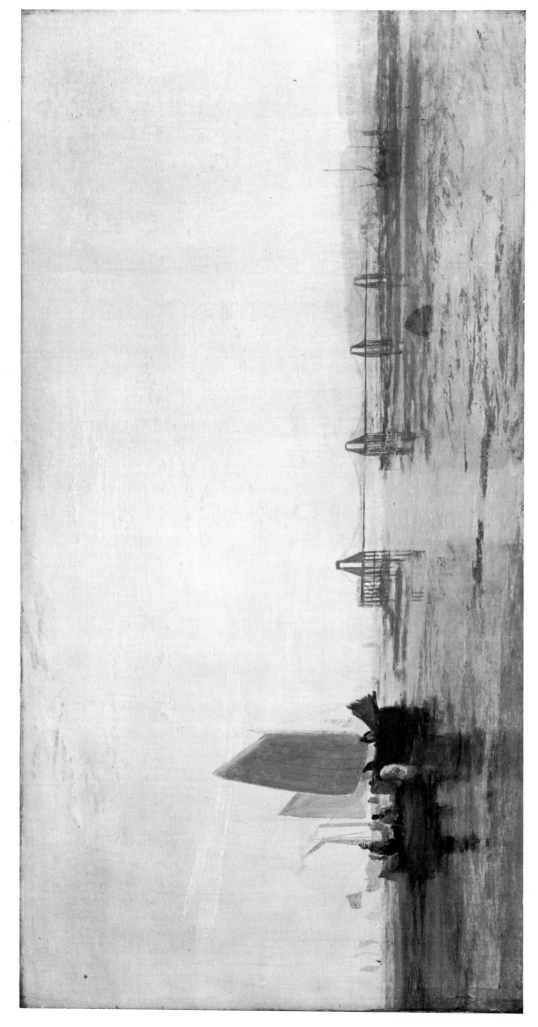

84. The Chain Pier, Brighton.
27¼×53¾ in. *Painted circa* 1830–1. *Tate Gallery.*

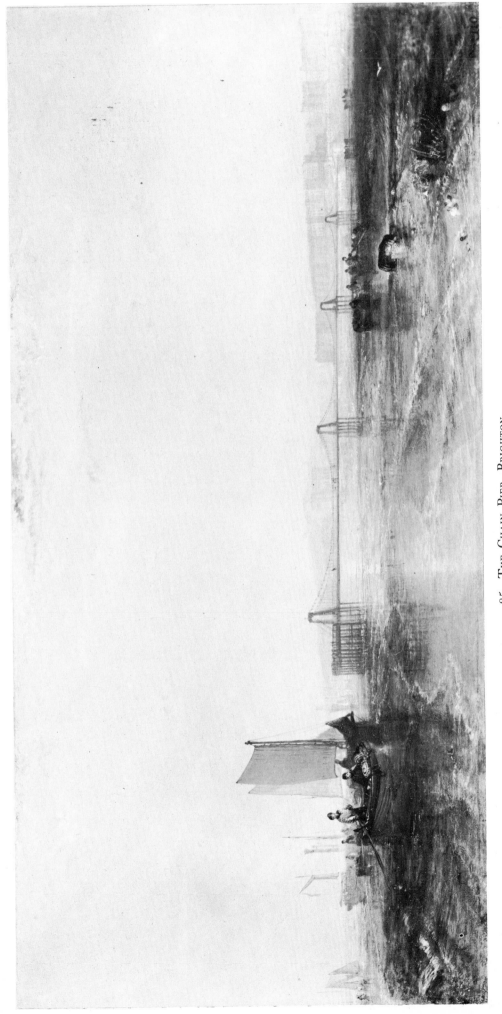

85. THE CHAIN PIER, BRIGHTON.

25 × 52 in. *Painted circa 1830–1. National Trust, Petworth, Sussex (lent by H.M. Government).*

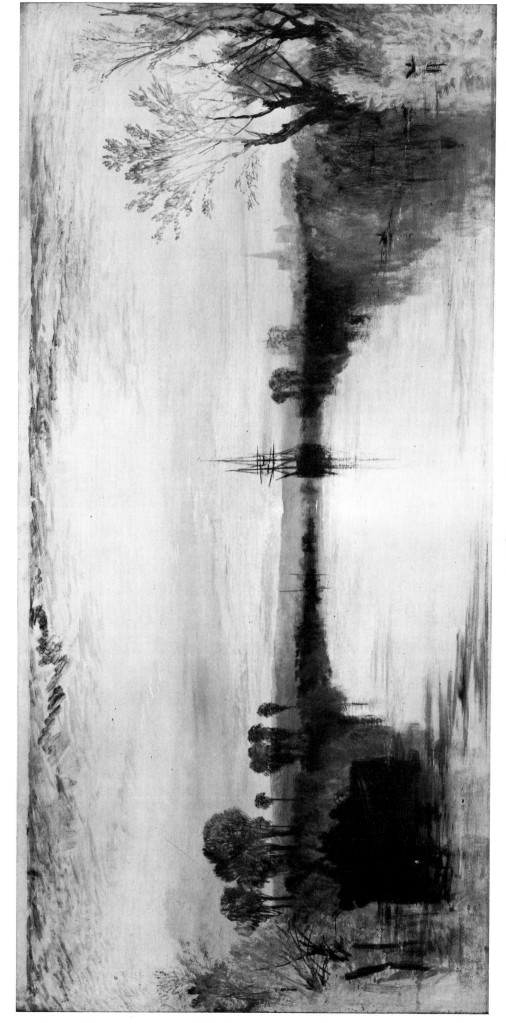

86. CHICHESTER CANAL.

25¾ × 53 in. *Painted circa* 1830–1. *Tate Gallery.*

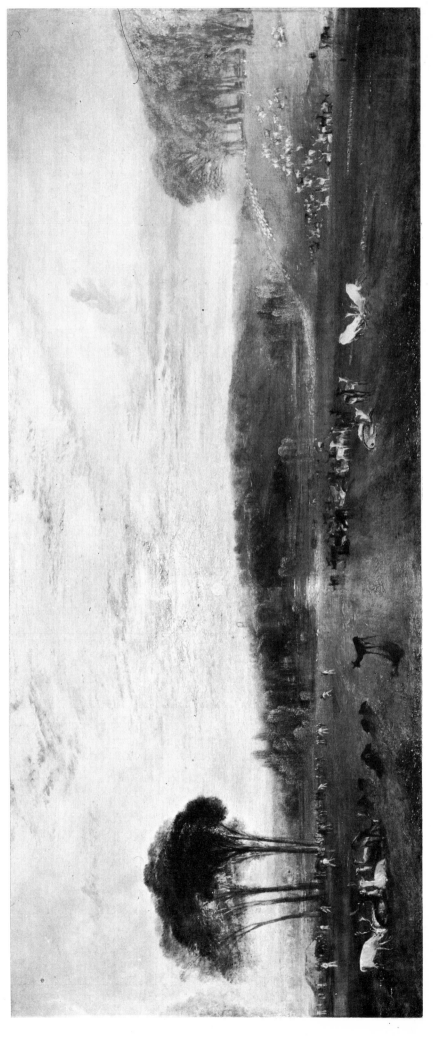

87. THE LAKE, PETWORTH: SUNSET, FIGHTING BUCKS.

$24\frac{1}{4} \times 57\frac{1}{2}$ in. *Painted circa 1830–1. National Trust, Petworth, Sussex (lent by H.M. Government).*

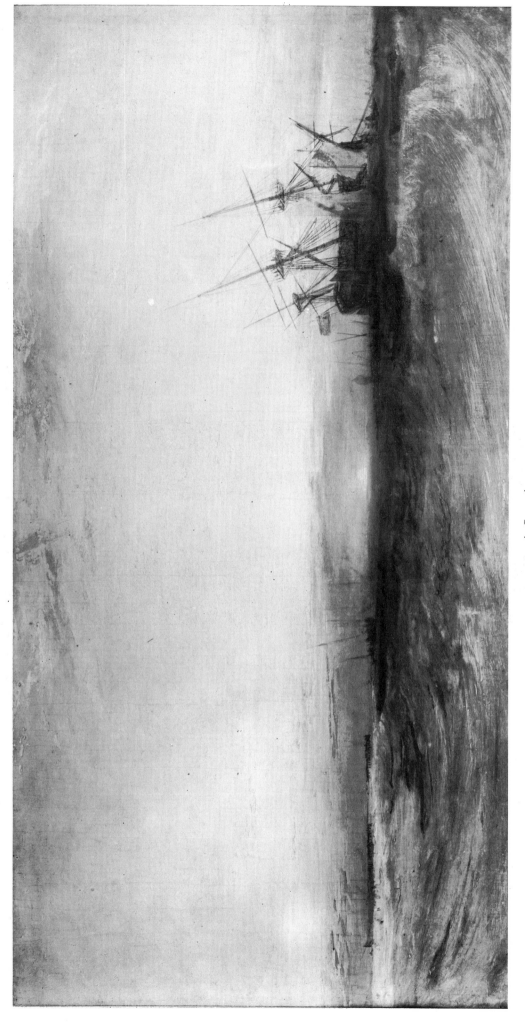

88. A Ship Aground.

$27\frac{1}{4} \times 53\frac{1}{4}$ in. Painted circa 1830–1. Tate Gallery.

89. Woman Reclining on a Couch.
$68\frac{3}{4} \times 98$ in. *Painted circa* 1830–1. *Tate Gallery.*

90. (*a*) EVENING, PETWORTH PARK.
Body colour, 5½ × 7½ *in. Painted* circa 1830–1. *British Museum.*

90. (*b*) PETWORTH CHURCH AND TOWN FROM THE EAST.
Body colour, 5½ × 7½ *in. Painted* circa 1830–1. *British Museum.*

91. (a) THE ARTIST AND HIS ADMIRERS.
Body colour, $5\frac{1}{2} \times 7\frac{1}{2}$ *in. Painted* circa 1830–1. *British Museum.*

91. (b) THE PICTURE GALLERY AT PETWORTH HOUSE.
Body colour, $5\frac{1}{2} \times 7\frac{1}{2}$ *in. Painted* circa 1830–1. *British Museum.*

92. MUSIC AT PETWORTH.
48 × 35½ in. *Painted* circa 1833. *Tate Gallery.*

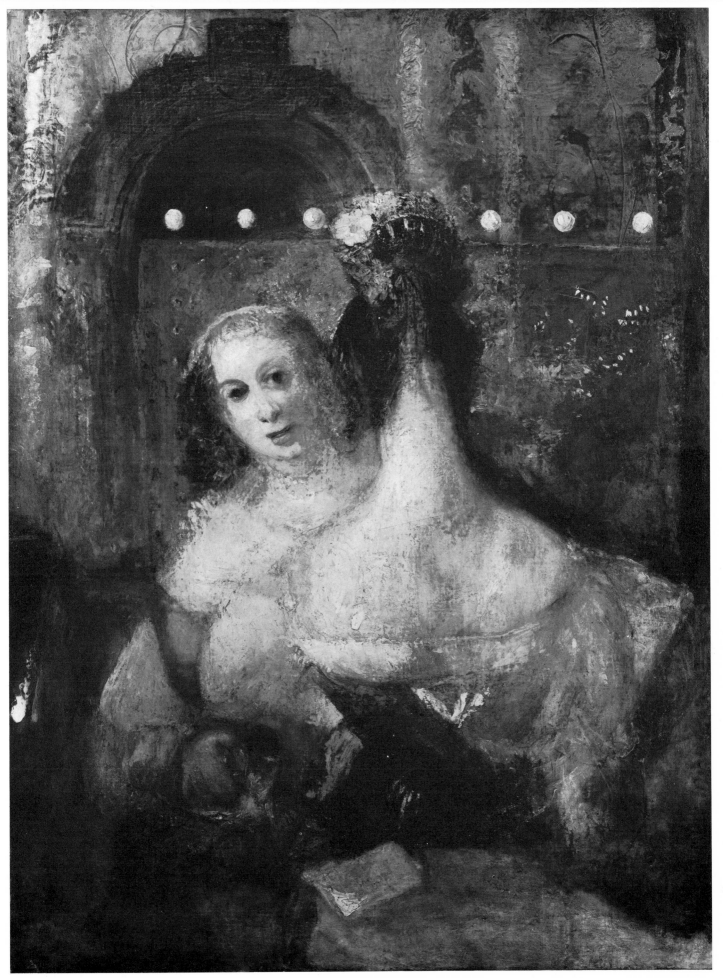

93. THE LETTER.

48 × 35¾ *in. Painted* circa *1835. Tate Gallery.*

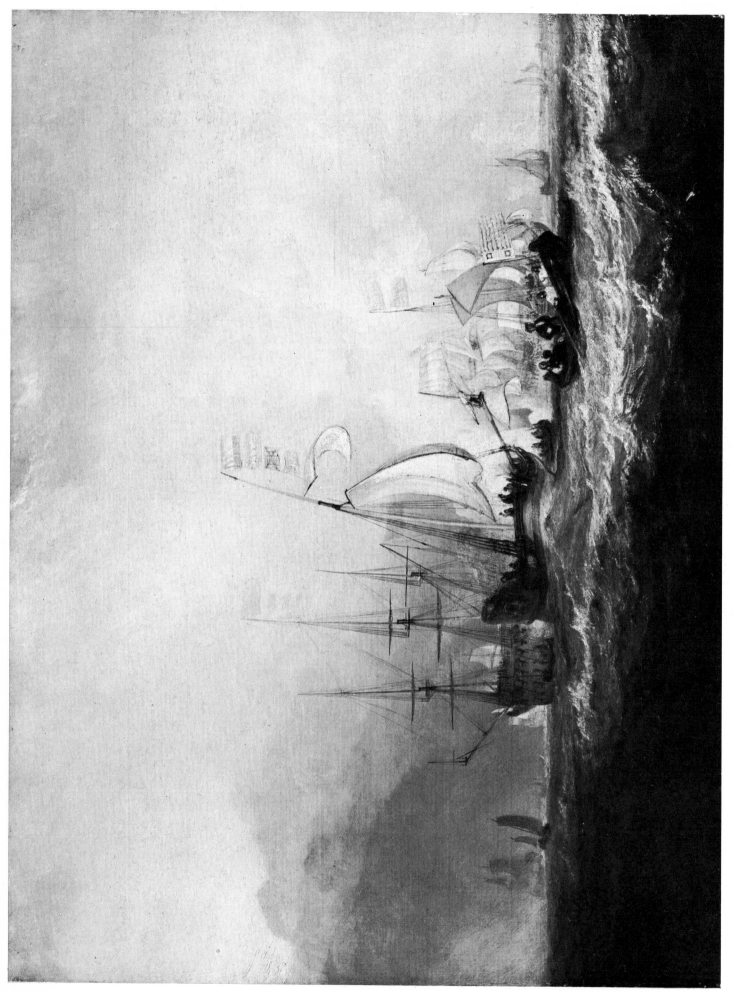

94. VAN TROMP'S SHALLOP, AT THE ENTRANCE OF THE SCHELDT.
35 × 47 in. Exhibited 1832. Wadsworth Atheneum, Hartford, Connecticut.

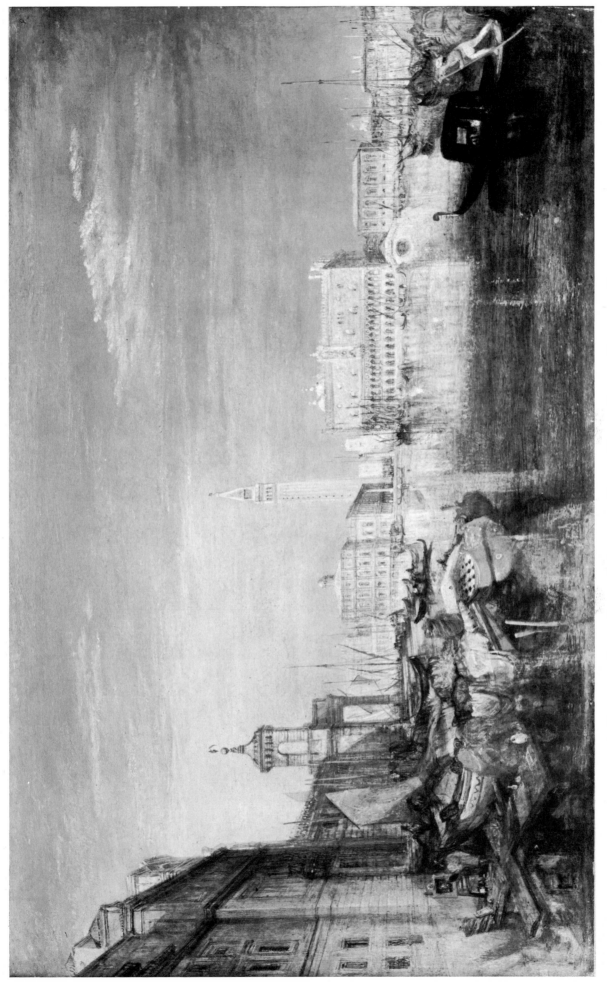

95. Bridge of Sighs, Ducal Palace and Custom-House, Venice: Canaletti Painting.
20 × 32 in. Exhibited 1833. Tate Gallery.

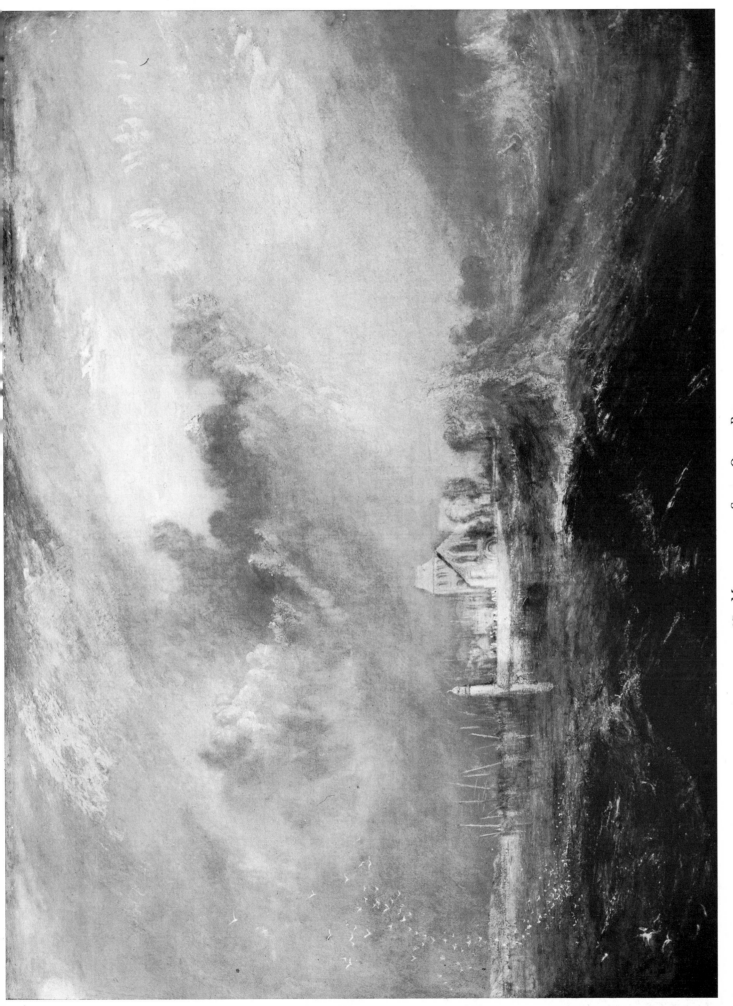

97. Mouth of the Seine, Quille-Boeuf.

$36 \times 48\frac{1}{2}$ in. Exhibited 1833. Fundação Calouste Gulbenkian, Lisbon.

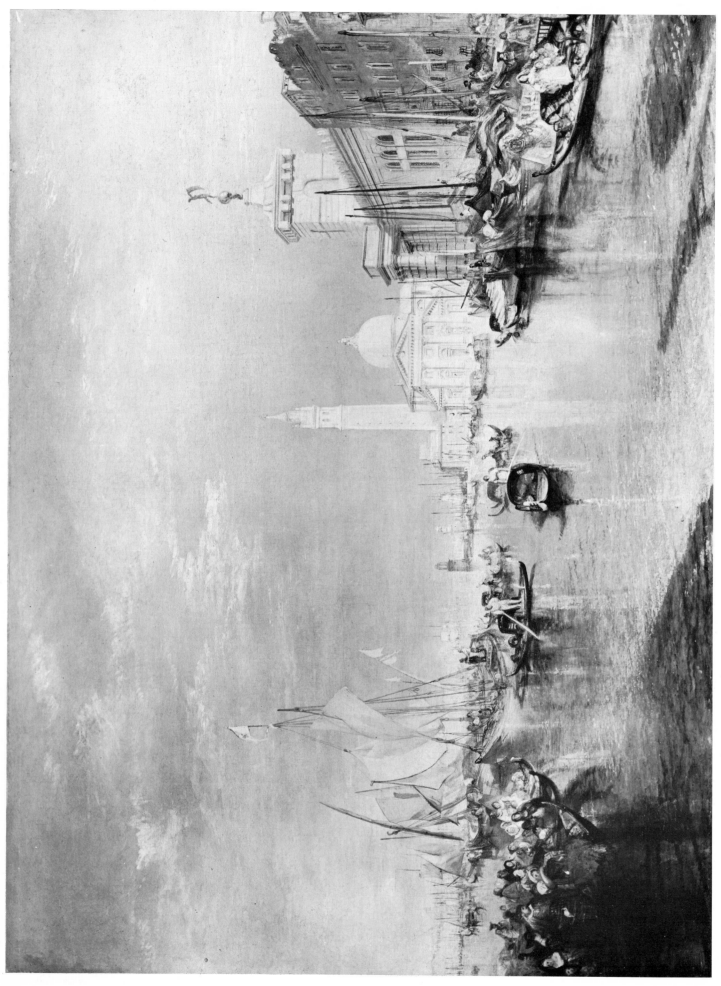

98. VENICE.

26×48 in. Exhibited 1834 (?). N. G...

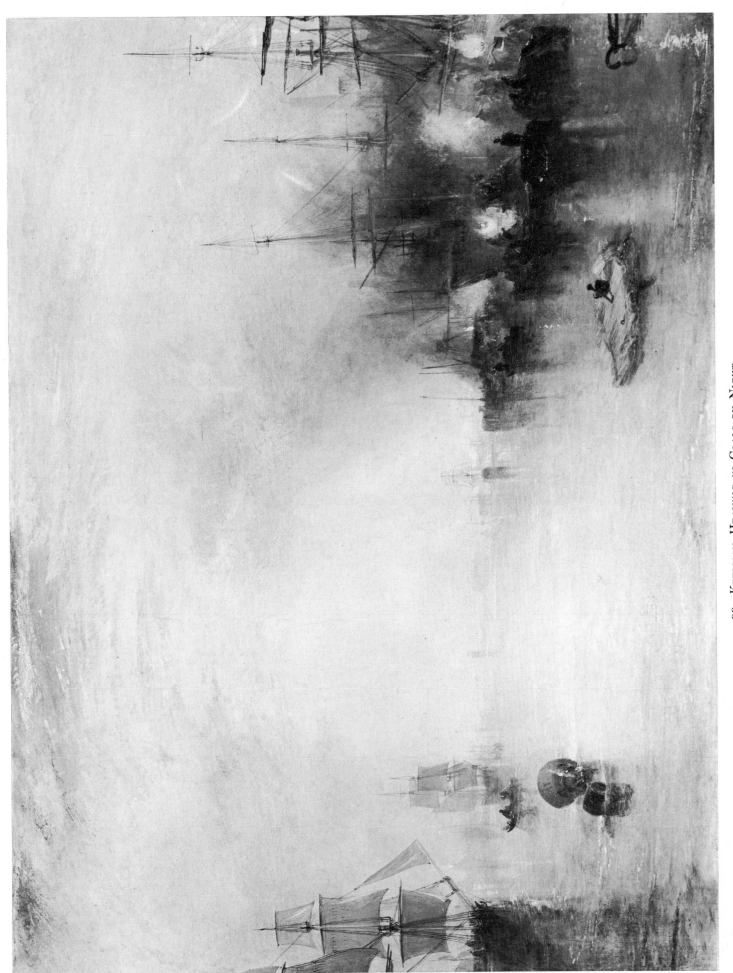

99. KEELMAN HEAVING IN COALS BY NIGHT.
$36\frac{1}{4} \times 48\frac{1}{4}$ in. Exhibited 1835. *National Gallery of Art, Washington.*

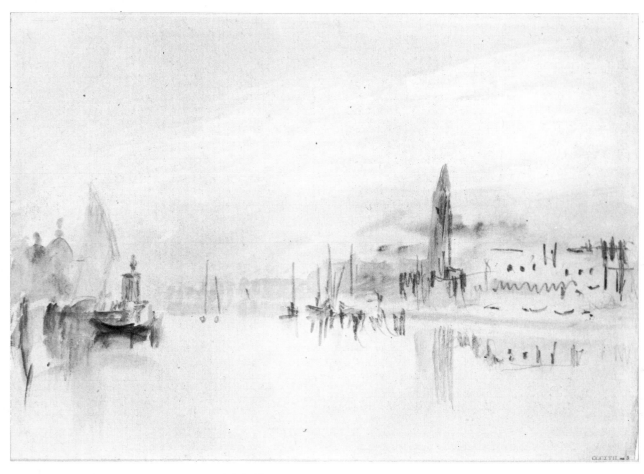

100. (a) ENTRANCE TO THE GRAND CANAL.
Chalks and watercolour, 7½ × 10¾ in. Painted 1835. British Museum.

100. (b) INTERIOR OF A WINE SHOP, VENICE.
Body colour, 9½ × 12 in. Painted 1835. British Museum.

101. (*a*) STORM AT SUNSET, VENICE.
Watercolour, 8½ × 12½ in. Painted 1835. Fitzwilliam Museum, Cambridge, England.

101. (*b*) STORM IN THE PIAZZETTA.
Body colour, 8½ × 12½ in. Painted 1835. National Gallery of Scotland.

102. JULIET AND HER NURSE.

103. Snow-storm, Avalanche, and Inundation.
36¼×48 in. Exhibited 1837. *Art Institute of Chicago.*

104. (*a*) RAINBOW.
Watercolour, 11½ × 17¼ in. Painted circa 1835–40. British Museum.

104. (*b*) PAESTUM IN A STORM.
Watercolour, 8½ × 12 in. Painted circa 1825–35. British Museum.

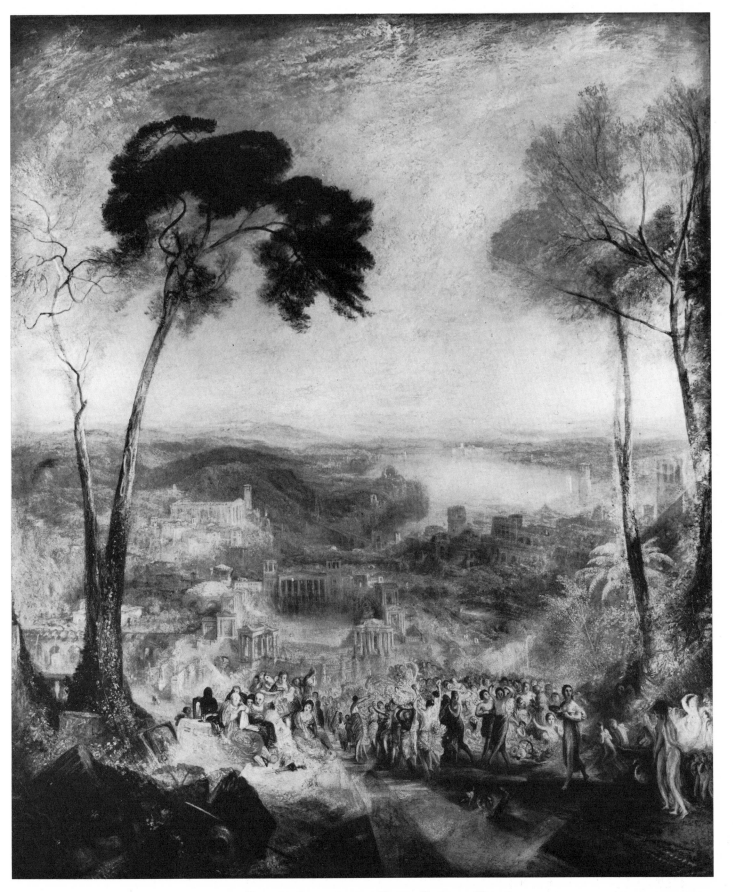

105. PHRYNE GOING TO THE PUBLIC BATH AS VENUS.
76×65 *in. Exhibited 1838. Tate Gallery.*

106. Heidelberg Castle in Olden Time.
52 × 79¼ in. *Painted circa 1835–40. Tate Gallery.*

107. CICERO AT HIS VILLA.

$35\frac{1}{2} \times 47\frac{1}{2}$ in. Exhibited 1839. Evelyn de Rothschild, Ascott, Buckinghamshire.

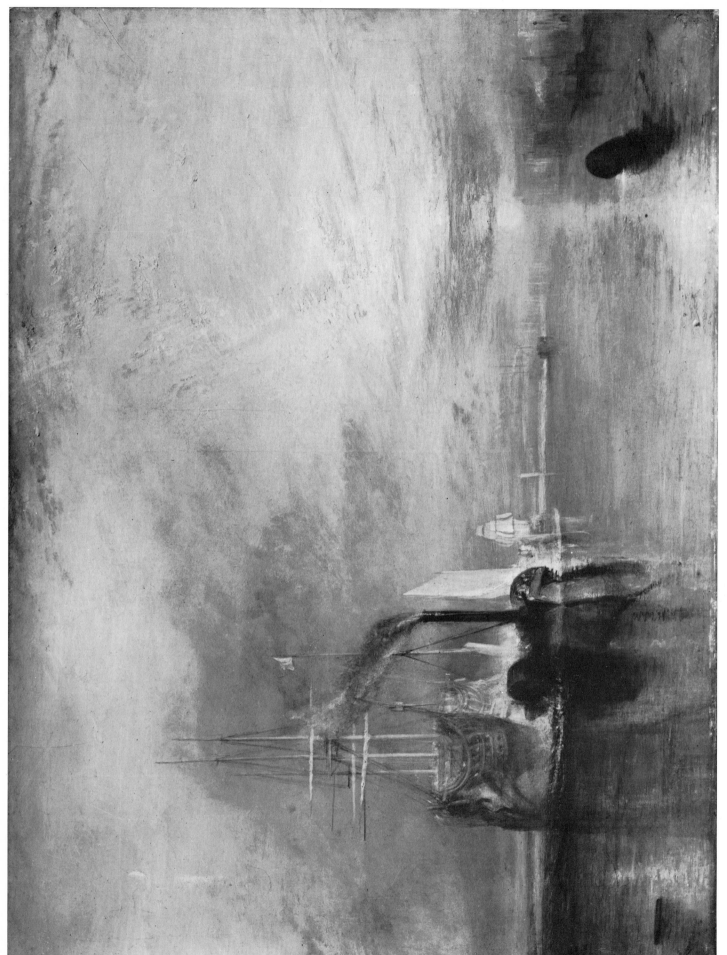

108. THE FIGHTING 'TEMERAIRE' TUGGED TO HER LAST BERTH.

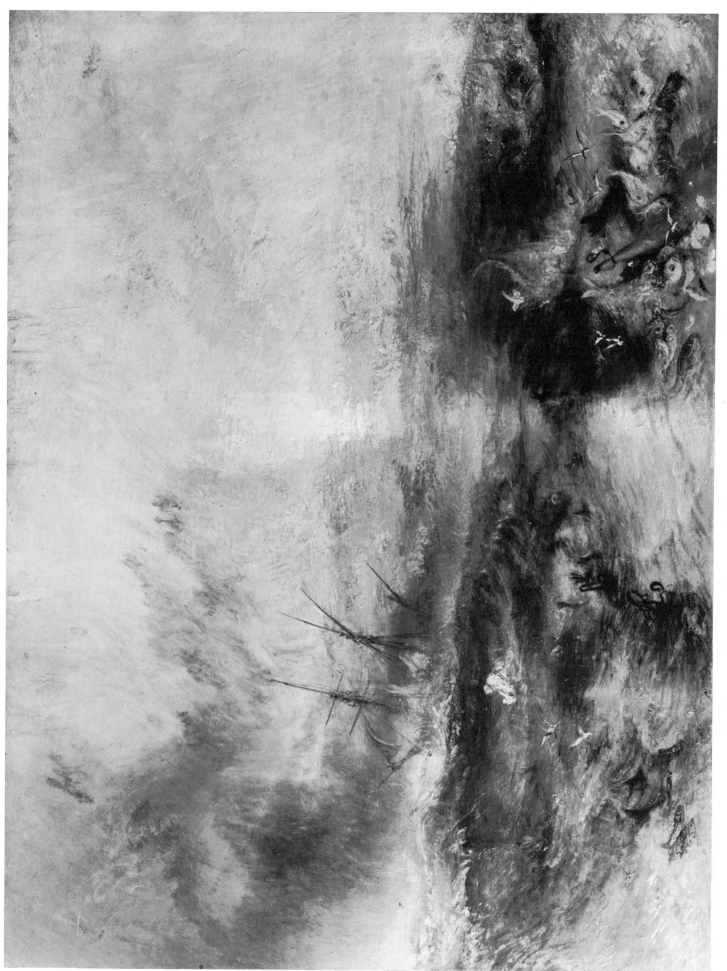

109. SLAVERS THROWING OVERBOARD THE DEAD AND DYING—TYPHON COMING ON.
$35\frac{3}{4} \times 48$ in. Exhibited 1840. *Museum of Fine Arts, Boston.*

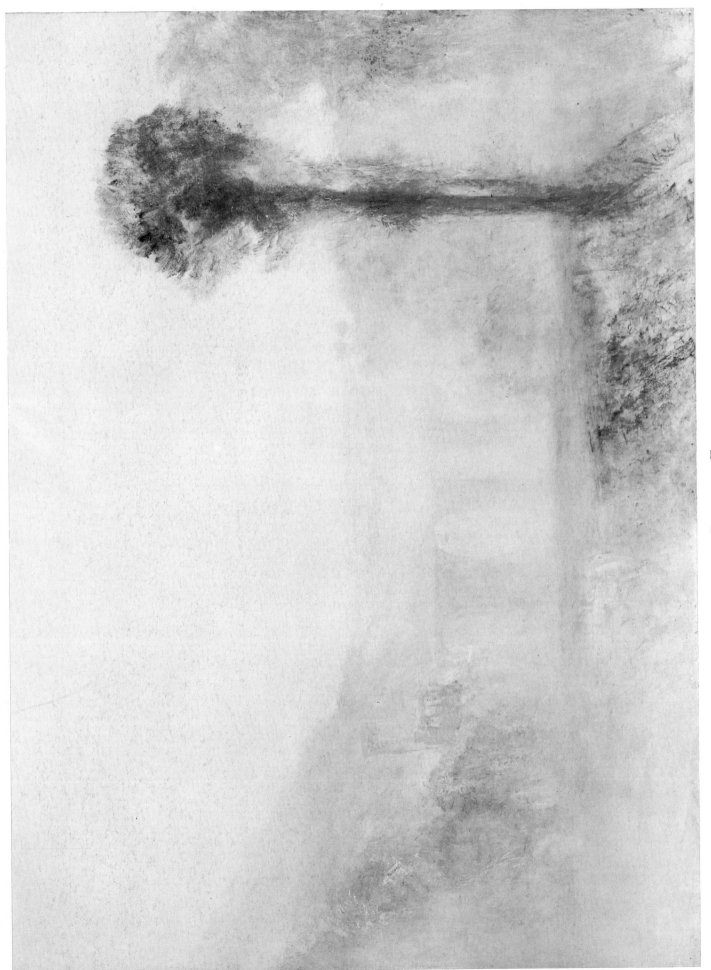

110. BRIDGE AND TOWER.
36 × 48 in. Painted circa 1835–40. Tate Gallery.

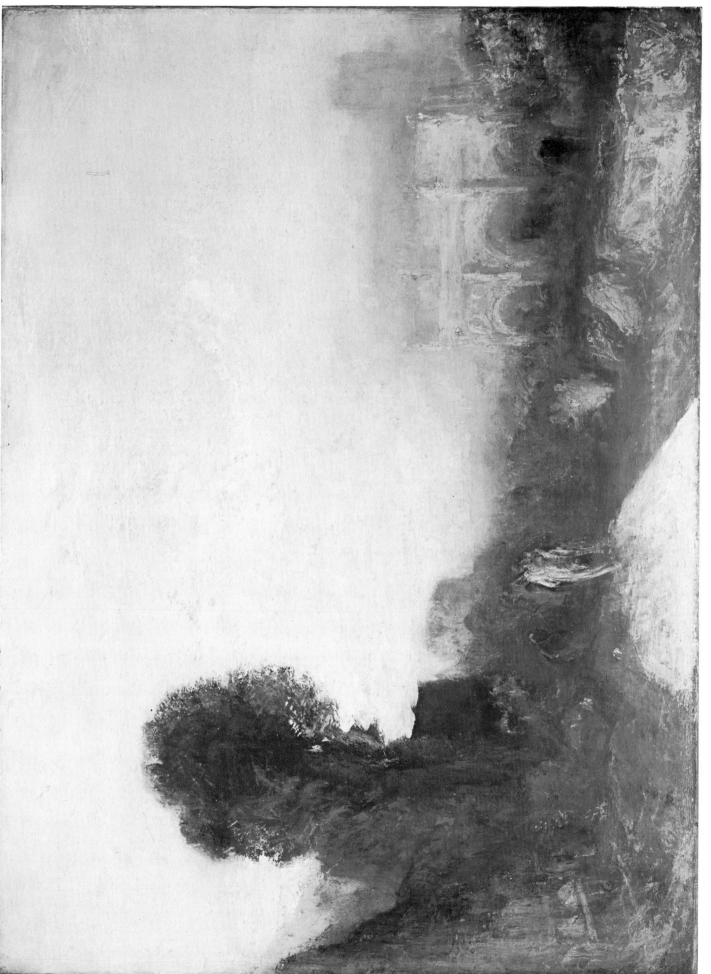

111. The Arch of Constantine, Rome.
$35\frac{1}{4} \times 47\frac{1}{4}$ in. *Painted circa* 1840. *Tate Gallery.*

112. WAVES BREAKING ON A LEE SHORE.
$23\frac{1}{2} \times 37\frac{1}{4}$ in. *Painted circa* 1840. *Tate Gallery.*

113. ROCKETS AND BLUE LIGHTS.

35 × 48 in. Exhibited 1840. Clark Institute, Williamstown, Massachusetts.

114. (*a*) VENICE: ON THE GRAND CANAL.
Watercolour, $8\frac{3}{4} \times 12\frac{1}{2}$ in. Painted 1840. British Museum.

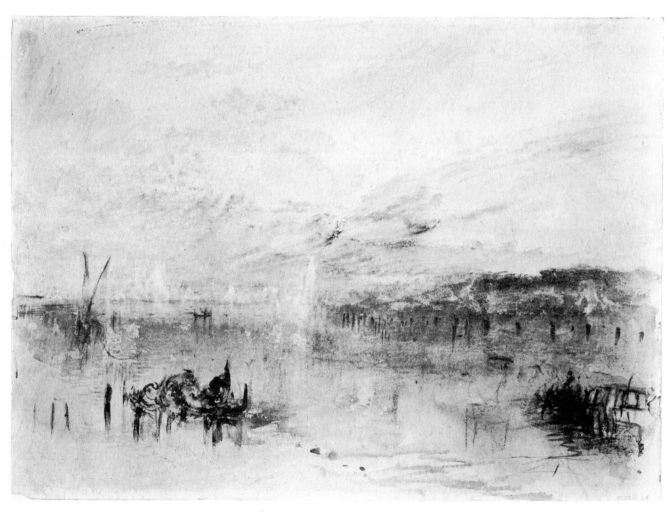

114. (*b*) APPROACH TO VENICE: SUNSET.
Watercolour, $9 \times 12\frac{1}{2}$ in. Painted 1840. British Museum.

115. (*a*) RHEINFELDEN.
Watercolour, 9 × 12¾ in. Painted 1844. British Museum.

115. (*b*) SCHAFFHAUSEN: MOONLIGHT.
Watercolour, 9 × 11¼ in. Dated 1841. National Gallery of Scotland.

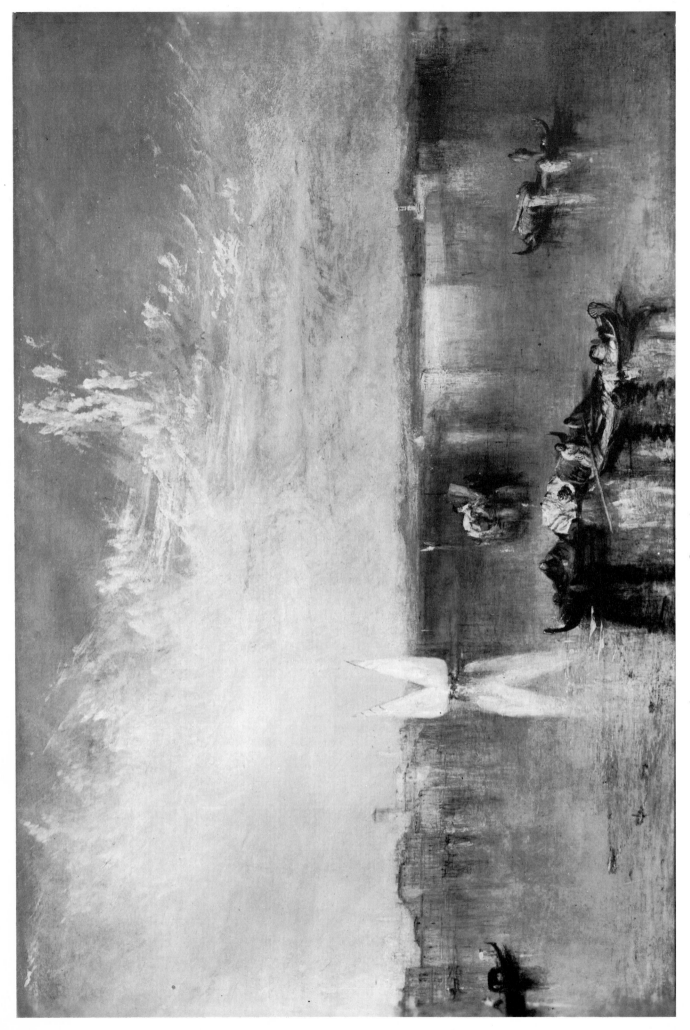

116. Campo Santo, Venice.
24½ × 36½ in. Exhibited 1842. Toledo Museum of Art, Ohio.

117. The Sun of Venice Going to Sea.
24½ × 36½ in. Exhibited 1843. Tate Gallery.

118. Yacht Approaching the Coast.
$40\frac{1}{2} \times 56$ in. *Painted circa* 1840–5. *Tate Gallery.*

119. PROCESSION OF BOATS WITH DISTANT SMOKE, VENICE (?).
35¼×47¼ in. *Painted circa 1842–3. Tate Gallery.*

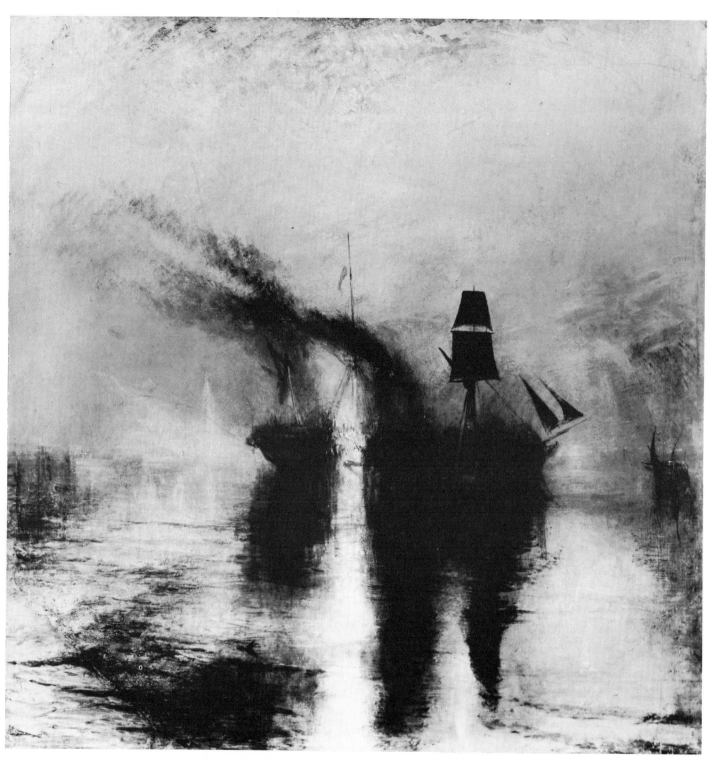

120. PEACE — BURIAL AT SEA.
$34\frac{3}{4} \times 34\frac{3}{4}$ in. *Exhibited 1842. Tate Gallery.*

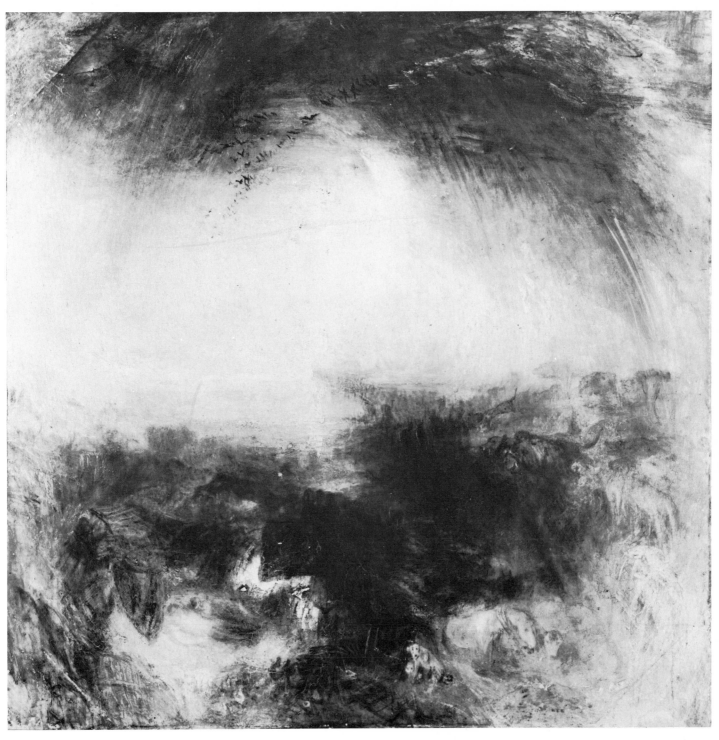

121. SHADE AND DARKNESS — THE EVENING OF THE DELUGE.
$30\frac{1}{2} \times 30\frac{1}{2}$ *in. Exhibited* 1843. *Tate Gallery.*

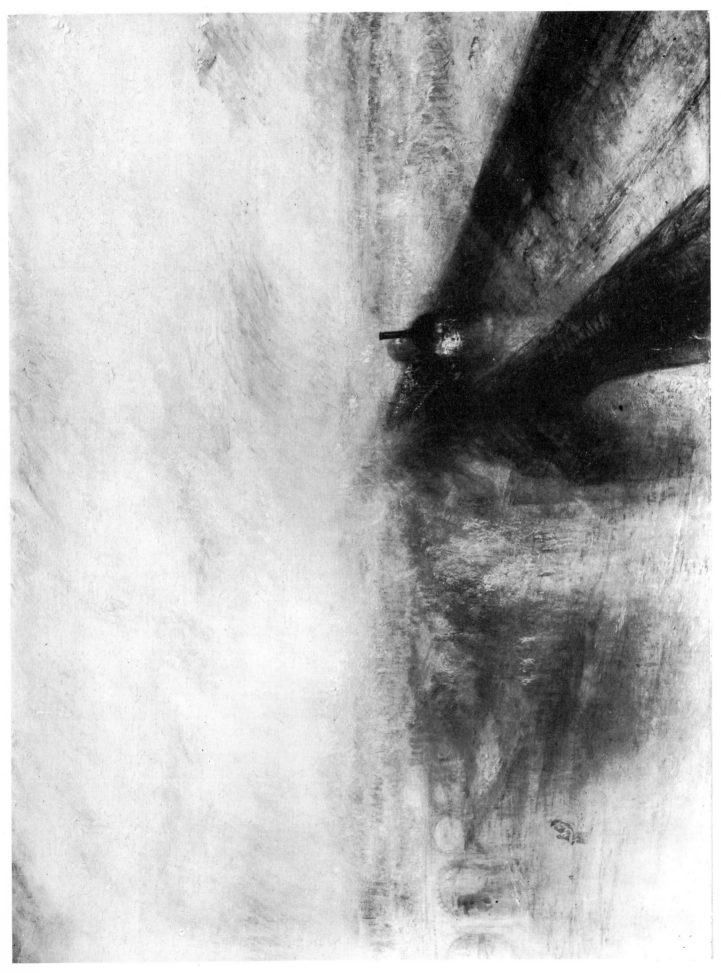

122. Rain, Steam, and Speed — The Great Western Railway.
$35\frac{3}{4} \times 48$ in. Exhibited 1844. *National Gallery, London.*

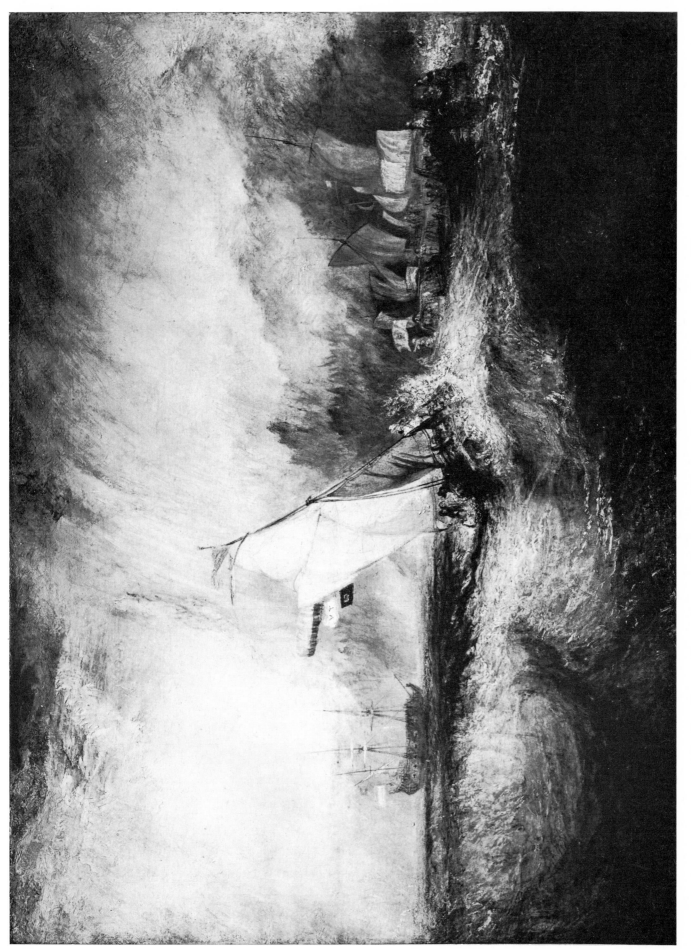

129. Van Tromp, Going About to Please his Masters, Ships a Sea, Getting a Good Wetting.
36 × 48 in. Exhibited 1844. *Royal Holloway College, Englefield Green, Surrey.*

124. NORHAM CASTLE.

36×48 in. Painted circa 1840–5. Tate Gallery.

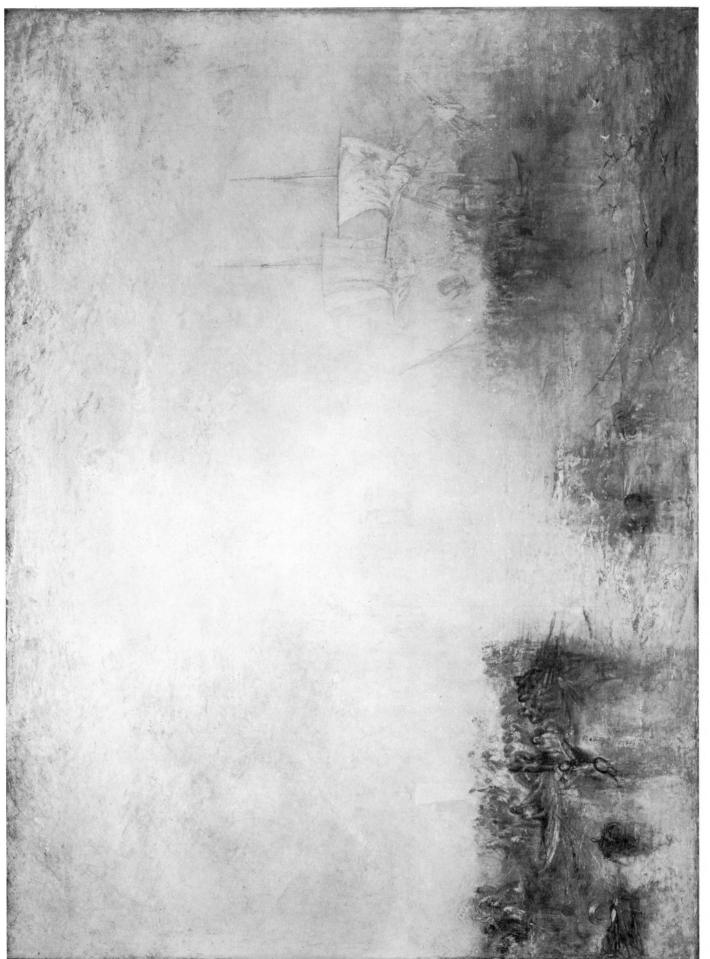

125. 'Hurrah! for the Whaler Erebus! Another Fish!'
36×48 in. Exhibited 1846. Tate Gallery.

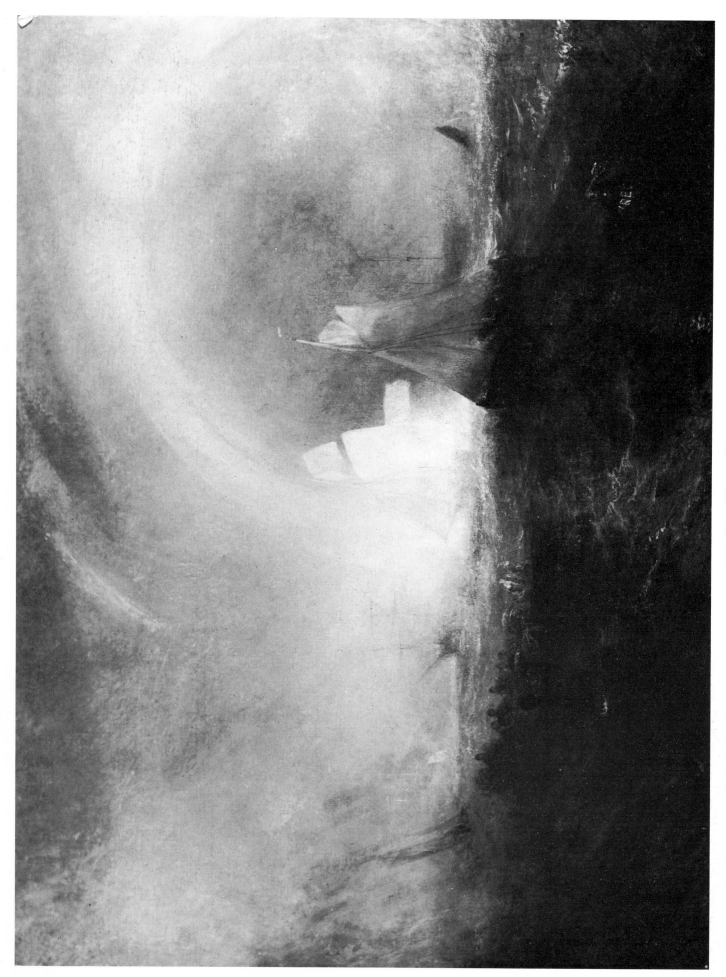

126. THE WRECK BUOY.

36¼ × 48¼ in. Originally painted circa 1809; repainted and exhibited 1849. Walker Art Gallery, Liverpool

127. The Visit to the Tomb.
36 × 48 in. Exhibited 1850. Tate Gallery.